Canadian Art

THE THOMSON COLLECTION
AT THE ART GALLERY OF ONTARIO

Canadian Art

THE THOMSON COLLECTION
AT THE ART GALLERY OF ONTARIO

CONTRIBUTORS

Jeremy Adamson, Katerina Atanassova
Steven N. Brown, Lucie Dorais, Charles C. Hill
Joan Murray, Roald Nasgaard, Dennis Reid
David P. Silcox, Shirley L. Thomson

SKYLET PUBLISHING /
THE ART GALLERY OF ONTARIO

Contents

6 Foreword

9 Introduction

11 First Nations Art from the Northwest Coast
STEVEN N. BROWN

25 Cornelius Krieghoff
DENNIS REID

43 James Wilson Morrice
LUCIE DORAIS

55 David B. Milne's Paintings and Prints
DAVID P. SILCOX

69 Lawren Stewart Harris: Towards an Art of the Spiritual
JEREMY ADAMSON

89 J.E.H. MacDonald
SHIRLEY L. THOMSON

105 Tom Thomson: Trailblazer and Guide
JOAN MURRAY

119 F.H. Varley
KATERINA ATANASSOVA

131 Paul-Émile Borduas
ROALD NASGAARD

147 William Kurelek
CHARLES C. HILL

Foreword

KENNETH ROY THOMSON, 2nd Baron Thomson of Fleet, or Ken as we all knew him, was an extraordinary human being. He built upon his father's legacy to construct one of the most successful global business empires. He amassed with an ever-growing passion what is undoubtedly the finest collection of art ever in private hands in Canada. He was the catalyst for and the enabler of Transformation AGO, and he still retained the common touch. Ken derived great joy from his interaction with people from all walks of life – whether pointing out to total strangers intriguing bargains at the local Loblaws, or sending a photograph (perhaps not of museum quality) he had taken of you with his basic camera at an event the night before.

At a lunch following a TD board meeting after Ken flipped one of his brightly coloured signature ties over his shoulder to avoid attracting the soup of the day, I asked him how he became interested in art. He began seriously collecting in 1953 when he spotted two miniature ivory busts in a Bournemouth antique shop. Shortly thereafter, Ken became excited by the prospect of acquiring an exquisite boxwood figure and was admonished by his advising dealer: "You must not look like that when you see it. You must control yourself and look very solemn. You will put the price up with enthusiasm like that." Ken took the advice to heart, but it was an enduring struggle to restrain his natural enthusiasm for marvellous works of art.

Over the years, Ken developed an ever more discerning and refined eye, but his guiding rule in acquiring art was, "If your heart is beating,

you know it was made for you." I remember Ken confessing that, while assembling his collection, he viewed the Art Gallery of Ontario as a competitor but, as time passed, he came to envisage the AGO as the ideal vehicle for keeping the collection intact and exhibiting it to the people of Canada so that they could experience the same pleasure as he did from his art. "It might make people see and enjoy objects previously unfamiliar to them. . . . It might open up their horizons. I do not see how you can walk past these beautiful objects, look at them, and not see the glory of art and its creation." Accordingly, Ken determined to donate his unsurpassed collection and to work with Matthew Teitelbaum and Frank Gehry to transform the Art Gallery of Ontario.

Ken wanted the works displayed in an atmosphere where the viewer could feel "at home." At one time, he contemplated music in the galleries, and he liked the idea of a series of rooms that led one into the other so that people could walk through "chapters" of his collection.

Ken remained intimately engaged in the Gehry project to the end. He continued to purchase works of art to enhance the quality of the Thomson Collection and with exceeding generosity took steps time after time to encourage the realization of Transformation AGO at the highest level. I remember Ken leaning over at a curatorial discussion of the David Milne exhibition in 2005 and saying, "I don't want to jinx it, Charlie, but I think our project is going to be the best." That seemed appropriate, because everything about Ken Thomson was the best.

A. CHARLES BAILLIE, O.C.
PRESIDENT, ART GALLERY OF ONTARIO

Introduction

MY FATHER COMMUNED WITH OBJECTS. The journey lasted a lifetime. The pursuit was manic and often solitary. My father channelled his energies and unravelled passions that allowed him a solace few could possibly comprehend. Deep friendships developed around this journey of perception and discovery. The facets seemed endless and were reflected. The legacy was a collection of objects that defied linear logic.

Some collectors derive pleasure from the status of ownership; others sustain interest through economic motives. The inherent value of an artwork is gauged by the heart. Experience is often visceral and radiates to one's core. The journey of an art collector is compelled by complex internal forces, from melancholy to wonderment.

My father's course evolved over the years and interactions around art became the barometer of life. He would extract the deepest pleasure from human companionship; artists, collectors, dealers, researchers and any soul with whom he might share his enthusiasm were enlisted for their visceral response to Group of Seven sketches or a Gothic diptych. My father's letters attest to the profound role of communication in his daily life. The art often turned out to be incidental to the friendships that lasted a lifetime. In all spheres the essence of my father's spirit was immersed within the act of consideration, rather than the prospect of possession. The formations of these collections represent a lifetime's journey inspired by the human condition.

The objects within the various collections remain tangible evidence of an immense ambition around the visual experience. My father followed his innermost convictions and had the courage to press his feelings. In some instances, he stood alone as a precursor to the subject or established new thresholds of value. The dogged determination drew the admiration of friends and foes alike, as primal competitive instincts emerged from this gentle soul. My life with father in this realm created a unique bond between us. The human spirit was constantly engaged in all its myriad of shapes and forms. The imprint was quite extraordinary, as the journey became an exploration of the human condition. Father's curiosity seemed insatiable and the objects were conductors through which the widest spectrum of human spirit coursed. The pursuit of art allowed father to make sense of the world and celebrate life in all its resplendent forms.

DAVID THOMSON

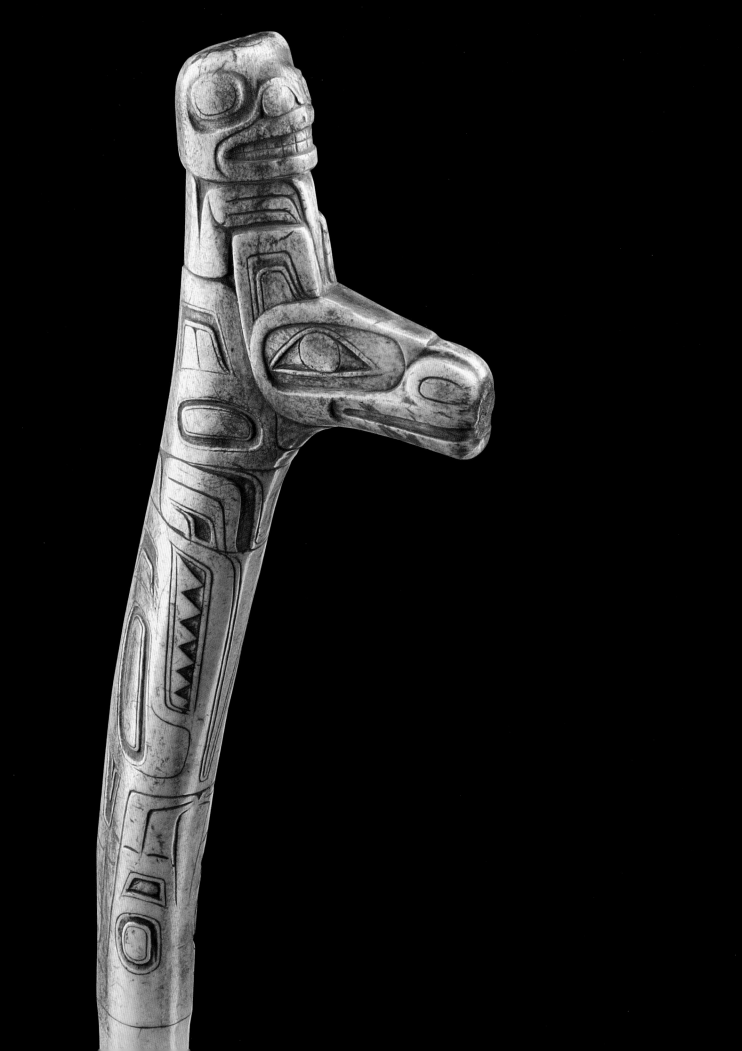

First Nations Art from the Northwest Coast

STEVEN N. BROWN

Canada's west coast is a region of densely forested, rocky islands both great and small, separated by innumerable channels and fjord-like inlets that slice between the high peaks and glaciers of the coastal mountain range as far as seventy miles inland. While the southern end of the coastline – where the cities of Victoria and Vancouver lie – is densely populated, the coast's western edge and northern extreme are quite the opposite. Except for the port city and rail terminal of Prince Rupert on the far northern coast, the only population centres are small towns or villages. Some of these are service communities for dams or resource processing operations, but most of them are villages of the indigenous First Nations population.

Many such villages have been occupied for generations and in some cases people have lived on these same sites for millennia. Frequently they are situated atop large tracts of cultural refuse that archaeologists refer to as middens. These are accumulations of bone, shell and organic debris that have built up over the centuries, often to a depth of several metres. Such middens can also be found beneath numerous, now vacant, locations that were occupied until the arrival of the Europeans in the late eighteenth century. From the 1780s to the mid nineteenth century, numerous pandemics of European diseases such as measles, malaria and especially smallpox swept through the First Nations population, which had no natural or developed immunity to these foreign microbes. It is estimated that about 80% of the indigenous population was lost during these pandemics, creating a cultural and population vacuum that was not reversed until the mid twentieth century.

There are nine major language families and cultural groups that constitute the First Nations: the Coast Salish, Nuu-chah-nulth, Kwakwaka'wakw, Oowekeno, Nuxalk, Heiltsuk, Haisla, Haida and the Tsimshian-speaking groups, individually known as the Gitk'san, Nishga'a and the Coast Tsimshian proper. These shared certain general traits of culture, adapted to the marine environment, and each possessed a flourishing heritage of sculpture, painting and dance that represented rich mythologies and cosmologies.

At the southern range of the coast, the Nuu-chah-nulth and Kwakwaka'wakw call the western and northern portions of Vancouver Island their home territory. The Coast Salish occupy the south-east of this largest of islands as well as the smaller islands and the mainland shore across the Gulf of Georgia, including the lower reaches of the Fraser River valley. This area enjoys the mildest overall climate and the most hospitable geography of the region, and has supported an abundant subsistence in its comparatively sheltered seas and numerous large river systems.

As one travels northward along the coast, leaving the solid protection of Vancouver Island, the geography grows increasingly inhospitable, but smaller islands sporadically block the wind and storm swells of the outer coast. These islands are in fact the tops of a marine mountain range,

inundated when sea levels rose dramatically at the end of the last major ice age, 10,000 years ago. Here and there along the ribbon-like channels between their steep slopes there are broad, protected, low-lying foreshores of habitable land. While some of these are no longer occupied, on others can be found isolated villages of the First Nations, who have populated these islands and channels for over 9,000 years. The remnants of once much greater settlements, some communities are made up of a few dozen souls, others of several hundred or more. Their multi-family houses were built of cedar – with posts, beams and roof boards split and hewn from this giant tree. Today single-family modern frame-style houses are the standard, though many communities have built replicas of traditional houses for community functions.

As the glaciers which had once locked the entire coastal region in an icy grip receded, peoples from the continental interior migrated coastwards. Oral histories recount tales of travel down through the mountains on the major coastal rivers, sometimes over or under vast fields of remaining glacial ice, before reaching inhabitable regions on the outer coast and barrier islands as well as along the inner, more protected channels and bays. There the settlers developed new technologies, social structures and systems in response to their new environment. The development of equipment for hunting sea mammals, for example, reached its peak among the Nuu-chah-nulth, who became hunters of migratory whales. Other Northwest Coast groups hunted seals for their meat, which was preservable, and blubber, which they could render into oil and which was an important source of fatty acids in a largely protein diet. But the main source of fresh and preserved food was Pacific salmon, a sea-run fish that has evolved into five different species on this coast. All Pacific salmon are anadromous: they begin life in the rivers, creeks or lakes of the coastal region, and migrate to the open sea for their adult years. Before dying, they return to the stream of their birth to spawn the next generation. To harvest this seemingly limitless resource in the summer and fall months 'fish camps' were set up, separated from the more permanent winter villages, sometimes by great distances. Fish in their hundreds and thousands were caught, preserved by smoking and drying, and packed into bentwood containers for later consumption or trade.

One of the most important technological developments of the Northwest Coast was the sea-going canoe, the only practical means of transportation along the interlaced waterways spanning the region. Canoes were made in nearly as many types as there were First Nations. They were nearly always carved from a single large red cedar log, though in the far northern area, where red cedars do not grow, Sitka spruce was substituted to good effect. The canoe hull was carved out of the log to nearly its final form, having been shaped down to a mere inch in thickness. The hull was then steamed using water and red-hot rocks, and

the wood heated through until it was moist and pliable. The hull was opened up at the middle until it was wider than the original log, a process which also made the sides considerably stronger. Steaming and bending raised the ends of the canoe higher in relation to the sides, adding to the seaworthiness of these remarkable vessels.

Canoes of varying sizes from three to over twenty metres in length were employed in hunting and food gathering, trade and warfare, and the travel needed to fulfil social contracts such as marriages and the defining cultural institution of the region, known widely today as the 'potlatch.' The potlatch was the means by which social arrangements and relationships were verified and recognized. In an oral culture, without written records of any kind, marriages and the transfer of cultural property such as hereditary privileges and titles were accomplished in a public setting before witnesses, whose obligation it was to remember what business was transacted and to carry the new arrangements forward in their own potlatch activities. Witnesses were 'paid' by their hosts in property, including preserved foods, wooden containers, canoes, garments for ceremonial use and blankets – either of Native manufacture or from trade with the Hudson's Bay Company.

Northwest Coast society was highly stratified and hierarchical. A few noble families or lineages might own whole fishing sites. These privileged lineages also controlled the membership in the secret societies that governed the display of cultural wealth such as the dance and song performances expressing sacred myth and the relationship between the physical and the spirit worlds. Commoners and slaves, captives from other tribes, made up the workforce needed to build houses and preserve food for the long, dark winters.

Northwest Coast art was primarily a commodity of the noble lineages, its purpose being to represent, in sculptured emblems, the animal-spirit progenitors of a clan dynasty. Whales, eagles, ravens, bears, wolves, frogs, salmon, sharks and many other kinds of animal, including creatures such as woodworms and dragonflies, were carved or painted to adorn the houses, canoes, storage containers and ceremonial objects of the noble classes. These figures were manifestations of the genealogies that underpinned the status of the nobles, and featured again in the ceremonial dramatizations and performance of dance complexes that further reiterated noble histories and status.

Objects in the Collection

Some of the most striking and widely appreciated ceremonial materials from the Northwest Coast are masks. Masks took many forms, from portrait-like human visages to representations of birds and animals. Some

1

Haida portrait mask, *c.* 1840
Wood, pigment, hair
23.5 × 21.0 × 15.0 cm

2

Tsimshian portrait mask
c. 1820–40
Wood, pigment, hair
20.0 × 19.0 × 9.5 cm

were made with articulations such as rolling eyes or moving mouths or beaks, which can lend a surprising degree of life and realism to a carved wooden image. All manner of tools, utensils and ceremonial objects like rattles, headdresses, robes and other regalia were decorated with clan and family crests, while some representations of creatures were particular to the object – for example, raven rattles.

The masks represented in the Thomson Collection are largely of the portrait type and are some of the finest of their kind. One of these (fig. 3) is among the most engaging sculptures to have come from the region – a Tsimshian carving formerly in the collection acquired in 1863 by Rev. Robert Dundas. Most likely made to represent the spirit of a revered ancestor, the mask is brimming with well-defined features, suggesting underlying bones and taut skin. Between open eyelids, the area of the eye itself is cut through to the interior of the mask. Pieces of what appears to be birdskin have been attached to the forehead and cheek areas; though the precise meaning of this is unknown, the effect is certainly powerful. Pieces of animal skin have been used as well for the moustache and beard, in a technique that is often seen in the more elaborate Northwest Coast masks. A mask like this employed in a fire-lit dramatization would certainly draw rapt attention from the audience, especially when coupled with the skilled motions of a practised performer.

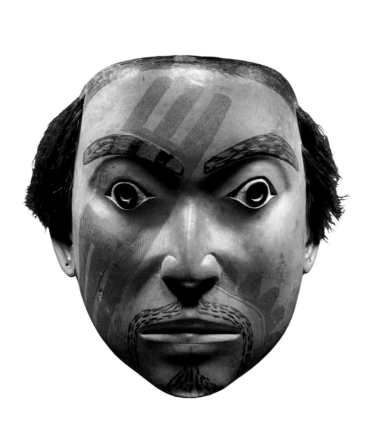

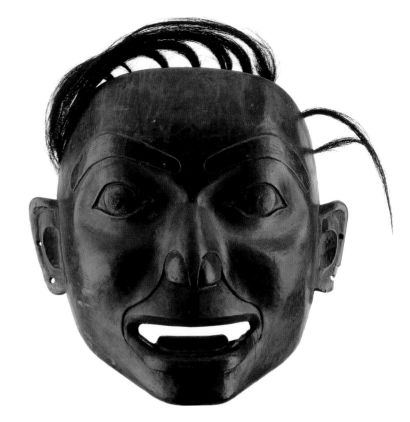

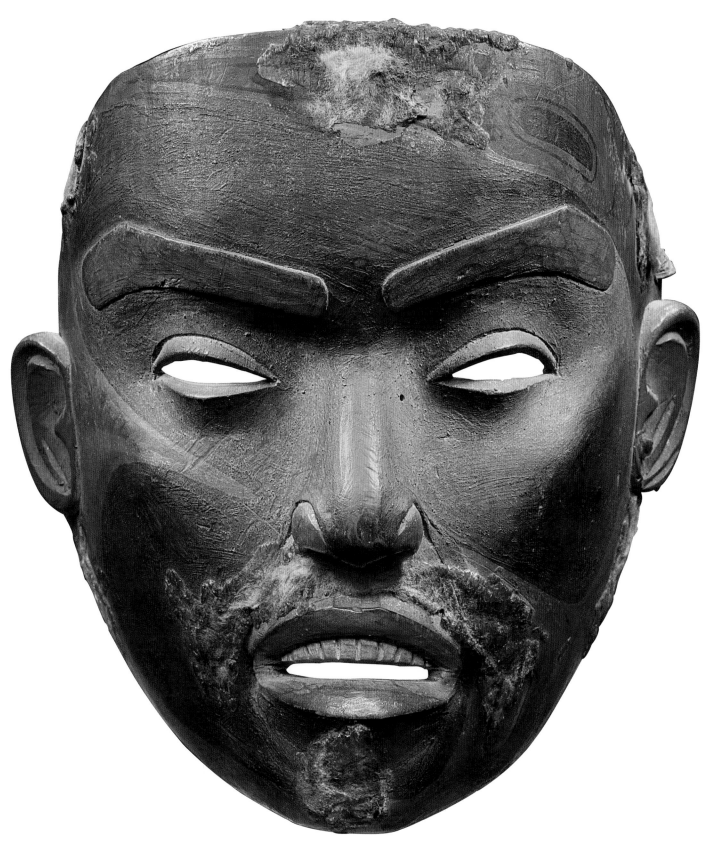

3
Tsimshian face mask

c. 1820–40

Hardwood, pigment, hide

19.0 × 17.7 × 10.5 cm

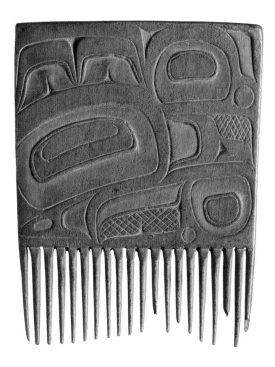

4
Tsimshian comb, *c.* 1830–60
Hardwood
11.3 × 8.7 × 0.8 cm

Two other masks from the Thomson Collection (figs. 1, 2) are also fine examples of the portrait-like genre: both have a bright and lifelike expression that speaks of the skill and artistry of their makers. The first is a very sensitive representation of a recognizably First Nations face, with soft skin and smoothly rounded features. A painted, almost hand-like form crosses the proper right side of the mask from cheek to forehead, through the eyesocket and seemingly beneath the eyebrow. This bright red form is a reflection of face painting, a means often used in ceremonial events to display symbols of family or clan lineages. Lines of black dashing are used to represent a moustache and beard of similar shape to those on the first mask mentioned. Red dashes, the symbology of which is unknown, embellish the eyebrows, and another red element can be seen painted on the proper left cheek. Human hair was attached to the sides of the forehead at the temples, a very unusual or perhaps unique feature of this mask, lending uncommon character to the face. The third mask of this group is much more stylized than the other two and yet also displays a visage full of life and spirit. Small, like the first mask, it has a large wooden plug, or labret, in the lower lip, indicating a high-ranking female. Small metal pins were inserted in the lower lips of young girls and were replaced with consecutively larger plugs as they aged. The custom is documented in glass plates made in the earliest days of photography in the region, from the late 1860s through the 1880s, of older women who still had labrets. Hanks of human hair pegged through holes drilled into the upper edge of the mask add a great deal to its lifelike qualities, which were even more remarkable when the mask was in movement during a performance. There is great refinement in the formation of its facial ridges and creases and of the edges of such features as the lips and eyesockets.

Many other kinds of objects feature among the 85 items that the Rev. Dundas acquired in a single day in October 1863 while on mission work for the Anglican Church in Metlakatla, British Columbia. The Dundas collection is important not only for its size and comprehensive variety but also for the unusually early and precise date of acquisition for a collection of this range. Art historians have been able to use the works in the collection as markers with which to compare objects of unknown date and provenance. Northwest Coast art evolved a great deal in the nineteenth century, but firmly dated materials like those of the Dundas collection, which are quite rare, enable us to attribute objects of similar form, patina and style to the same or a related time frame.

Other Dundas objects in the Thomson Collection include a wooden comb (fig. 4), typical of the highly decorated utilitarian artefacts for which the Northwest Coast is well known. Some such combs feature sculptural forms in deep relief that make up the handle, but this more subtle example is decorated in a two-dimensional design exemplifying what is known as the Northwest Coast 'formline' style. The word 'formline' describes the

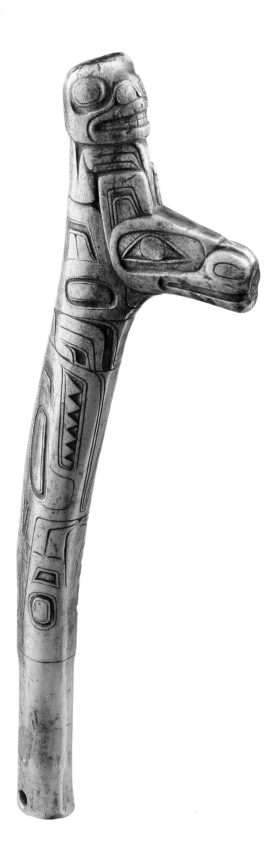

5
Tsimshian antler club, *c.* 1750
Elk or caribou antler
31.0 × 7.7 × 1.8 cm

raised calligraphic shapes that surround the carved-out areas, which work with the forms to make a pattern that in this case appears to represent a bird, though the design is rather ambiguous. Its elegance, however, is evident, and its complexity indicates the hand of an experienced master artist. Such decorated household objects would have been the prerogative of the noble class and were often passed down from one generation to another. Indeed this fine comb exhibits a good deal of wear on the tines, particularly about the centre of the row of teeth, where the most friction against the hair would have been encountered.

Another example of a two-dimensionally decorated object in the Thomson Collection is the spectacular antler war club (fig. 5), one of the oldest of the objects that made up the Dundas collection. In contrast with the design work on the comb, which is executed in a mid-nineteenth-century style, the style of the club dates it to the eighteenth century or possibly even earlier. The more rectilinear nature of the forms and patterns is an archaic characteristic in the composition. The formlines separating the carved-out areas are broader and more angular in movement than in later examples. The style the antler represents was common across the northern Northwest Coast, among the Tlingit, Haida and Tsimshian, from about a millennium ago: it had changed very little up until the late eighteenth century, when the first Euro-American explorers and traders arrived in the region. From that time into the first half of the nineteenth century the formline styles of the northern First Nations underwent change much more rapidly than they had done earlier, and diverged more broadly, owing in part to the influence of other momentous changes brought about by the arrival of outsiders in increasing numbers (see Brown 1998).

The club includes some sculptural features that are very well integrated with the two-dimensional design work. The head of a wolf protrudes from one side, carved from the remnants of one of the branching tines of the antler, which comes from either an elk or a caribou. A humanoid head is carved at the top of the club, with its hands resting on the wolf's ears. The wolf's body wraps about the cylinder of the club, with its forms more or less parallel to the line of the head. The wolf's forefeet reach forward from the back side of the club to meet at the front below the head.

Below the wolf, separated by a thin incised line, can be seen the large head of what is most likely a sea lion, with its set of highly visible triangular teeth. In Northwest Coast art, particularly in the archaic and more traditional styles, creatures are represented most often by selected identifying characteristics, rather than as complete and naturalistically proportioned images. Behind the head of this sea lion, its pectoral fins flow back toward the handle, while its tail flippers extend upward from the handle to the rear of the head. Only between twelve and fifteen such

6

Tsimshian shaman's rattle
c. 1800–40
Hardwood, sinew ties
27.5 × 14.0 × 9.5 cm

carved antler clubs exist in museums or private collections around the world today, and the precision of the relief work and the masterful handling of its design set this club apart from the rest.

Globular rattles were also sometimes embellished with two-dimensional designs. These carved wooden globes were ceremonial properties of shamans, employed to summon and to placate the spirits in attendance at curing rituals. The rhythmic, textured, swishing sound of wooden rattles was said to please the spirits, and the shamanic doctors called upon certain of these, their helping spirits, to aid them in their mastery over those that had created illness in their patients.

Some such rattles were carved into sculptural images, with the globe of the rattle forming the skull shape of a human or animal spirit. Others, like this one (fig. 6), were covered entirely with a two-dimensional composition of interlocking formlines that was then relief-carved for added depth and definition. This rattle, also acquired from the former Dundas collection,

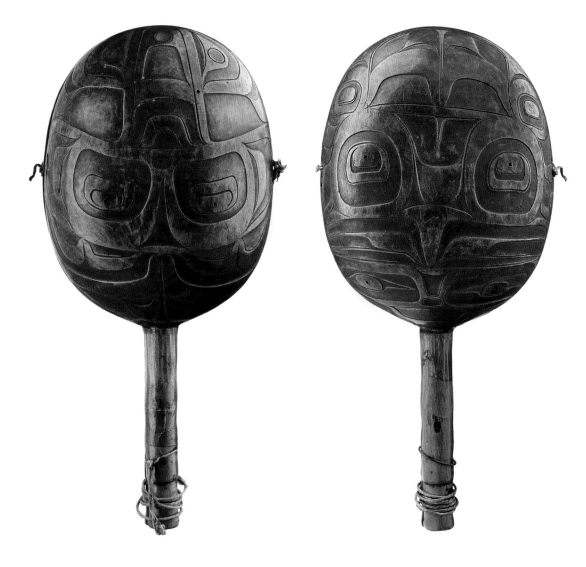

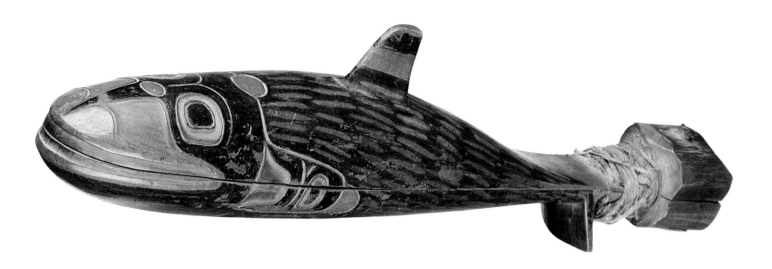

7

Tsimshian clapper, *c.* 1840–60
Yellow cedar or spruce, pigment,
fibre ties
26.5 × 5.5 × 3.5 cm

exhibits a style that suggests it was made in the early nineteenth century.
The forms envelope the globe in a graceful and elegant pattern of ovoid
shapes and U-forms, all beautifully balanced and interlaced in an older,
traditional manner that has more in common with the archaic style of
the antler club than do other works from later in the century.

An example of these is the small whale-shaped clapper (fig. 7), which,
judging from its appearance, was made not long before it was acquired by
Rev. Dundas in 1863. The whale is still depicted in formline style, but only
in the head and pectoral fins, the majority of the body being represented
as a solid black form, embellished only by the addition of short lines of red
dashing across its surface. The tail of the whale is blended into the form of
the clapper's handle, a small section of wood located just behind the point
where the two sides of the clapper have been thinned down. Their resultant
flexibility allows the two halves to snap against one another when the
instrument is shaken, producing a sound related to that of castanets.

One of the richer and more exotic materials encountered in Northwest
Coast art is ivory, of which the sources were sperm or orca-whale teeth or,
more rarely, walrus tusks. No coastal First Nations hunted the sperm
whale or the orca, also known as the killer whale. The Nuu-chah-nulth
limited their cetacean hunting to the humpback and grey whales, neither
of which are toothed but are of the baleen type, that is, have comb-like
plates in their mouths to filter plankton and other small varieties of krill.
Orca or sperm-whale teeth could, however, be obtained from animals
that had expired from natural causes, although sperm whales, which
provide the largest and most impressive ivories, ordinarily do not venture
among the barrier islands and inlets of the coast, preferring to stay in

Shaman's cup, *c.* 1780–1810
Sperm-whale tooth
10.6 × 5.6 × 3.7 cm

more open waters. Walrus are not native to the area at all, living on the far western shores of the Alaskan coastline. Nevertheless trade among First Nations provided Northwest Coast carvers with their long tapering tusks, which are readily recognizable by the crackled, mottled appearance of their centre core within the smooth, outer casing.

Ivory was employed on the Northwest Coast for finely detailed sculptures such as amulets, dagger hilts and combs. Two amulets and a carved tooth identified as a shaman's cup are particularly interesting in this collection. The cup (fig. 8) is arguably the oldest object of the three. It exhibits an archaic style of two-dimensional design that is similar to that of the antler club, though evidently by a different artist. Shamans used small vessels like this, sometimes of wood or basketry as well as ivory, to take drinks of salt water as part of their divining rituals. This cup was made by carving out the interior of a large sperm-whale tooth and smoothing its outside surface. Though the tip of a sperm-whale tooth is quite rounded and blunt, here it has been slightly flattened off so that the object will stand bottom up. Some ethnographic sources have identified this type of object as a lime mortar, the ground powder product of which was mixed with the native species of tobacco for use as snuff. This cup, however, shows

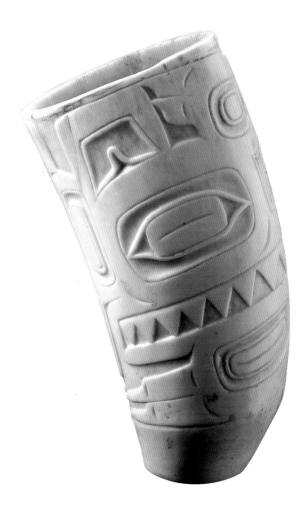

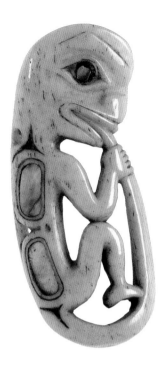

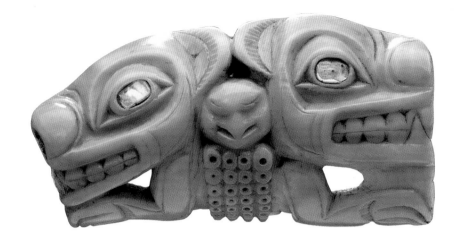

9
Tsimshian shaman's amulet, *c.* 1840
Marine mammal ivory, abalone shell
7.8 × 3.5 × 0.8 cm

10
Tlingit shaman's amulet (double-ended bear), *c.* 1840
Marine mammal ivory, abalone shell
10.2 × 5.3 × 2.5 cm

no evidence of such a usage. The fine relief-carved design, reflecting the angular, broad-formline characteristics typical of eighteenth-century work, most likely represents a sea monster or a killer whale, as the artist has incorporated into the image symbols for pectoral fins, a bilateral tail and prominent, sharp teeth.

The two amulets are also of the shamanic tradition and were once used by shaman doctors as a kind of touchstone to their helping spirits. The amulets were evidently left with a patient for a time, after a curing ritual had been enacted. The smaller amulet (fig. 9) exhibits a compact image of a land otter, with its long tapering tail in the uncommon position of curving around to meet the creature's own mouth. The land otter was a primary image in shamanic art, believed to be particularly well suited to represent shamanic experience. The head of the creature has human characteristics, including a much abbreviated snout. Two simple design forms embellished with abalone shell denote the spinal structure of the otter-man.

Carved from a section cut from one side of a large sperm-whale tooth, the double-ended bear amulet (fig. 10) also exhibits, between the two bear figures, the small image of an octopus, shown with only four of its eight tentacles. The octopus is nearly as ubiquitous in shamanic imagery as the land otter. The image of an octopus, or just its tentacles, symbolizes the creature's ability to move along the sea bottom and through the tiniest of openings with the grace of water itself, reflecting the spirit actions of the shamans. The heads of the two bears recall masks, and they are carved nearly as deeply as a half-mask would be, with their shoulders, forelegs and feet positioned just below their lower jaw. Yet one can readily discern the influence of the two-dimensional design tradition, which defines the form, orientation and spatial relationships of the eyesockets,

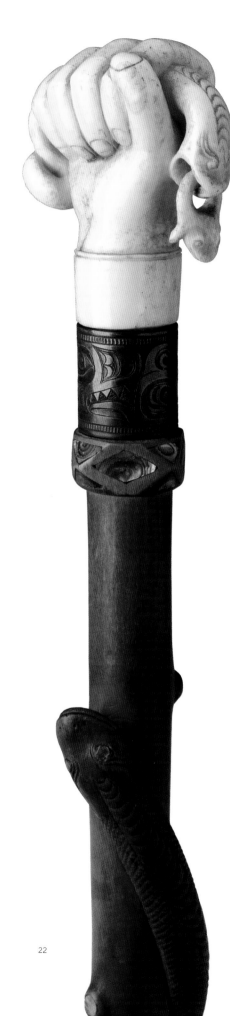

lips and nostrils and the stylization of the ears. It is often the case that Northwest Coast art can be described equally as two-dimensional design carved in very deep relief or as sculpture with strong overtones of two-dimensional design.

One of the best-known historical First Nations artists (among relatively few artists of the past recorded by name) is Charles Edenshaw, maker of the carved walking stick and gold bracelets in the Thomson Collection (see figs. 11, 12). Edenshaw's common Haida name was Da.a xiigang, which has often been anglicized to Tahaygen. He was a prolific carver, creating remarkable works in wood, argillite (a type of soft, black shale), ivory, silver and gold. Born in 1839, he started his career making very traditional artworks of Haida convention, such as bent-corner chests, boxes and bowls, and houseposts. When Haida culture began to change radically in the last quarter of the nineteenth century, as a consequence of the onslaughts of disease and of the dominant colonial culture, Edenshaw adapted by continuing to create great artworks, but for a changing clientele. Forbidden by zealous Protestant missionaries from conducting potlatches and traditional dance performances, Haida chiefs no longer commissioned art to display their inherited prerogatives and clan emblems. Increasingly Edenshaw, like other First Nations artists of his day, created his work for outsiders, who valued traditional native art as a curiosity. He made and engraved dozens of silver bracelets and a handful of gold ones. He also painted a large number of spruce-root hats, expertly woven by his wife, Isabella.

Engraved bracelets are seen by some (Davidson in Brown 1995) as a replacement for the tattoos of family emblems that Haida nobles once wore on their forearms, transformed into a medium that was not forbidden by the missionaries. Edenshaw's bracelets exhibit his masterful sense of composition and his clean, detailed style of engraving. The stick is one of a dozen or so that he made in his later years (Edenshaw died in 1920, but

11
CHARLES EDENSHAW
(1839–1924)
Haida walking stick,
c. 1890–1910
Wood, walrus ivory,
abalone shell, coin silver
93.5 × 6.3 × 4.4 cm

12
CHARLES EDENSHAW
(1839–1924)
**Haida bracelet with
split heron engraving**
c. 1890–1910
22-carat gold
5.8 × 2.1 cm

his best-known work dates from about 1890 to 1910). The sticks generally follow a common pattern, the wooden shaft being carved with a snake spiralling up between small shell-inlaid peaks, carved to look like branch nubs. Snakes are not common in Northwest Coast art, and the symbolism Edenshaw intended with this image can only be surmised. At the top of the wooden shaft he placed a silver collar or ferrule, which was engraved with a bracelet-like design and serves to strengthen the connection between the wood and the ivory finial. Each of the sticks he made has a unique ivory finial, though he employed some variations, like the hand holding this snake, on more than one stick. Of the three known hand-and-snake sticks, this is by far the most elaborate, with extra turns depicted in the snake's body and a tiny frog hanging free from the snake's mouth. The details of the hand are exquisite, with tendon lines on the back and wrinkles where the fingers bend. Edenshaw described similar imagery on an earlier cane to the collector James G. Swan at Masset village in 1885, saying that it was based on the Greek story of Laocoön. He is known to have had copies of *Harper's Illustrated News*, and was apparently well read and well educated outside his own culture as well as within it.

Northwest Coast art is a broad and intriguing subject. These few examples, though too small in number to provide a truly representative overview of the field, are nonetheless of high enough quality to give one an appreciable picture of what this art has to offer. The art from this part of the world was born of a culture very different from our own, in its core beliefs about the world and human origins within it, and in its ideas and practices regarding the lines and relationships between the spiritual and physical worlds. These cultures and their beliefs are embodied in this art, enabling us to glimpse their world through it – in the visages of these masks, in the patterning of these carved figures and in the calligraphic movements of a formline design.

FURTHER READING

Augaitis *et al.*, *Raven Travelling: Two Centuries of Haida Art* (exhibition catalogue, Vancouver Art Gallery, 2006)

Steven N. Brown, *Native Visions: Evolution in Northwest Coast Art from the Eighteenth through the Twentieth Century* (Seattle: University of Washington Press, 1998)

Steven N. Brown (ed.), *The Spirit Within: The John H. Hauberg Collection at the Seattle Art Museum* (exhibition catalogue, Seattle Art Museum, 1995; the comment by Robert Davidson regarding tattoos, from an interview I did with him in 1993, appears on p. 128)

Donald Ellis (ed.), *Tsimshian Treasures: The Remarkable Journey of the Dundas Collection* (Vancouver: Douglas & McIntyre, 2007)

Aldona Jonaitis, *Art of the Northwest Coast* (Seattle: University of Washington Press, 2006)

P.L. MacNair *et al.*, *The Legacy: Continuing Traditions of Canadian Northwest Coast Indian Art* (exhibition catalogue, British Columbia Provincial Museum, Victoria, 1980)

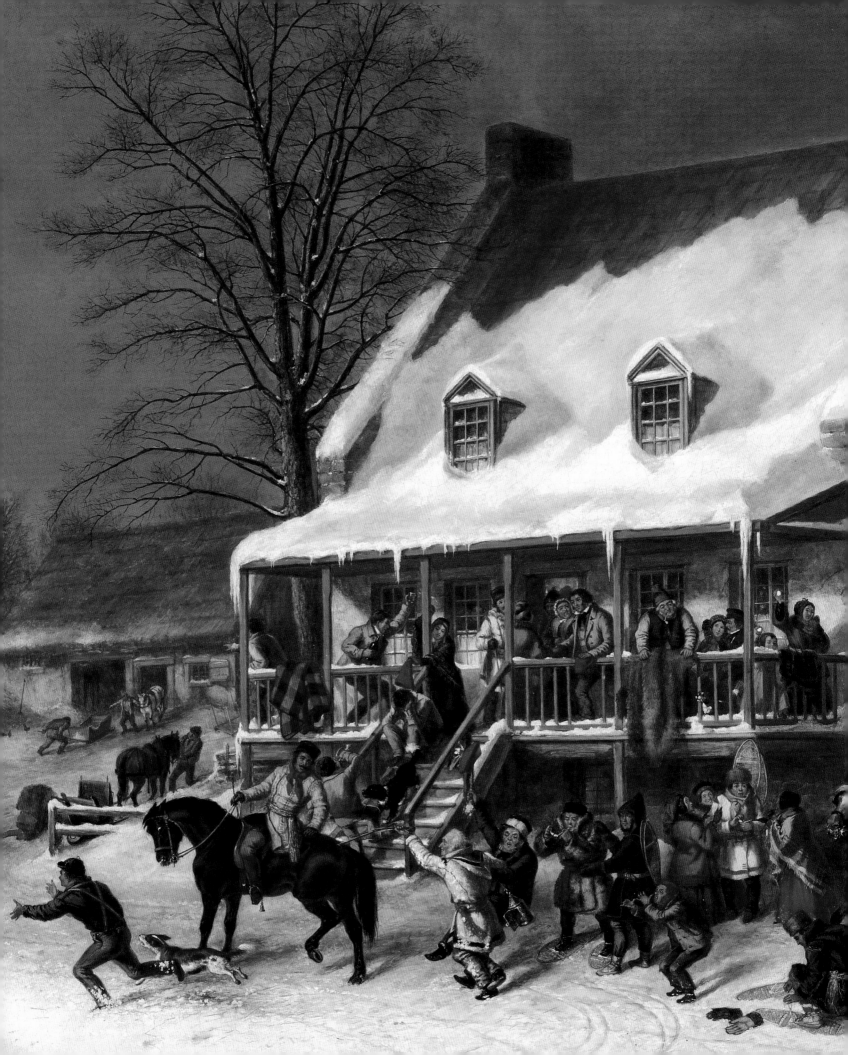

Cornelius Krieghoff

DENNIS REID

Cornelius Krieghoff (1815–1872) is the most widely recognized Canadian artist of the nineteenth century, and his scenes of rural French Canadian and Native life of the two decades preceding Confederation have profoundly shaped the way succeeding generations have visualized this important stage in Canadian history. Some commentators have been critical of this influence, questioning the authenticity of his representations. After all, they point out, the foreign-born Krieghoff simply applied a time-tried European formula to the depiction of stock Canadian images, essentially creating views for tourists. The numerous versions that survive of his most popular images, they claim, underscore his commercial motivation and, ultimately, his lack of creative vision. I would argue, to the contrary, that Krieghoff was formed as an artist in Canada, that he responded creatively to a perceived need, and that his images reflect both close observation and a sensitive understanding of the complex social dynamics of his new home. Canada made Krieghoff an artist and he, in turn, interpreted the emerging nation as deeply rooted in traditions of human habitation dating back centuries.

Krieghoff's roots, of course, were in Europe. He was born in Amsterdam in 1815. His mother was from Ghent in Flanders (now Belgium), his father from Ufhoven, Thuringia (central Germany), and they settled in Mainberg, near Schweinfurt, in Bavaria, in 1822. There is no evidence that he had any extensive artistic training in Europe, although his father ran a high-end wallpaper manufactory in Mainberg, and the family appears to have been involved in the region's artistic circles. Krieghoff is documented next in July 1837, when he enlisted in the United States Army in New York, giving his occupation as "clerk." He was discharged in May 1840 in Burlington, Vermont, near the Canadian border, and on June 18 his son Henry was baptized in Boucherville, on the south shore of the St Lawrence River, just north-east of Montreal. We do not know when he had met his French-Canadian wife, Émilie Gauthier, but they had a second child, a daughter, about a year later, and in June 1841 the burial of their son is recorded in Montreal. In May 1843 a letter from his father to a business partner refers to Krieghoff as the owner of an upholstery business in Rochester, New York, and in June that year he held an exhibition of paintings in that city. At the end of the following January he advertised as an artist in Toronto, with his studio in the rear of the famous Jacques & Hays furniture manufacturers, which suggests he was still supporting his family as an upholsterer. In October 1844 he was in Paris, where he registered as a copyist at the Louvre, the student of Michel-Martin Drölling (1786–1851). Sixteen months later he surfaced again in Montreal, advertising as an artist.

There were few artists in Montreal at that time, even though it was the principal city in British North America, as Canada was then known. Only two are listed in the city directory of 1845–46, but in January 1847 Krieghoff

joined sixteen others in an exhibition of what was called the Montreal Gallery of Pictures. He contributed forty-eight works, one of which appears to have been *Breaking Lent* (fig. 1), which we believe was the painting described in the catalogue as *Canadian Interior, a Friday's Surprise*. While the handful of works that survive from the Boucherville, Rochester and Toronto periods reveals a skill barely at the level of the small number of itinerant painters who serviced the Great Lakes and St Lawrence region at the time, *Breaking Lent* reflects the skills Krieghoff must have developed during his stay in Paris. A genre scene of the sort that was enjoying widespread support among the middle class in Europe and North America at the time, it is based essentially on seventeenth-century Dutch proto-types that also, in their day, were painted for a rising bourgeoisie.

This canvas is one of Krieghoff's most accomplished figure scenes of the period. It is presented in the form of a domestic stage, dressed with an array of furnishings. The objects of the household are arranged into relatively discrete still-life groupings that, while conveying information about the inhabitants' domestic practices, function as little virtuoso eye-pleasers on their own. The array of washing utensils in the lower right, for instance, the beautifully lit blanket coat lower left, and the pitcher positioned so exquisitely on the stove in thoughtful relationship to a small informal grouping of wall-hung objects, are some obvious examples. We are drawn to linger pleasurably over a range of contained spaces in a similar fashion, each one, such as the enclosed transom to the left, the back passageway to the right rear, and the permeable space beneath the table and chairs, a complex visual poem articulated through the play of

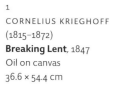

1
CORNELIUS KRIEGHOFF
(1815–1872)
Breaking Lent, 1847
Oil on canvas
36.6 × 54.4 cm

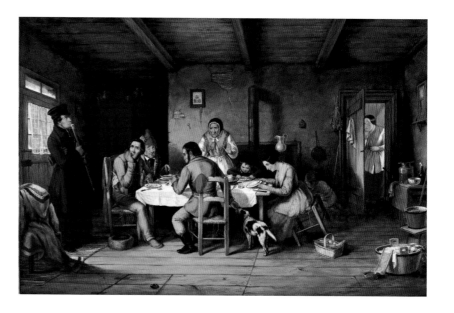

Cornelius Krieghoff

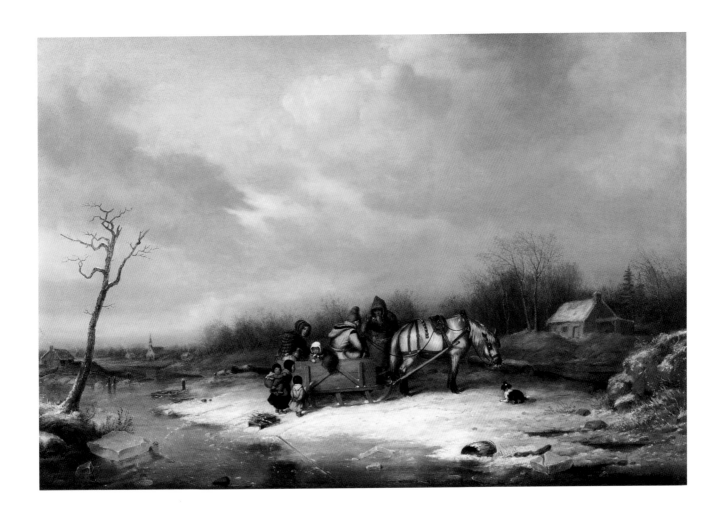

2

CORNELIUS KRIEGHOFF
(1815–1872)
**Habitant Family with Horse
and Sleigh**, 1850
Oil on canvas
45.8 × 67.3 cm

light, shade and delicately nuanced colour. As pleasing as these elements are, however, they are but enrichments of the main focus of the painting, a domestic drama in which an officious priest encounters a rustic French-Canadian family breaking the tradition of fasting during Lent. The interrelationship of the figures is skilful, as is the depiction of facial features, reflecting a range of responses to being caught in transgression. There is some humour in the scene, certainly, but we are left pondering authority and its place in the everyday world.

Another painting Krieghoff exhibited in the Montreal Gallery of Paintings exhibition in January 1847 was a copy he had painted at the Musée du Luxembourg when in Paris of a work by a Swedish artist, Peter Gabriel Wickenberg (1812–1846), *German Winter Scene: A Prussian Forester talking to Children in a Sleigh*. Also based on seventeenth-century Dutch precedents, it was the inspiration for a whole series of Montreal paintings of mid-winter social encounters in sleighs on the ice. One of the finest is *Habitant Family with Horse and Sleigh* (fig. 2), of 1850. In this, as in the interior scene, there is

CORNELIUS KRIEGHOFF
(1815–1872)
Lt. Robert McClure, 1847
Oil on canvas
60.7 × 46.2 cm

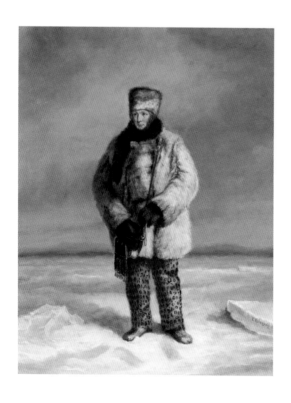

an eye-catching array of still-life-like compositions – the beautifully observed block of ice beneath a winter dormant tree in the lower left corner, a discarded barrel frozen in the ice in the right corner, and a child's sleigh laden with kindling near the central scene. The atmosphere is effectively set against a spectacular, heavy winter sky, with the local parish church visible in the distance, a comforting counterpoint to the isolated rustic dwelling nearby to the right. All of this warmly contains the intimate encounter between two families, the men enjoying a taste of tobacco together, while the children converse. Even the sleigh's horse enjoys communion with the other family's small dog. All are comfortable, at home in this harsh but enclosing environment.

The greatest strength of the Montreal Gallery of Paintings exhibition was the work of a group of seven professionals who called themselves the Montreal Society of Artists. In addition, there were two honorary members, both officers in the British Army, and eight guest exhibitors, who appear to have been amateurs as well. Such people, drawn exclusively from the dominant anglophone business and professional community and the Montreal garrison, also constituted Krieghoff's core supporters. It is clear from the number of his Canadian paintings that ended up in Britain that returning army officers and colonial officials acquired Krieghoff's scenes of traditional French-Canadian and Native life in the Montreal region as mementoes of their service in the country, but he also developed a reputation as a portraitist. He received a few government commissions, and we know of a number of more modest portrayals of local businessmen and their families.

One outstanding portrait of the period, however, reflects Krieghoff's connection with the garrison. This is the small, full-length portrait of *Lt. Robert McClure* (fig. 3), of 1847. The subject, who would go on to fame and knighthood a decade later for his service in the high Arctic, had already been in the far north in 1836, followed by service in the Great Lakes and the St Lawrence region. What is curious is that his bulky fur coat, sealskin trousers, fur hat, muffler and bear-like fur gloves, and the St Lawrence looking like an Arctic wasteland, evoke both his earlier experience and his future exploits. The only reference to his time in Montreal is perhaps the Native pouch he is wearing. Is the Bavarian long-stemmed meerschaum pipe he carries an allusion to his possible friendship with Krieghoff?

We know that one lifelong friend of the artist was the Quebec City auctioneer John Budden (fig. 4). Also dating from 1847, Krieghoff's portrait of Budden is informal yet classically elegant. In an oval format, it shows Budden in hunting gear, sitting on the ground with his legs extended and one arm behind, his body turned three-quarters away from the viewer, his face in profile. His dog sits on his far side, and a wonderful still life of beaver hat, gun and hunting sack secures the lower left. The details of his footwear and clothing, as well as his features, are superb.

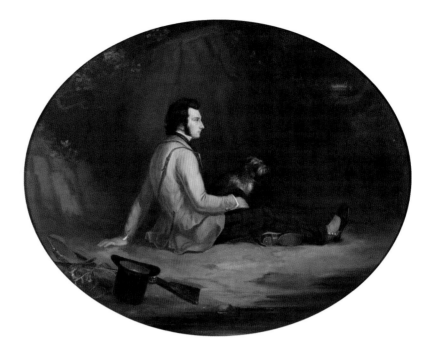

4
CORNELIUS KRIEGHOFF
(1815–1872)
John Budden, 1847
Oil on canvas
59.7 × 76.2 cm

The landscape setting is cursory yet warmly earthy. Budden is clearly a man content with himself and comfortable in nature.

Political unrest in Montreal led to the decision in 1849 to move the seat of colonial government out of the city, and to alternate sittings between Quebec City and Toronto until a permanent capital could be chosen. Toronto was the first location. This shift in Montreal's fortunes probably helped Krieghoff decide to accept the invitation of Budden to join him in Quebec, which he did, it seems, some time early in 1853. He turned a considerable portion of his energies in Quebec to landscape, both as a more prominent component of his French-Canadian habitant and Native scenes and as a pursuit in and of itself.

Soon after settling in the city, he declared his ambition in this direction with a spectacular canvas, one of the largest he would ever paint, of the ice cone at Montmorency Falls (fig. 5). The ice cone formed in winter from the mist that rose from the open, rushing falls of the Montmorency River into the St Lawrence River just below Quebec. It was a favourite gathering spot for those enjoying a sleigh ride on a bright winter day, and the festive nature of the scene had attracted artists since the turn of the century. More recently a local artist named Robert Todd had made something of a speciality of 'portraits' of fancy sleighs in front of the Montmorency cone, but Krieghoff's picture, not only by its size but in its sense of scale – number and variety of figures and the care devoted to the expansive landscape setting – was calculated to outdo all the competition. Krieghoff's painting was

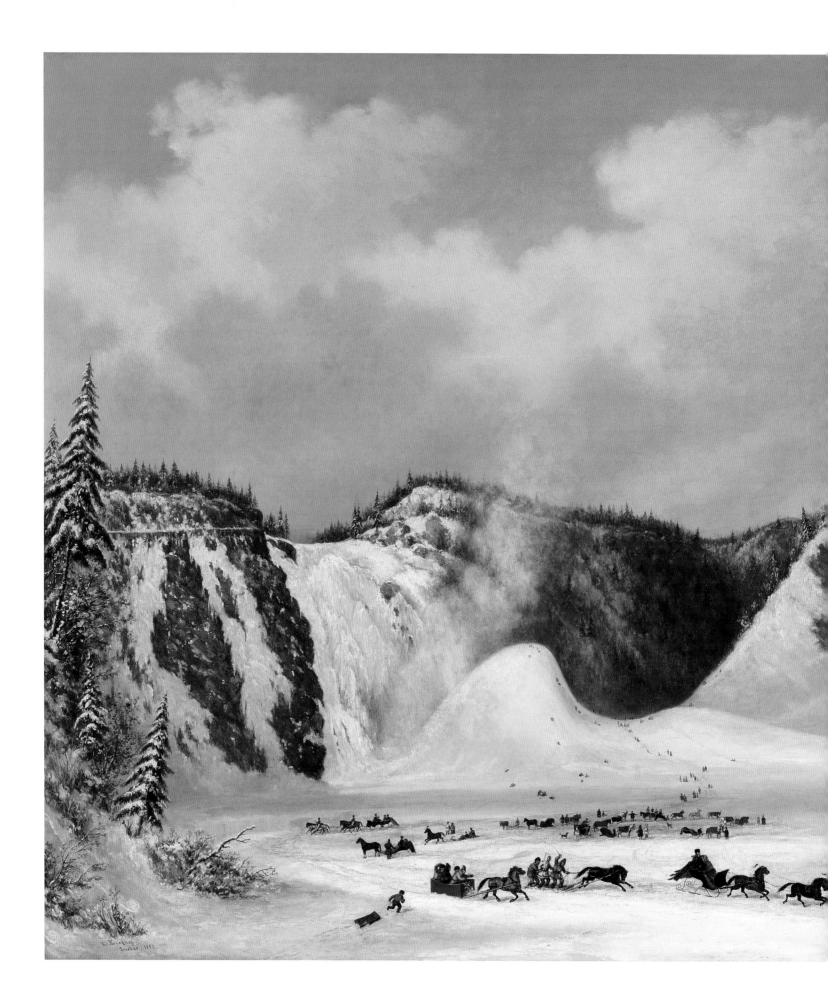

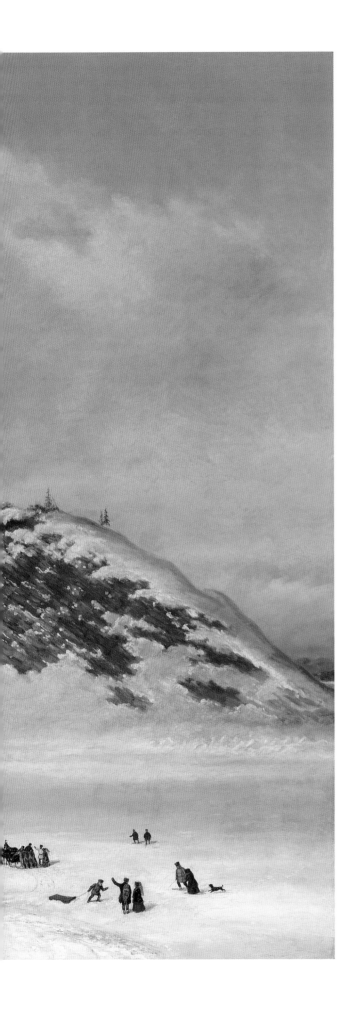

CORNELIUS KRIEGHOFF
(1815–1872)
Montmorency Falls, 1853
Oil on canvas
91.6 × 121.9 cm

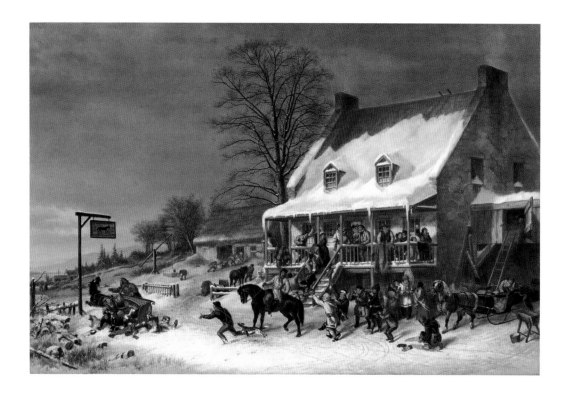

6
CORNELIUS KRIEGHOFF
(1815–1872)
Breaking up of a Country Ball in Canada, Early Morning (The Morning after a Merrymaking in Lower Canada), 1857
Oil on canvas
60.9 × 91.3 cm

publicly displayed in a shop window from May to August in 1853, and advertised in a local newspaper. Todd left Quebec for Toronto that same year.

Another ambitious theme of the Quebec years was the depiction of revellers leaving a country inn following an all-night party. Like the large *Montmorency Falls*, it allowed the representation of a cross-section of Canadian society. In at least two versions, including *Breaking up of a Country Ball in Canada, Early Morning* (fig. 6) of 1857, the inn is based on one called Gendron's, which was situated on the Beauport coast about two and a half kilometres from Montmorency Falls. In spite of the fact that so many of the characterizations in these pictures seem particular enough to be portraits – the mustachioed man on the spirited bay horse at the centre, for instance – none of the figures has been identified. To seek that degree of specificity is anyway to follow a false trail, because it would seem these paintings were meant to address broader human values – celebration, conviviality, the inclusiveness of *bonhomie*. This theme, which in a sense can be taken back to Pieter Bruegel's peasant feasts in the sixteenth century, was of particular interest in the mid nineteenth century in Britain, the United States and Europe, in the guise of country weddings or other festive gatherings.

All three of Krieghoff's known merrymaking scenes of this period are beautifully painted, with particular attention to the depiction of the end of a moonlit night on one side of the canvas and the first glimmer of the rising sun on the other, with all the subtle lighting variations in between

that that range implies. The usual set-piece still lifes are also very well executed. But the principal pleasure is in the detailed observation of the interrelated groups of figures. Each grouping is complete in itself, effectively melded together in light and colour harmonies like one of his still-life details. Then either the gesture of a figure or the strong lines of a compositional device leads us to another group, where we become absorbed with its internal intricacies, to be led soon on to another, and so on.

There are a number of major pictures of the later 1850s in which Krieghoff presents a similarly complex social dynamic. One of the earliest of these is *Playtime, Village School* (fig. 7) of about 1857. The scene is apparently set at 'Canadian Lorette,' a white community near the native Huron village of Lorette. At the centre of the image is the familiar encounter around a sleigh, but it is encircled by a range of lively vignettes. To the right a couple

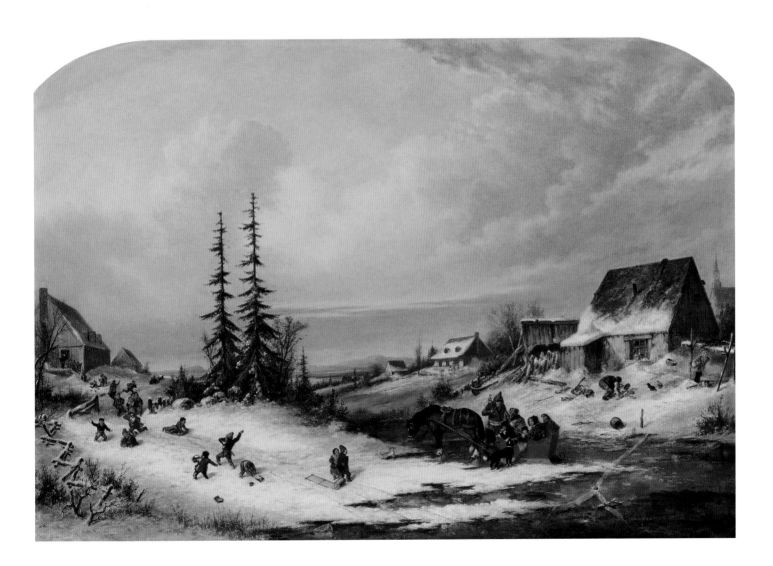

CORNELIUS KRIEGHOFF
(1815–1872)
The Narrows at Lake St Charles
1859
Oil on canvas
36.1 × 54 cm

prepares a bake oven in spite of the snow, and there are other signs of village life here and there. The main action is from the village school, as the children tumble out for their play break in the snow. It is the only theme of the Quebec period set in a village, and the school also brings a note of modernity, of actuality, to an otherwise picturesque scene.

Krieghoff was part of a tight circle of friends in Quebec that included, besides Budden, two brothers named O'Connor and a prominent lumber merchant and banker, James Gibb, whose father was a ship builder. Theatre, art and good conversation brought them together, but they also shared a love of hunting, fishing and the outdoors, and that too is reflected in a surprising number of Krieghoff's paintings of the period. Sportsmen's camaraderie is celebrated in the most glorious fashion in a painting of 1859 entitled *The Narrows at Lake St Charles* (fig. 8). The lake, which is about thirty kilometres north-west of Quebec, was one of a number within relatively easy reach of the city. Although many of these lakes had been settled in the early decades of the century, mainly by retired soldiers, farming was barely visible, and they were well along to reverting to their

9
CORNELIUS KRIEGHOFF
(1815–1872)
Chippewas on Lake Superior
1860
Oil on canvas
40.5 × 61.2 cm

wild state by the 1850s. They were considered choice locations for summer cottages and fishing and hunting resorts. The painting shows – as identified in Krieghoff's hand on the original stretcher – 'Old Gabriel' Teoriolen, a Huron guide, to the left, John Budden in the centre, Krieghoff, with his portfolio, seated with his back to us, and James Gibb. They are at a favourite fishing spot off Campbell's Point, named after a notary, W.D. Campbell, who had a cottage there. Gibb seems to have been the first owner of the painting. It has an arched top, which lends dignity to its appearance, and the landscape is beautifully handled, among Krieghoff's very best. It clearly was important to the artist and to that small circle of friends that represented the core of his patronage in Quebec.

The relatively few images of Natives Krieghoff painted in Montreal are like museum dioramas with figures stiffly posed in traditional costume in front of their dwellings, typical artifacts scattered about, and a cursory landscape as a backdrop. The Native scenes of the Quebec period are quite different, with the landscape dominant and the more generalized figures shown in close relationship to nature. *Chippewas on Lake Superior* (fig. 9) of

1860 has at its centre a respectful if nonetheless romantic depiction of nomadic life, portraying a dignified discussion at an ordained place. This simple, idealistic message is framed by the most extravagantly sumptuous landscape. The depiction of the various species of tree, of the goldenrod in the foreground right, of the delicate ferns, is a virtuoso performance, yet is saved from pedantry by the subtle sweeps of light and shadow that crisscross the scene. Again, the composition moves us around and through the myriad delights while grounding us repeatedly in the core image. By way of contrast, one of the great later Native images, *On Lake Laurent* of 1863 (fig. 10), sets the ritual on a vast stage, the tiny figures acting out the drama against a backdrop of searing, transitory ecstasy only moments before the descent to freezing darkness.

The original French settlers established farms all along the St Lawrence River, but as these traditional areas began to fill up in the middle of the nineteenth century thousands of landless young people immigrated to New

11
CORNELIUS KRIEGHOFF
(1815–1872)
**Clearing Land near the
St Maurice River (Pioneer
Homestead, Quebec)**, 1860
Oil on canvas
61.3 × 81.8 cm

England to work in the mill towns, or to the American West to homestead. In fear of losing a sizable proportion of the francophone Catholic population, the government opened crown lands for settlement in the regions of the Saguenay, the St Maurice River above Trois-Rivières, along the Gatineau River north of Bytown (Ottawa), and in parts of the Eastern Townships south-east of Montreal. Such *colonisation*, as it was known in French, was vigorously supported by the Church, as well as the government, and thousands sought to start new lives on often marginal land. Krieghoff would have encountered *colons* up the St Maurice and Shawinigan Rivers, and perhaps in the hinterlands far up the Montmorency and beyond Lake St Francis, probably most often in the manner he encountered Natives, while on hunting or fishing trips. It remained one of his central themes through the balance of the Quebec period.

Clearing Land near the St Maurice River (fig. 11) of 1860 shows the settlement process at the end of the first summer season, before the snow. The figures are small, nature very much the subject, with two stately, surviving trees the focus of the composition, even as smoke billows from a clearing fire behind and one settler attacks a birch with an axe. The two big trees are right in the middle of a fenced-in corn-plot beside the log house, which makes no sense. Early photographs show that clear-cutting was the first step in creating farmland from wilderness. The magnificent sheltering trees we see in Krieghoff's paintings reflect his values, not the *colons'*. By 1862 and a painting like *Winter in Laval Mountains near Quebec (The Crack in the Ice)*

(fig. 12), he is celebrating this ethos of life in the wilderness in harmony with nature in monumental terms. The area around Laval had been settled for some time by then, but it was in the Laurentian Shield and so had the necessary wilderness qualities. The usual encounter at the stopped sleigh is the focus, but the setting is the real subject, a setting presented with such scale and dignity, and with such precise compositional articulation of form and line, that it becomes like a large, open church, with nave, transept and side chapels. The habitant figures are not subsumed to this landscape as the Native figures of the period are, largely because evidence of their mark on nature is everywhere. In this sanctified landscape, the tall dead tree at the centre of the picture becomes a symbol of ultimate sacrifice around which the whole system evolves.

On his forays into the hinterlands Krieghoff also would have encountered signs of the huge timber trade, the mainstay of the emerging nation's economy, and this, too, became a distinct theme. As we would expect, the natural setting is paramount. In *Jam of Sawlogs, Shawinigan Falls* (fig. 13), for instance, of 1861, a small figure of a sport fisherman sits in the foreground, intent on the task at hand, indifferent to the powerful torrent above. He is oblivious, it seems, to the wreckage of sawlogs, some near him of enormous size, which litter the shore and rocks precariously all around. The bush bordering the river is painted in minute detail, yet composed in broad movements of light and dark laced through with intricate depictions of the specific hue and texture of various species in a magnificent orchestration of natural effects.

When the Canadian contribution to the Paris Exposition Universelle in the summer of 1867 was announced in the spring of 1866, it was mentioned that Krieghoff would be contributing "an oil painting illustrative of lumber trade." We know his contribution from an old photograph. It was more than one painting, although the large central canvas dominated the whole: this was *Sillery Cove, Quebec* (fig. 14), of about 1864, representing one of the great square-timber depots where the ships were loaded for Britain. Surrounding it was the most elaborate frame, set into which were eight much smaller views of different stages in the lumber industry, from stocking the remote camps through the steps of preparation for the spring flood when the logs were floated downstream to the St Lawrence to be formed into rafts for the final leg to Quebec: there the square timbers were graded, sorted and stored in floating piles for loading into ships. At the top of the elaborate frame was a carved garland of maple leaves surmounted by a crown, the symbol of the Province of Canada. At the bottom was a small plaque that read *Painted by C. Krieghoff/ Quebec/ Framed by W. Scott/ Montreal Canada East*. As splendidly extravagant as this presentation seems today, it did not seem to draw much attention either in Paris or back home. The man who first described the photograph, in 1919, did not know the grouping was part of the Canadian display at Paris. He believed it to have

12
CORNELIUS KRIEGHOFF
(1815–1872)
**Winter in Laval Mountains
near Quebec** (**The Crack
in the Ice**), 1862
Oil on canvas
63.6 × 91.6 cm

been installed above the speaker's chair in the Legislative Assembly at Quebec. It could, following its return from Paris, have been fitted into the plans for refurnishing the chambers, following Confederation, as the legislature of the new Province of Quebec, but there is no other evidence that it ever was.

The fact that Krieghoff's work was chosen to represent a key resource of the new nation on the international stage is evidence enough, nonetheless, of his status by the time of Confederation. What is curious is that he had left the country four years earlier. A Toronto newspaper announced his departure at the end of August 1863, "on account of ill health," noting that he intended "to reside in Italy or France." He kept in touch, however, sending work back for sale, both his own and that of other artists. Then in August 1870 he and his family returned to Quebec, reportedly for a visit. They ended up staying more than a year, leaving at the end of 1871. Less than three months later it was announced that he had died in Chicago, where he had moved with his wife and daughter.

An obituary in a Quebec newspaper asserted, "Krieghoff's fame belongs peculiarly to Canada; it was the country of his adoption, and in depicting its scenes he has always stood without a rival. There is hardly a Canadian home without some memento of him. Canada will not easily replace his loss." Krieghoff did not benefit from important government or Church commissions during his lifetime, so did not enjoy the public profile such patronage usually brought, and his wife and daughter seem to have done little, if anything, to encourage the honouring of his memory in Quebec and Canada following his death. It has been collectors – owners of one or

14
CORNELIUS KRIEGHOFF
(1815–1872)
Sillery Cove, Quebec, 1864
Oil on canvas
67.6 × 90.8 cm

two treasured pieces as well as the more fervent devotees, not uncommon in his lifetime and since, with thirty or forty or more – who have preserved the legacy, assuring its survival, while steadily enhancing its value. Krieghoff was an artist particularly attuned to his audience. That is perhaps the main reason his images of Canada fascinate us so much still.

FURTHER READING

J. Russell Harper, *Krieghoff* (Toronto: University of Toronto Press, 1979)
Hugues de Jouvancourt, *Cornelius Krieghoff* (Toronto: Musson Book Company, 1971)
Raymond Vézina, *Cornélius Krieghoff, peintre de mœurs* (Quebec: Editions du Pélican, 1972)

This essay has been adapted from Dennis Reid, 'Cornelius Krieghoff: The Development of a Canadian Artist', in Dennis Reid, *Krieghoff: Images of Canada* (Vancouver and Toronto: Douglas & McIntyre, Art Gallery of Ontario, 1999)

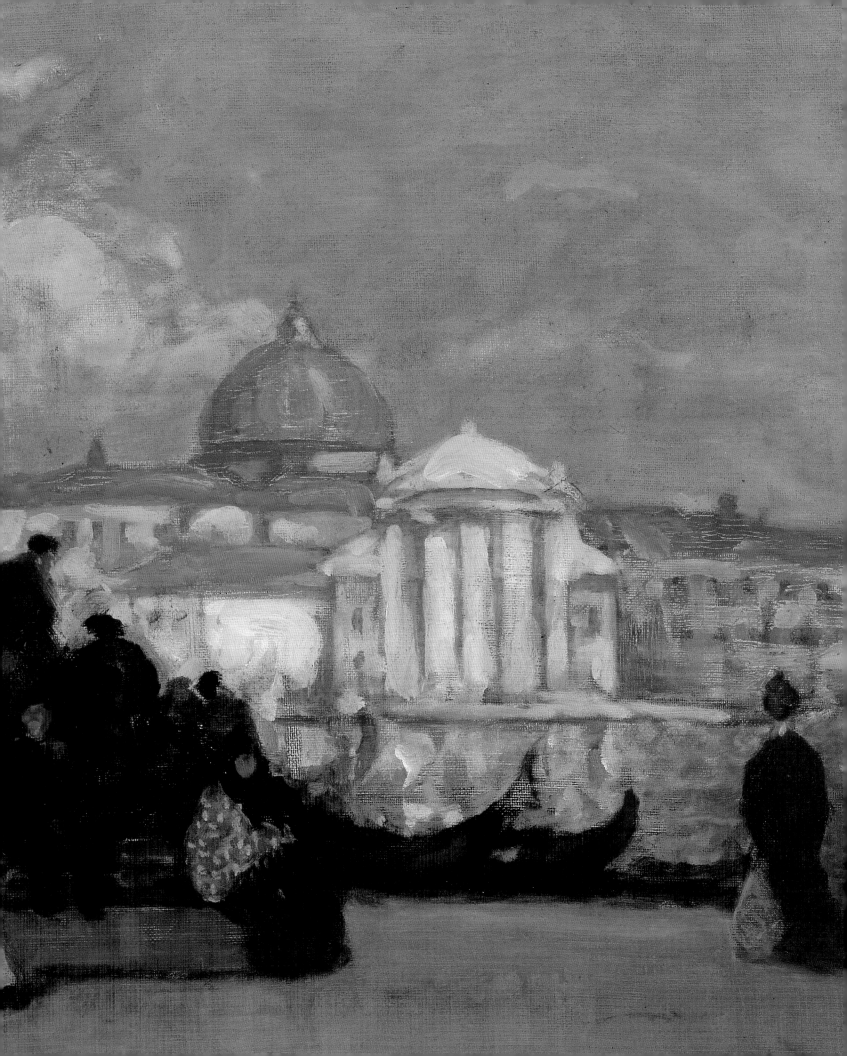

James Wilson Morrice

LUCIE DORAIS

Paris, 1907. A young Montreal painter, John Lyman, having just arrived in the capital of France, is visiting the Salon de la Société Nationale with a friend. There are more than a thousand works but he has eyes for only one, a view of the St Lawrence with ice floes, *The Ferry, Quebec* by James Wilson Morrice (1865–1924). Lyman's response is typical of the fascination exerted by the works of Morrice, or by the man himself. That we know so little about him – he lived in Paris, travelled extensively, drank copiously and was the model for characters in a few British novels – adds to the attraction.

A career that lasted nearly forty years produced only around a thousand works, about half of them being the tiny little paintings on wood panels (*pochades*) that made his fame. No letter to him has ever been found, and those from him – which number less than a hundred – are no more than short notes. Practical things like dating a painting, or even giving it a title, he did not find important. Needless to say, he has created endless problems for art historians, and trying to compile a catalogue of his work that is truly 'raisonné' is not an easy task.

However, Morrice also left 29 sketchbooks (three have been disbound and dispersed) containing close to 1,500 drawings and, from his last years, hundreds of little notes, but alas very few concerning art. A careful study of these sketchbooks helps us understand better where Morrice went and, in some cases, when. But they do not cover his entire career, and some of the events mentioned below are rather deductions than known facts.

Morrice had simple tastes. He lived and painted in a small apartment at 45 Quai des Grands-Augustins in Paris, overlooking the Seine, apparently not well kept; his father's fortune would have allowed him to live more comfortably, but he preferred his "room with a view." He enjoyed company, and friends later commented on his good humour, even if they did not share his love of whisky and absinthe. He was rather short, and prematurely bald; he dressed in tweeds, played the flute and smoked a pipe. As for his love life, we know only of Léa Cadoret, a young Breton-born Parisian whom he met when he was well into his thirties; though she kept her own apartment in Paris, Morrice eventually bought her a house on the Riviera; although they never married, he left her a comfortable sum in his will.

Morrice's father had set up as a trader in Montreal, specializing in textiles. He was soon prosperous enough to move into a mansion in Montreal's 'Golden Square Mile,' still following the precepts of the Presbyterian Church. Expected, like his elder brothers, to work for the family firm, 'Jim' was sent to Toronto to get a BA, then a law degree. However, as soon as he was called to the Ontario Bar he turned his back on the law, preferring "the love of paint." By May 1890 he was already in Paris; he spent some time in England in 1891, but was back in Paris by June of the next year, and the French capital remained his principal place of residence for the rest of his life.

JAMES WILSON MORRICE
(1865–1924)
The Beach at Mers, *c*. 1898
Oil on canvas
60.3 × 81.6 cm

Paris at that time was the art capital of the world, and thousands of aspiring artists crowded the numerous art schools and private academies. Morrice frequented the Académie Julian for a while, before seeking the advice of the old painter Henri Harpignies, a landscapist deeply influenced by Corot. Through a series of small oils on canvas board – pure landscapes quickly painted *sur le motif* – we follow the young Morrice around the environs of Paris or London, and as far as North Wales. In a few tiny oblong wood panels that Morrice brought back from Capri and Venice, probably in 1894, we find figures appearing, at first timidly.

All these landscapes are very simple in composition and their technique, in which the paint is applied in wide brushstrokes, is straightforward. None of them betrays any interest in Impressionism. Nor do the many works that

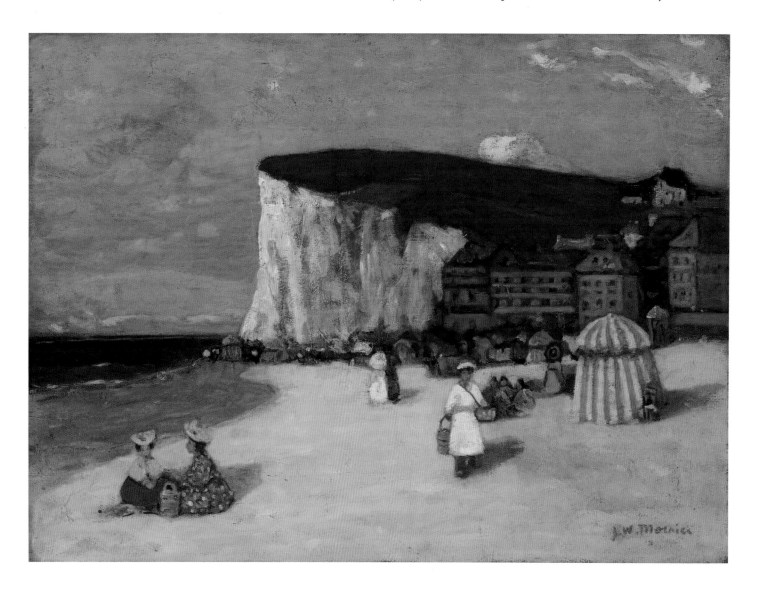

Morrice painted under the friendly tutelage of Robert Henri, an American artist he met in fall 1895; these, rather, are influenced by the 'nocturnes' of James McNeill Whistler. Tonal views of Paris streets at dusk were a favourite subject for both these young artists. Away from Paris and Henri, Morrice would still tone down his favourite olives and pinks with grey, whether depicting Dieppe in Normandy, Saint-Malo and Cancale in Brittany, or Dordrecht in the Netherlands – townscapes mostly, but a new interest for the working population becomes evident, at least in the pages of his sketchbooks.

It was in Canada, surprisingly, that Morrice finally learned about the bright colours of the Impressionists. During his first known visit back to Canada, from late October 1896 to late April 1897, he met Maurice Cullen, who had brought back the new style from Paris the year before, and thought it much better suited to the bright Canadian winter; Morrice, who painted alongside him at Sainte-Anne-de-Beaupré, agreed. He was so excited by the new possibilities that he deferred his return to Paris and sent a painting in his new style to the Art Association of Montreal's annual Spring Salon; it was barely noticed by the critics.

Back on European soil, after a Whistlerian relapse in Venice, Morrice started to see his adopted country with the eyes of an Impressionist. In *The Beach at Mers* (fig. 1) he depicted middle-class families at the beach in bright, sunny colours. It was a new subject in a new town: Mers-les-Bains was then just emerging as a family-oriented bathing-place, a recent outgrowth from neighbouring Le Tréport, north of Dieppe. And for Morrice it was also a new technique: the colours are applied layer by layer until they form a thick crust, evoking, as an early biographer, D.W. Buchanan, wrote, "the surface patina of an ancient oriental bowl." Even when *Early Snow on the Quai des Grands-Augustins* (fig. 2) elicits again a more muted harmony of greys and pink, the superposition of layers, due in part to some repainting, still creates a very luminous result.

Although much smaller in scale, *Déjeuner* (fig. 3) is perhaps closer to mainstream Impressionism: the small touches of colour are applied very quickly on a wood panel the size of a postcard, but the picture is complete, signed in a corner and titled by Morrice himself on the back. This is probably the picture exhibited as *Déjeuner de famille* in London (with the International Society, whose president was Whistler) in fall 1901.

Panel sketches were becoming very popular in Paris, but few artists used such a small format. One who did was the American artist Maurice Prendergast, whom Morrice had probably met around 1892, even though he does not seem to have adopted such panels before his Italian trip of 1894, and to have employed them only sporadically until 1900. After that date he painted so many that about half his subsequent oeuvre consists of these small gems. They were usually painted outdoors, from the low vantage-point of a park bench or a café chair; the artist's hand alternated

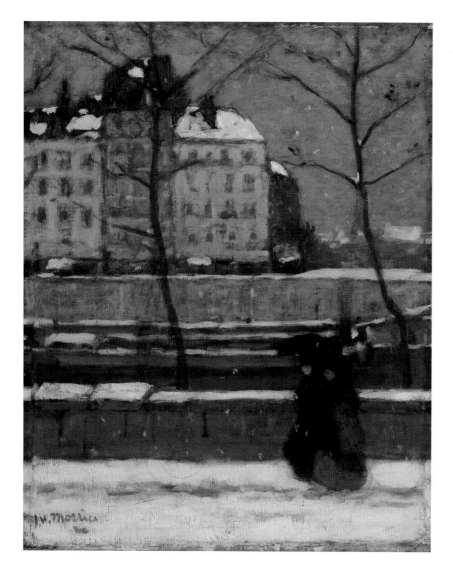

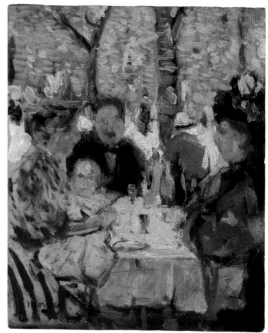

2
JAMES WILSON MORRICE
(1865–1924)
**Early Snow on the Quai des
Grands-Augustins**, *c.* 1901
Oil on canvas
47.8 × 38.4 cm

3
JAMES WILSON MORRICE
(1865–1924)
Déjeuner, *c.* 1899–1901
Oil on wood
15.4 × 12.6 cm

between his brush, his pipe, and occasionally his glass of whisky. Many actually depict outdoor cafés, the nearest customers seated one or two tables away from the artist. The *Déjeuner* is unusual in that we form part of the family gathering – an intimacy recalling the work of the Nabis Bonnard and Vuillard; it is not known, though, whether Morrice was already aware of their work.

Venice (fig. 4), another *pochade* on wood, but in a larger format, was painted during one of Morrice's numerous trips to the city, probably that of 1904. There is much less detail here: Morrice does not tell a story, but wants us to share his poetic vision of the end of a summer day on a Venetian canal. Bright clothes are drying in the setting sun, tiny silhouettes hurry on the quay. Only the eye of a wandering artist, a *flâneur* (as

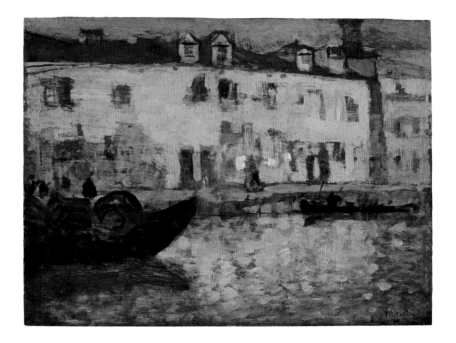

4
JAMES WILSON MORRICE
(1865–1924)
Venice, *c.* 1904
Oil on wood
24 × 32.9 cm

Morrice has often been called), would have found this subject and seen its potential: there are no palaces, no gondolas; working boats are delivering goods to warehouses bordering the canal of San Pietro in the Castello district, an area on the extreme edge of the tourist map. Yet this little picture spells 'Venice' like no other; it is perfect in itself, and does not need to be blown out to canvas size to have an impact.

The *Bull Fight, Marseilles* (fig. 5) is based on a sketch done during that same summer trip of 1904. Spanish *corridas* were very popular in the Provençal city at the time. Morrice probably attended a fight at the main arena on the Prado boulevard, recognizable by the plane trees surrounding it. Probably the signed sketch (now NGC 30463), which is very close to the finished painting, was not painted on the spot, either, but later in the artist's hotel room or even back in Paris. During the *corrida*, Morrice could only jot down the architecture and the main action in pencil in his sketchbook. The finished painting carries over the red and green harmony first elaborated in the oil sketch, but in a more sedate way; the bright yellow sand sets it off, bringing the middle ground forward to accentuate the decorative aspect. The plane trees create a nice rhythm, perhaps reminding us that Morrice was also a musician.

Bull Fight was a big success at the 1905 Spring Salon of the Société Nationale. Since about 1898 Morrice had greatly increased his contributions to Canadian, American and European exhibitions, but the Société Nationale des Beaux-Arts, in Paris, was his main event. Artists and critics were seduced by his delicate harmonies, and the French State bought two of his paintings (one, *Quai des Grands-Augustins*, is now in the Musée d'Orsay).

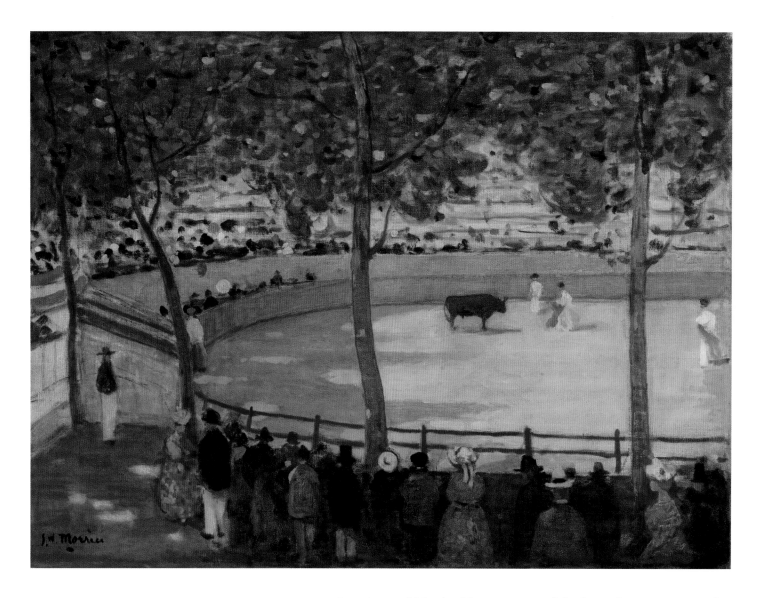

5
JAMES WILSON MORRICE
(1865–1924)
Bull Fight, Marseilles, 1905
Oil on canvas
60 × 80.8 cm

In spring 1906 Morrice felt secure enough in the Paris art scene to send Canadian subjects to the Société Nationale, all four of which were entitled with the prefix *Effet de neige*. *Effet de neige (Québec)* (fig. 6) was photographed for the catalogue, and the surviving glass negative served as substitute for reproductions until, in 2003, the painting resurfaced and was brought with great fanfare back to Canada, where it was soon reunited with the preparatory sketch for it (fig. 7). Sketch, painting and photograph together allow us to study the way Morrice worked; the fact that we can date these works with certitude is a rare bonus.

Morrice had spent Christmas 1905 in Montreal with his family, then travelled to Quebec before returning to Paris, via New York, around 1 March; the exhibition catalogue, with the photograph of the finished canvas, was

published less than two months later. The title written on the back of the panel by the artist, *Mountain Hill, Quebec*, refers to the famous hairpin, Côte de la Montagne, that links the *haute-ville* to the *basse-ville*; earlier that afternoon he had sketched the view in the first turn walking down from the terrace (NGC 30483); just after sunset, he repositioned himself to overlook the traditional houses closing the view at the second turn. He had to work very quickly, because the cold made the paint stiff; having first drawn the main details with his pencil, he quickly filled them in with a restricted palette.

Although, as might be expected, the canvas has much more detail than the sketch, it has hardly any more colours; and, as far as we can tell, the brighter ones were added after the catalogue photograph was taken. The modifications subsequent to the photograph are mainly found in the middle portion of the painting: the sleigh at left, now narrower, is better defined and its black-dressed *cocher* has acquired a bright red scarf, while the little silhouettes at the right are given a less anecdotal role: in the original version, they busy themselves around a rudimentary table or stall. More tracks in the snow, more greyish snow on the embankment at left, and added snowflakes in the sky help to make the overall composition more decorative. This was a good decision, since the painting was sold not long after, probably at the 1907 Salon d'Automne, where it was exhibited with a slight but significant change of title in the catalogue: *Effet de neige (Canada)*.

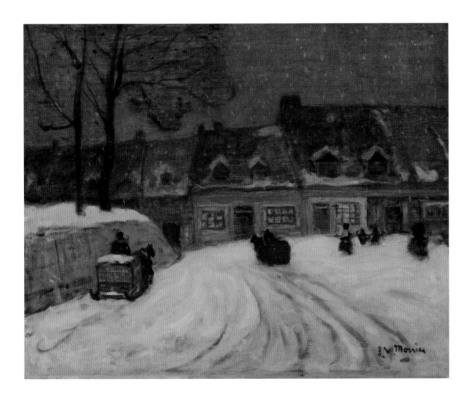

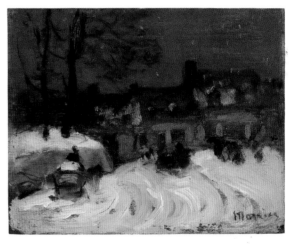

6

JAMES WILSON MORRICE
(1865–1924)
Effet de neige (Québec), 1906
Oil on canvas
64.9 × 80.5 cm

7

JAMES WILSON MORRICE
(1865–1924)
Mountain Hill, Quebec, 1906
Oil on wood
12 × 15.3 cm

8
JAMES WILSON MORRICE
(1865–1924)
Scene in Venice (San Giorgio)
c. 1906
Oil on canvas
55.1 × 46.2 cm

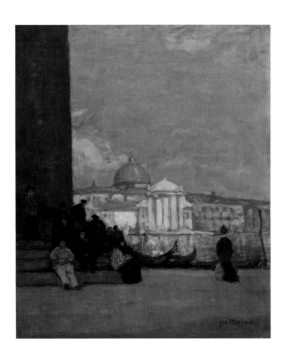

Although painted less than ten years after *The Beach at Mers* and *Early Snow on the Quai des Grands-Augustins*, *Effet de neige,* like the *Bull Fight,* is in a different technique. Instead of adding layer upon layer of colour, Morrice now used thin paint applied directly in small patches that were then rubbed into the canvas with a cloth, "until," wrote D.W. Buchanan, "the surface became radiant as a ruby." Additional touches of pure colour were needed to enliven the whole. Though here used timidly, colour would soon become more dominant in Morrice's oeuvre.

The new technique was fast, enabling him to send many works to exhibitions: Paris, London and Pittsburgh regularly saw his latest production. Canadians were not so lucky: owing to lack of recognition and sales, Morrice tended to send older works to the Art Association of Montreal or the Royal Canadian Academy. Things might have changed when Edmund Morris, in 1907, invited Morrice to become a member of the Canadian Art Club; Morrice was very interested at first, but soon reverted to sending less important or older work. The most recent ones were reserved for his favourite Paris outlet, which was now the Salon d'Automne.

Alternating travels with rushed studio work before exhibitions was starting to take its toll on Morrice, who often complained to his friend Morris that he had too much work. He rarely mentioned his consumption of alcohol, but his friends were alarmed. Moreover, Parisian critics had stopped noticing his annual views of Saint-Malo beaches or Paris and Venice quays, especially after the Fauve explosion of colour at the 1905 Salon d'Automne, where Morrice had exhibited four *pochades*.

Morrice's work undoubtedly benefited, however, from his opening to more contemporary art, as we can tell from rare comments, in letters to Morris, about exhibitions he saw – Cézanne ("Fine work almost criminally fine ... savage work ..."; January 1910), the ground-breaking Post-Impressionists London exhibition ("Art that will last"; January 1911), and especially Bonnard ("the best man here now – since Gauguin died"; June 1911). Morrice might not have been aware of Pierre Bonnard's work when he painted *Déjeuner*, but nobody can deny that his superb series of nude model studies painted around 1912–14 owe a lot to the French painter, and not a little, especially their colourful backgrounds, to Henri Matisse.

Unfortunately there is no record of what Morrice thought of Fauvism, but around 1906 he introduced rather brighter colours into his works: *Scene in Venice (San Giorgio)* (fig. 8) is an excellent example. Morrice's admiration for Matisse is well known; they had been acquainted with one another at least since 1908, when both were on the painting jury of the Salon d'Automne, the one that rejected the first Cubist paintings of Georges Braque ("This art I am incapable of understanding," wrote Morrice in 1911).

Matisse and Morrice met again by chance in Tangier in early 1912. It was Morrice's first trip to North Africa, and the many sketches he brought back betray his enthusiasm for the bright light and the exotic

costumes. *Tangier, the Beach* (fig. 9), one of the four Moroccan canvases he sent to the next Salon d'Automne, shows signs that Morrice had seen the works of the French artist; indeed, Matisse wrote to his wife that the Canadian had seen two of his sketches and loved them; one was a "blue landscape," but it has not been identified. "Bright color is what I want," wrote Morrice to Morris on 1 November, and so he returned to Tangier. Matisse was already there, accompanied by another member of the Fauve group, Charles Camoin; the trio shared many conversations at supper, but the Frenchmen were a bit put off by Morrice's love of whisky.

Morrice made a third trip to North Africa, to Tunis, in spring 1914; it was not a long trip, and only a few drawings and sketches can be identified as Tunisian. A pair of portraits of young Arabs in a wallpapered room has long been associated with Tunis, and *Negress* (fig. 10), a compelling picture, probably belongs with them. John Lyman, who first owned the painting, called her *Négresse algérienne*, a title he may have learned from Morrice directly, though he bought the painting after his friend's death. Her dress is definitely North African, and her unveiled face suggests that she is a working woman and perhaps not Muslim. It is tempting to view Morrice's sitter as one of the employees at his Tunis hotel; her attitude suggests such a reading. Whether painted in Tunis or back in Paris, the portrait is perhaps Morrice's best. He has succeeded in balancing bright red and bright pink –

10
JAMES WILSON MORRICE
(1865–1924)
Negress, *c.* 1914
Oil on wood
35 × 26.6 cm

two colours that could easily clash – through the brown shades of the sofa and, more importantly, of the sitter's face. In its unity, *Negress* is the culmination of what Morrice had assimilated from having studied at first hand the art of Matisse and, at exhibitions, that of Bonnard.

After this discovery of the true South, Morrice would paint less and less in Europe: his next important trips would be to Cuba in 1915, back to Morocco some time after the war, Trinidad in 1921, and to Corsica and Algeria in 1922. He seems to have spent most of the war years in Paris, except for a visit to Montreal in early January 1917 (in the company of Lyman and his wife) and a stint on the Picardy front as a War Artist in February 1918.

His official commission as a War Artist, a huge canvas now hanging at the new War Museum in Ottawa, initiated a modification to his technique. Because he had to travel lightly and work quickly, Morrice used watercolours as well as wood panels for his sketches. He used the two supports alternately until the trip to Morocco; afterwards, watercolour prevailed.

Morocco Buildings (fig. 11), however, is based on a drawing made on the spot (in Sketchbook #21, Montreal Museum of Fine Arts). It is not dated, not even signed, but it appears to be finished. Its previous title, *Outside the Mosque*, was invented in the early 1930s by Morrice's executors; they placed it in Algiers, which Morrice had visited in 1922. D.W. Buchanan, in his 1936 catalogue raisonné, dated it to 1911–13, even though a preparatory watercolour for the painting (private collection) indicated a date after the War. The style of the painting, with thin paint and ample brushstrokes evoking the watercolour technique, is very close to that of Morrice's Trinidad paintings of 1921. The problem was resolved when the present author positively identified the subject of another drawing in Sketchbook #21 as a view of the Boulevard El Allou in Rabat, closed at one end by the *medersa* of the Casbah of the Oudaya. The subject of this painting, so beautiful with its luminous white wall framed by the foreground green shrubs and a glimpse of the indigo sky, is not a mosque at all, but a pair of typical Moroccan houses. Blind to the exterior except for the *moucharabieh*, with their interiors built around a patio, they were situated right across the boulevard from a *kiosque à musique*. It is probably spring or summer, since the laurel bushes adorning the boulevard are in bloom.

Morrice's quest for the sun grew more urgent in the early 1920s, and he spent more and more time, when not travelling further afield, with Léa on the Côte d'Azur. Health problems (stomach ulcers in particular) often interfered with his travelling, but at the end of 1923 he was well enough to return to Tunis, then tour Sicily with his brother Arthur and his family. The drawings from Palermo and Taormina do not betray his failing health, but the only sketch that can be identified as Sicilian (a sailing ship in Palermo; Montreal Museum of Fine Arts 974.34) remains unfinished. From Sicily he returned to Tunis, and it was there, in January 1924, at the age of fifty-nine, that Morrice died.

11
JAMES WILSON MORRICE
(1865–1924)
Morocco Buildings, *c.* 1920
Oil on canvas
60 × 81.5 cm

FURTHER READING

Donald W. Buchanan, *James Wilson Morrice: A Biography* (Toronto: Ryerson Press [*c.* 1936])

Nicole Cloutier *et al.*, *James Wilson Morrice, 1865–1924* (exhibition catalogue, Musée des beaux-arts de Montréal, 1985 [bilingual])

Jack Cowart, *Matisse in Morocco: The Paintings and Drawings, 1912–1913* (exhibition catalogue, National Gallery of Art, Washington, DC, 1990)

Lucie Dorais, *J.W. Morrice* (Ottawa: National Gallery of Canada, 1985 [also available in French])

Charles C. Hill, *Morrice: A Gift to the Nation: The G. Blair Laing Collection* (Ottawa: National Gallery of Canada, 1992 [also available in French])

G. Blair Laing, *Morrice: A Great Canadian Artist Rediscovered* (Toronto: McClelland & Stewart, 1984)

John Lyman, *Morrice* (Montreal: L'Arbre, 1945 [in French])

David B. Milne's
Paintings and Prints

DAVID P. SILCOX

David Milne (1882–1953) is a favourite artist of artists, curators and critics – but not, by any stretch, of everyone. Some viewers find his paintings too austere or too tough: the trouble was, "he didn't use enough paint," as A.Y. Jackson complained. Other artists, however, have recognized in him the visual equivalent of perfect pitch, and admire his technical virtuosity, intellectual substance and emotional impact.

Milne was the son of a Scottish farmer in a small, rural community in Ontario. He had that typically Scottish characteristic of a private resilience and stubbornness accompanying a public bravado and even cockiness. The brightest student in the region for decades, he made his way in 1903 to New York, where, after studying art and working on the fringes of the world of illustration and design, he had an epiphany – that he wanted to be a distinct and original artist. Indeed his radical and sparkling paintings soon got him recognized. One of his earliest public notices was for a pastel, aptly called *The Defiant Maple*, shown in the Philadelphia Watercolor Club's exhibition in 1910, about which the critic of the Philadelphia *Public Ledger* wrote, succinctly: "*The Defiant Maple* of David Milne is clever, if bilious." Milne continued to garner usually impressive notices, especially from the critic of *The New York Times*, who saw him as extending the tradition of Georges Seurat and Paul Signac.

Among the important venues for contemporary work in New York were the watercolour societies and the avant-garde N.E. Montross Gallery. The Montross Gallery, Milne's dealer and art supplier for many years, was also the home gallery for The Eight, later known as the Ashcan School – Robert Henri, Arthur Davies, Maurice Prendergast, George Luks, William Glackens, Everett Shinn, John Sloan and Ernest Lawson – artists whom Milne knew and exhibited with. The apogee of Milne's early career was his exhibition of five works in the famous Armory Show of 1913. But when the climate for art changed with the advent of the Great War in 1914, like many of his contemporaries he withdrew from New York to the country. Thereafter he lived almost entirely in remote areas, where he could devote himself to thinking about, and working at, his painting and printmaking.

Pink Billboard (fig. 1) shows Milne just as he had found his own form of expression in 1912, a few years after his stint at the Art Students' League (1903–06). He found his subjects along the streets of New York, reduced his palette to a few distinct colours and pared the details of his subject to bare essentials. The artist Harold Town called Milne the "master of absence" because Milne could leave so much out of a painting without losing the essentials.

A related *tour de force* of Milne's fresh and complicated style is Milne's *Billboards* in the National Gallery of Canada. Another close cousin to these two is *Columbus Circle*, a lost painting that was shown in the Armory Show, where it was vilified by critics. *Pink Billboard* thus represents a crucial moment in art history, as well a being a striking work on its own.

1
DAVID B. MILNE
(1882–1953)
Pink Billboard, c. 1912
Oil on canvas
51 × 51 cm

2
DAVID B. MILNE
(1882–1953)
Black Cores, July 1915
Watercolour over
graphite on paper
45.7 × 56.4 cm

Black Cores (fig. 2), painted just three years later, at the end of July 1915, shows Milne at another stage in his bold experiments, for it is about as near as he ever came to total abstraction. Milne knew that fundamentally every painting is an abstraction – in drawing, in form, in value (black, white and mid-value, to use his terms), and in colour (or hue, as he usually called it). The painting is a prelude to a watercolour called *Massive Design*, in which Milne dropped the slate-blue colour to leave only black and green, and simplified the groups of shapes substantially. The origin of these two paintings was specifically noted by Milne: writing in 1920 about another painting, *Pool and Contours*, Milne describes: "…three of the most important things I have developed in my painting. 1. The black 'cores' of the trees, a convention started in a watercolour made in 1915 from near Gun Hill Road looking across Webster Avenue to White Plains Avenue [in the Bronx]. This started from the need for a convention to represent trees looked at against the light where they showed a dark shadowed part surrounded by an illuminated part." (The two other developments were the clear-water, washed-over areas of the reflection paintings done at Boston Corners – see *Dark Shore Reflected, Bishop's Pond* [fig. 5 below] – and the use of "coloured streaks to mark the boundaries of shapes – contours," which evolved when he was painting the torn battlefields of France and Belgium in 1919.)

David B. Milne's Paintings and Prints

3
DAVID B. MILNE
(1882–1953)
Woman in Brown II
September 1916
Oil on canvas
50.4 × 60.7 cm

When he left New York in the spring of 1916, Milne and his wife Patsy settled in Boston Corners in upstate New York. Although he served for eighteen months in the Canadian army in 1918–19, half of them as a War Artist, this area was his home turf until 1924, and the most idyllic in his life. From 1921 on his summers were spent in the Adirondacks, where he worked as a handyman and he and his wife ran a teahouse.

Woman in Brown II (fig. 3) is an example of Milne's work from his first exuberant and inspired summer in Boston Corners. Milne's work was infinitely greater in range than his predominant landscape motifs, whether urban or rural, might suggest. Among his most important works are still lifes and figure paintings; during the early years of their relationship, Patsy was often a subject, either reading in their apartment or working in the garden or, in this case, reading by a brook or pond. The obvious nod to camouflage in the subject was one that Milne would readily have acknowledged, for, from the day war was declared in Europe, Milne followed events closely – even keeping a scrapbook of clippings showing the battlefronts and the progress of the conflict. Many of the paintings this summer of 1916, one of the most prolific in Milne's career, dealt with the shifts in perception that camouflage and deliberate deceiving of the eye can accomplish.

4
DAVID B. MILNE
(1882–1953)
The Line Fence, January 1920
Oil on canvas mounted
on hardboard
47.2 × 55.2 cm

Repainting a subject was not unusual for Milne. He frequently made changes to both oils and watercolours; often he painted numerous variants before finally admitting defeat or victory. This work is a slightly larger version of his first, and he used the occasion to simplify some elements subtly, reduce detail and alter a few of the shapes. Although to most eyes these two versions are virtually identical, to Milne the changes were major alterations and refinements. For a time, Ken Thomson owned both paintings so he could trace the artist's thoughts and processes between the first version and the second.

The Line Fence (fig. 4) is one painting among a precious few that portray the quintessential character of Boston Corners for Milne, both as a subject and as a symbol of his vision of 'place.' He painted it at the end of January 1920, shortly after he returned from his experiences as a War Artist, when he had confronted new and horrific subjects and seen the chaotic aftermath of battle. The broad panorama of the valley seen from the "rising ground behind Joe Lee's house," the "string of coloured beads" that was the houses, barns and other buildings of Boston Corners, and the great arc of Fox Hill closing off the distance, all conspire to create a sense of

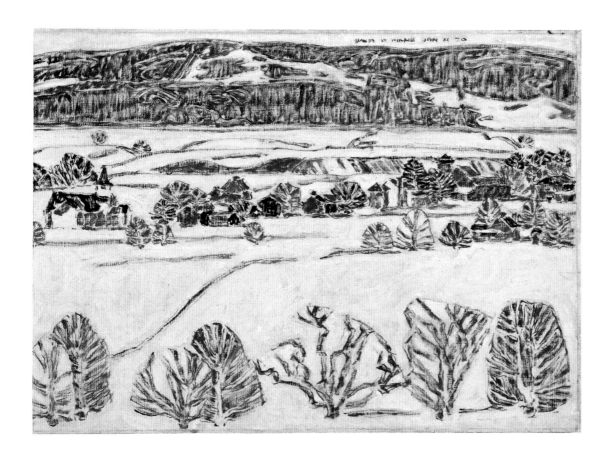

David B. Milne's Paintings and Prints

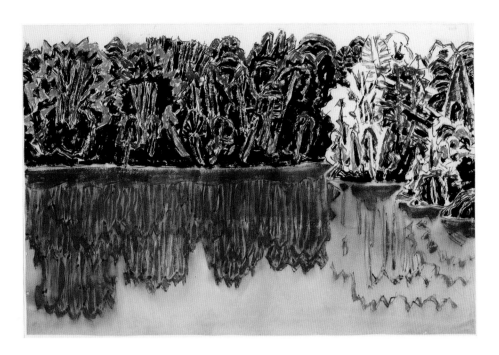

5
DAVID B. MILNE
(1882–1953)
Dark Shore Reflected,
Bishop's Pond, *c.* October 1920
Watercolour over graphite
on paper
36.8 × 54.5 cm

peace and comfort. In his notes, Milne gave himself full marks for
this painting:

"Color more brilliant and warmer than usual. Interest is in the
middle band (unusual). Upper and lower bands subordinated, lower one
consciously, upper one unconsciously. Drawing and arrangement of
middle band better in this than in any other that I remember; note
particularly the barred streak of the gravel bank, a very interesting lancet
shape. The Fox Hill band was washed out [i.e. rubbed out and repainted]
once outside and once after coming in [back at the house]."

Dark Shore Reflected, Bishop's Pond (fig. 5) is from the summer of that same
astonishingly productive year, and it demonstrates the second most
important development in Milne's painting, as described above – the use
of a clear-water wash across half of a painting to create a subtle but notice-
able shift in texture between a subject and its reflection. Reflections were
a recurring theme throughout Milne's painting career, but he had first
tripped across the dramatic effect of the clear wash in 1916. Bishop's Pond
was quite close to the Milne house and, being surrounded by trees, kept
the wind from ruffling the reflections. This work is one of several variants
on the same subject (*Pink Reflections, Bishop's Pond* is in the National Gallery
of Canada), and concludes an almost miraculous run of half a dozen
masterful works in watercolour by Milne that autumn.

After an unpleasant winter alone in Ottawa in 1924–25, Milne and
Patsy spent the next five summers at Big Moose Lake in the western
Adirondacks, where Milne built a cottage, and the winters running the

DAVID B. MILNE
(1882–1953)
Outlet of the Pond, Morning
January 1928
Oil on canvas
48.8 × 51.1 cm

teahouse at the foot of the Lake Placid ski jump. The cottage was originally intended to be a teahouse that they could run in the summer, making enough profit to carry them through the winters, when Milne would spend his time painting. The project took nearly four years, since Milne did all the work himself, including the substantial foundations and the great stone fireplace – even splitting the granite slabs that face the mantel. He sold the house at the end of 1928, which helped him eke out a spartan living over the next difficult years.

Outlet of the Pond, Morning (fig. 6) may be regarded as one of the most perfect of Milne's paintings. Although during his years in the Adirondacks

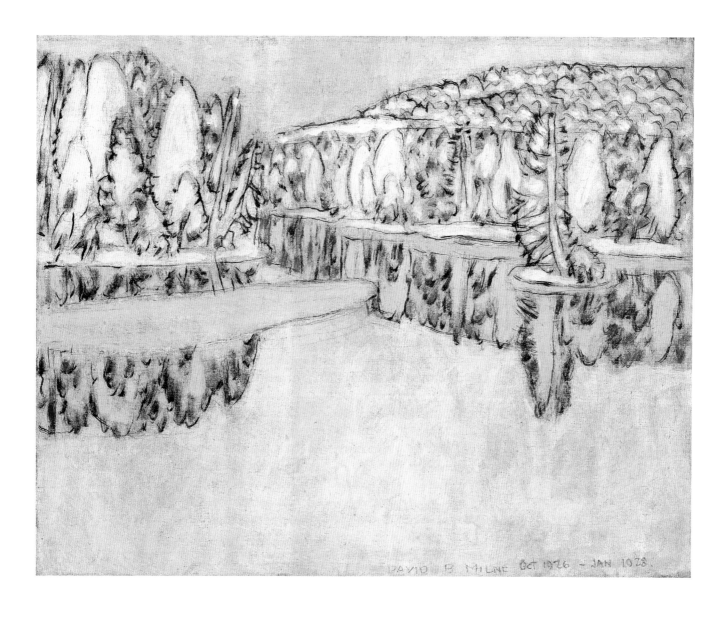

David B. Milne's Paintings and Prints

7
DAVID B. MILNE
(1882–1953)
Painting Place, February 1929
Colour drypoint on paper
20.1 × 28.8 cm

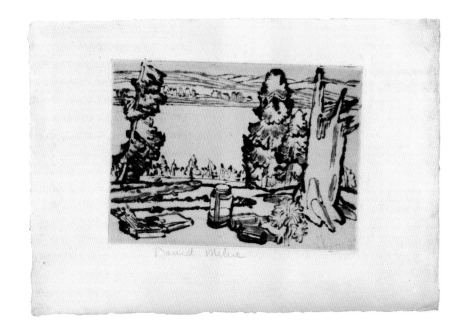

his production was quite low overall, and the tenor of his life was often hobbled by unwanted distractions, major works kept popping out – the *Painting Place* series (fig. 7), the occasional but brilliant floral still lifes, or the broad but captivating vistas of the Lake Placid area. This outstanding canvas takes a mundane subject, a simple view of Squash Pond, where Milne liked to go to get away from all the reminders of work he did not want to do, and transforms it into a world of mystery and haunting ambiguities. He described this painting in a letter to his friend James Clarke in January 1928: "The upper masses with water and sky are white with detail scratched on, slightly emphasized with small spots of brilliant color. The reflections . . . and the windbreak are in a secondary white value. I had some junk in the foreground, logs, roots and snags with mid-value reflections. These I have taken out. The shape groups of the thing are particularly good, very slightly separated, and were the picture as I saw it." Later, this subject was created anew as an equally enchanting drypoint.

Milne returned to Canada in the spring of 1929, alone; his relations with Patsy were parlous, and for five years his attempts at painting had been too much interrupted by the requirements of unrelated work. He was determined to reclaim his life as a painter, and he headed for a distant spot where he could sequester himself totally. He ended up in Temagami, a small town on a large lake in northern Ontario that was in fact a famous resort destination. Notwithstanding that, Milne got a canoe and found a secluded island to camp on. By the end of the summer he had produced about thirty paintings. He was not thrilled with all of them, but he was once again back on track as an artist.

8
DAVID B. MILNE
(1882–1953)
Riches, the Flooded Shaft
(**The Pool of Temagami**), 1929
Oil on canvas
52 × 62.2 cm

Riches, the Flooded Shaft (fig. 8) is one of about eleven variants of a motif that was subjected to Milne's repainting and editing process that summer – an abandoned mine shaft filled with water. Milne was fascinated by it, and it became the subject for both paintings and a drypoint. He wrote to his friend James Clarke about it: "To the miner it may be a disappointment but to the painter in search of color it is a find. Everything in the way of color that there is and in all possible intensities and combinations. The pits are filled with water. Some apple green (milky) in the middle with yellow in the shallower parts. Another one is bottle green in the middle (clear) bordered with golden leaves. The sulphur in the water coats everything with a coat of yellow."

The white section at the bottom of the painting created what Milne called a "dazzle spot," an area that snags the eye instantly: it starts the viewer into the painting with a jolt. Milne wrote of this device in this painting to his friend Stockton Kimball, a doctor in Buffalo: "A prospect hole. The rock is all ore, contains iron, copper, sulphur and arsenic – and all the colors you would expect from such a mixture of ores. The dazzle area again, but in an outside subject. Its effect is heightened by the area

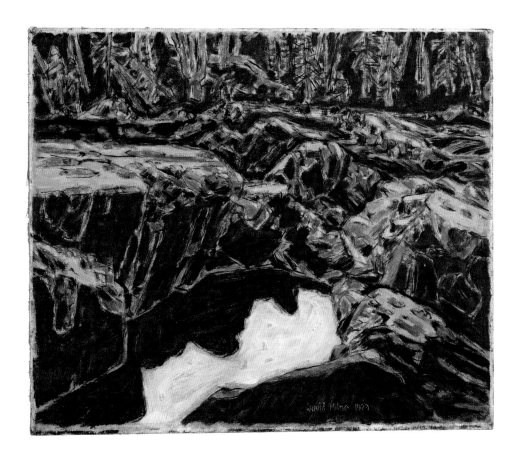

9
DAVID B. MILNE
(1882–1953)
Corner of the Etching Table, 1930
Oil on canvas
41.2 × 51.6 cm

of unbroken black in the reflections of the rocks. The picture is very much a unit – a one. Brought about in the first place by the steadying effect of the two powerful values [black and white] in the water and then by welding the detail together. The tree band separates from the rocks only by the character of its detail – not at all by change of value or hue."

After the summer in Temagami Milne moved to Weston, then a suburb of Toronto, where he rented a studio in the Longstaffe Pump Works near the Humber River and worked steadily throughout the winter at both paintings and drypoints. He reworked some subjects from the Adirondacks and also reconsidered aspects of the Temagami flooded shaft series. *Corner of the Etching Table* (fig. 9) again uses the device of the "dazzle spot," although this time more conventionally. The painting shows, through the paraphernalia of the artist's studio, a sort of self-portrait of Milne at mid-career – a painting of the Glenmore Hotel from Big Moose Lake in the background, a framed drypoint of a Lake Placid subject leaning against it, and the cloths, pigments and tools of the printmaker in the foreground. He commented: "A pronounced use of the dazzle area. The light from the window reflected by the glass of the framed drypoint . . .

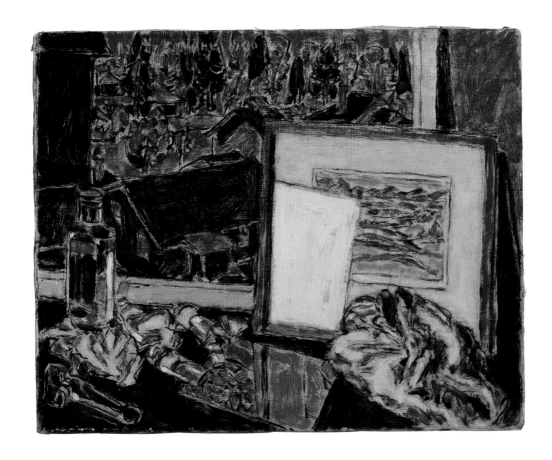

10
DAVID B. MILNE
(1882–1953)
Barns, 1930
Oil on canvas
40.7 × 51 cm

the dazzle value is carried through other objects in the picture and serves the same purpose."

With the Depression setting in during the spring of 1930, Milne moved to Palgrave, a small village in the Caledon hills north-west of Toronto, where he could garden and live more cheaply. Although he separated legally from his wife three years later (and this last stretch together was a misery for them both), Milne's painting in the face of privation and contentious stress was ambitious, complex, expansive and astonishingly rich in invention. Even making allowances for the inordinate amount of repainting Milne did during these three years, they were among the most productive of his life, for both painting and printmaking. The Thomson Collection has extensive holdings of work of Milne's Palgrave period because Blair Laing, an influential guide and critic to Ken Thomson, had acquired most of the Palgrave paintings from Vincent Massey in 1958, and for many years had kept a large number of the best ones for

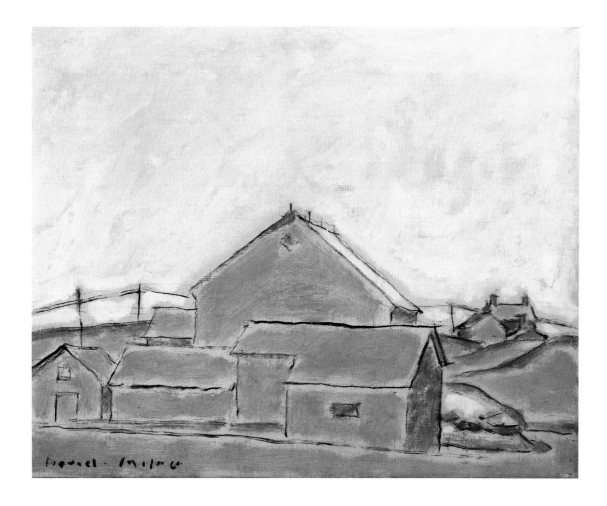

David B. Milne's Paintings and Prints

11
DAVID B. MILNE
(1882–1953)
Winter Sky, January 1935
Oil on canvas
30.5 × 41.3 cm

himself. He began to let them go toward the end of his life, and his last sale of his favourites was to Ken Thomson.

Barns (fig. 10) is a quintessential Palgrave-period painting. In many respects it is an equivalent, almost two decades later, of *Black Cores* (see fig. 2), a work that, in its austerity, sidles up to the borders of abstraction. Milne painted *Barns* in his first year at Palgrave, made a drypoint of it, then came back to the painting a year or two later: "[Barns] is about the simplest picture I have ever tackled – the least lines, the least colour, the least detail. Space – or maybe spaces. Very little black outline, the most prominent use of it is in the flagpole on the building on the left. In other places it is used as spots at corners and ends This morning I took it out and hung it on the side of the house and sat and thought over it until noon. Had everything absolutely decided on. Then I rubbed it out ... and drew it in again and painted it this afternoon. Pretty good Where there is so little in the thing, you haven't much leeway, you have to have what is there do something."

When he left Palgrave in 1933 Milne meandered by canoe up to the Severn River and an area of southern Muskoka near the foot of Georgian Bay. He finally settled on the uninhabited Six Mile Lake, where he camped and then finally constructed a nine- by twelve-foot cabin, largely out of scavenged lumber and tarpaper. As it turned out, Milne lived in this isolated spot longer than in any other. And, despite its remoteness, he was more regularly connected with artists, curators, dealers, collectors and writers than at any other time in his life since he left New York.

Winter Sky (fig. 11) is a 1935 New Year's Day painting of Milne's Six Mile Lake headquarters, banked with snow. Like most of the usually small canvases from this time, it is the product of considerable thought, careful planning, and then quick execution. For Milne, all the thinking and planning had first to guide and then ultimately submit to an intense emotional and focused phase in which the artist worked at a white heat, totally absorbed, and without distraction or pause. All the preparations lead to that one short period of utter concentration, without which the painting would lack the magic of fusion, of resolution.

In 1937, after a hiatus of twelve years, Milne again began to paint in watercolour; soon thereafter almost his entire production was in this medium. Although many of these later works were virtuoso creations, the modernist tenets which had guided Milne's early and prime years as an artist were largely abandoned. He met a much younger woman, moved to Toronto to live with her, fathered a child, then lived in relative obscurity in Uxbridge, Baptiste Lake and Bancroft – small places northeast of Toronto. At Baptise Lake he built another, more substantial log cabin. Ill health plagued his last few years, and a series of strokes led finally to his death in Bancroft.

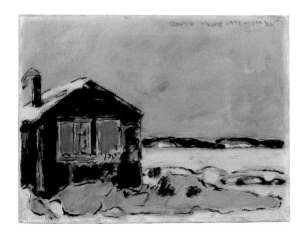

12
DAVID B. MILNE
(1882–1953)
Waterfall, 1930
Colour drypoint on paper
17.5 × 22.6 cm

The colour drypoints

Milne had the idea for coloured drypoints as early as 1921; it developed out of his intensive period of painting the aftermath of war in France and Belgium, and again right afterwards in Boston Corners. He was already quite familiar with various kinds of printing methods, since he had done etchings, lithographs and other forms of printing in New York after leaving the Art Students' League. The initial test of his invention, in the winter of 1922, was at Mount Riga, near Boston Corners, when he scratched three copper plates with the image of a New England house and orchard, each plate representing a colour. The printing was done, after a fashion, using the neighbour's washing machine wringer as a makeshift press. Registration of the plates over each other was only approximate, but Milne could visualize the goal clearly. He wrote enthusiastically about the process to his close friend James Clarke, a distinguished advertising artist, and dropped hints that with a proper press some fine results might be achieved.

For the next few years, the project was shunted aside by the exigencies of making a living, a dispiriting time for Milne. Clarke must have sensed this, as he had on previous occasions when Milne needed encouragement, for at the end of 1926 he bought and sent Milne the press, a Gore Portable Etching Press, Model A. Initially, Milne was awkward in drawing with the etching needle, then baffled about getting the registration exact, then astonished when his planned colour schemes didn't turn out as expected. Soon enough he learned how all these elements could be controlled, and in the most subtle of ways. He began to produce finished prints of a quality

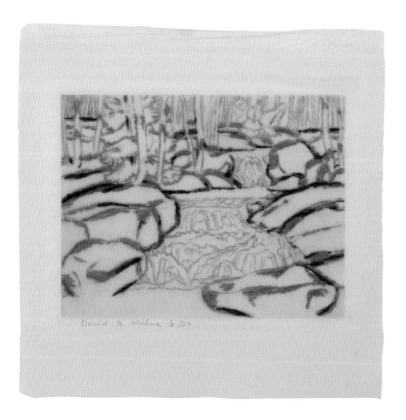

13
DAVID B. MILNE
(1882–1953)
Prospect Shaft, 1931
Colour drypoint on paper
21.6 × 21 cm

and grace that were startling and elegant. They seemed, as Milne once said about his ideal for painting watercolour, "almost to be wished onto the paper."

Milne promised Clarke the first good print of each subject as repayment for his gift of the press. Thus Clarke became the recipient of Milne's choice of the best impression of each subject – a rare and telling factor, given that Milne's impressions often varied greatly from one to the next. For Milne, running the edition was journeyman's work; what he enjoyed was the exploration and experiment until an ideal print was realized, then he lost interest. Besides, he saw no purpose in printing an edition without a ready market to sell them to (there was none), using up expensive paper which he could not afford. Although Milne indicated editions of twenty-five or fifty on some prints, he only printed a whole edition on two or three occasions much later.

The Thomson collection of Milne's colour drypoints is exceptional, and exceptional within the Thomson Collection, for Ken Thomson was not a print collector. The core of these consist in the large majority (eighteen) of the hand-picked drypoints that Milne gave to Clarke. These prints, originally more than twenty-four, were bought by Robert McMichael in 1962 on the understanding that they would be put on permanent public display as part of the McMichael Canadian Art Collection. (Clarke gave the money to Patsy Milne, who was in need.) McMichael, however, promptly sold most of the work. This group of eighteen drypoints (figs. 12, 13) was sold together and eventually purchased by Ken Thomson.

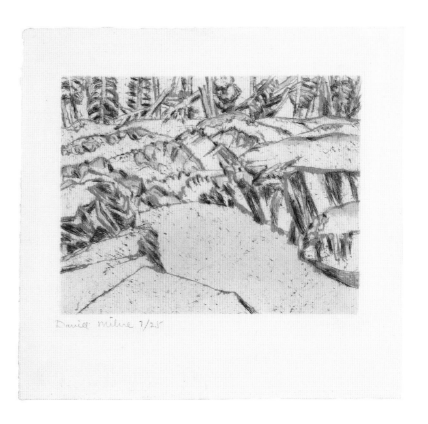

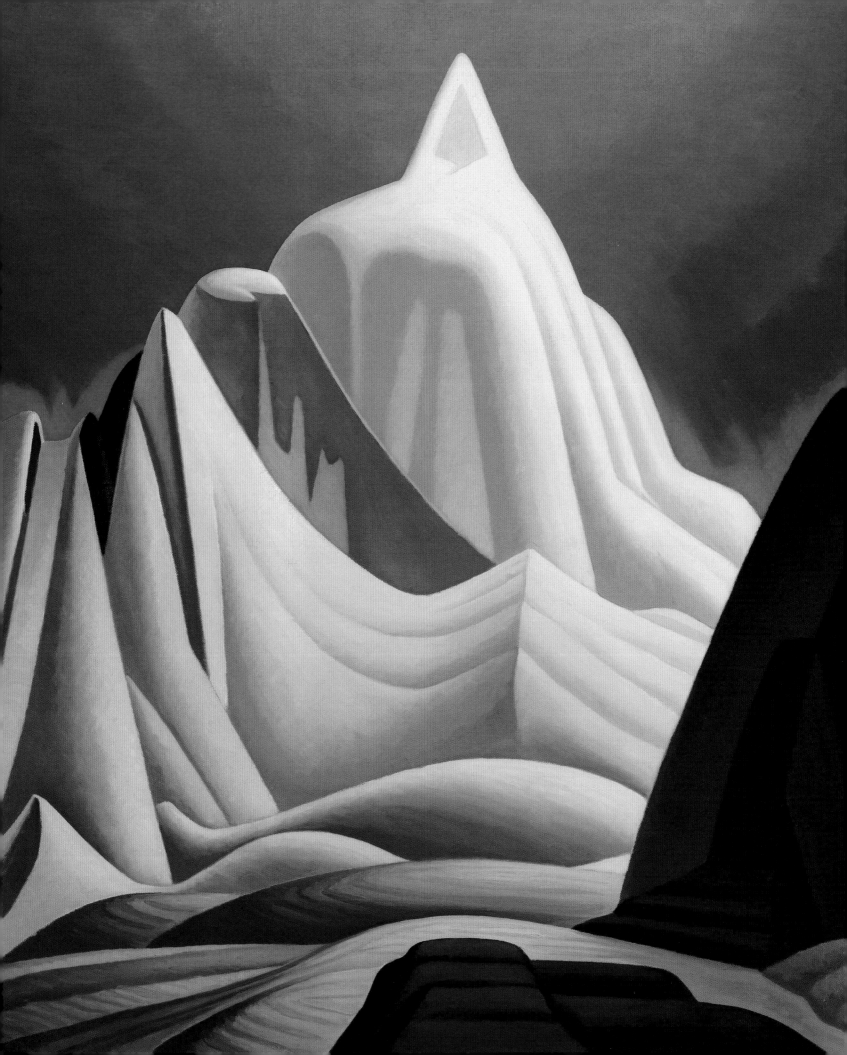

Lawren Stewart Harris: Towards an Art of the Spiritual

JEREMY ADAMSON

In early 1908 twenty-three-year-old Lawren Stewart Harris (1885–1970) returned to Toronto after more than three years studying art in Berlin and travelling through Germany, France, Italy and England. For two months at the end of 1907 he had journeyed by camel from Jerusalem to Cairo, producing illustrations for a series of travel articles by Canadian writer Norman Duncan for *Harper's Magazine*. The academic training he had received in Berlin and his exposure to art of all kinds in the German capital was thorough. He had studied under three different artists, familiarized himself with the rich collections of the national museums, and regularly visited both the annual displays of conservative German art organized by the Academy of Arts and the more controversial shows put on by the avant-garde exhibition group the Berlin Secession, a probable model for his own later Group of Seven. The city's progressive art dealers regularly showed paintings and drawings by emerging French and Paris-trained artists, and Harris later indicated that as a student he had been particularly attracted to the work of Gauguin, Van Gogh and Cézanne.

The young Canadian was also exposed to the wider German tradition of regional landscape painting in which artists, either alone or collaborating as a group, attempted to convey the special 'home' feeling or *Heimat* of a geographical area, revealing the way terrain and climate had influenced not only local architecture but the daily lives and rituals of its inhabitants. Back in Toronto, Harris, too, was attracted by the idea of geographical determinism. Like others, he was convinced that winter and the proximity of the northern wilderness directly influenced the character, culture and spirit of Canadians.

According to the later testimony of his second wife, Bess Housser Harris, "the impact of returning to Canada was terrific." He was "transferred, transported ... into a whole new experience The quality and clarity of the light excited him." Almost immediately, Harris rented a studio over a grocery at the corner of Yonge Street and Cumberland Avenue and resumed a practice he had established as a student in Berlin – sketching rundown houses in poor, inner-city neighbourhoods. This might seem a strange occupation for someone of Lawren Harris's background. Like his friend Vincent Massey, he was an heir to the financial fortune generated by the Toronto-based Massey-Harris Co., the British Empire's largest manufacturer of farm machinery. Moreover, he was not a social reformer. He had grown up among the city's business and social elite, attending private school, summering in Muskoka, and living in a large and fashionable brick house next to the university. (Harris's boyhood residence on St George Street is presently the University of Toronto's Department and Centre for the Study of Religion.) But his Berlin habits held fast, and from 1908 to 1926 simple, vernacular dwellings – not only in Toronto, but also in Hamilton, Barrie and Halifax – were to be a unique and distinctive category of his work. Harris regarded such homespun architecture as

LAWREN STEWART HARRIS
(1885–1970)
Houses, Richmond Street, 1911
Oil on canvas
61.1 × 66.6 cm

characteristically Canadian and displayed his house pictures in all the Group of Seven exhibitions, including the last one in 1931.

In 1911 Harris exhibited the first of his downtown canvases, two winter scenes along Wellington and Melinda Streets painted the previous year, describing the former as an endeavour to depict the clear, hard sunlight of a Canadian noon in winter and "to suggest the spirit of Old York [Toronto]." In the same show he also displayed his first landscapes, two snowbound views in northern Minnesota's logging country, an area to which he had travelled in early 1909 with Norman Duncan on another illustration assignment. However, in 1912, at the annual Toronto displays of the Royal Canadian Academy, the Ontario Society of Artists (OSA) and the Canadian National Exhibition (CNE), he exhibited his first Canadian landscape canvas, again a logging subject, as well as five new urban scenes, including *Houses, Richmond Street*, painted in 1911 (fig. 1).

Harris's favourite location was St John's Ward, a notorious mixed-use neighbourhood adjacent to the central business core. However, his Ward pictures are largely devoid of the bustling human activity that characterized the district (fig. 2). Unlike the urban realists of the so-called Ashcan School, who painted the lively street life in New York's immigrant Lower East Side in the early 1900s, or Max Liebermann the Berlin Secession

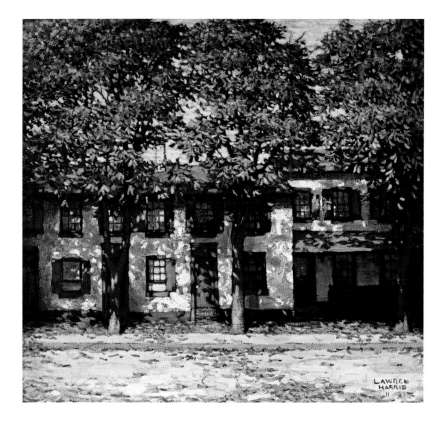

Lawren Stewart Harris

2
LAWREN STEWART HARRIS
(1885–1970)
In the Ward, 1917
Oil on wood-pulp board
26.8 × 34.8 cm

leader, who pictured the crowded, outdoor markets of Amsterdam's Jewish quarter in 1905, Harris focused on the architecture, not the activities of the people. Where figures do appear, they function more as formal elements than as story-telling devices (fig. 3). One later critic hoped that "as time goes on, [Harris] will shift the emphasis somewhat from the buildings people inhabit to the people themselves." But he never did.

In terms not only of subject-matter, but also of compositional arrangement, vigour of brushwork and brightness of colour, Harris's 1911 picture was a radical production for a Toronto painter. The composition is self-consciously simple, consisting of three parallel planes arranged vertically within a shallow pictorial space – the brightly lit, leaf-strewn street and sidewalk; the dappled building façades with their rectangular doors, windows and shutters, accented by vertical tree-trunks; and the upper band of entwined fall foliage screening the sky. The overall flatness of the composition, along with Harris's broken brushwork and use of contrasting, complementary colours – greens and reds, and blue and orange – clearly reflects his knowledge of Post-Impressionist European painting.

When it was exhibited at the OSA show in 1912, the 'home' feeling of the painting caught the attention of the editors of *International Studio*, then the most influential English-language journal of contemporary art. They reproduced it in their December edition with an accompanying text: "Painters reveal their nationality in nothing more than in their rendering of the sights of every-day life. *Houses in Richmond Street*, by Mr Lawren Harris, could only have been painted in Toronto." The magazine decreed it one of the finest canvases in the exhibition. From this point forward, Harris's art would be at the forefront of advanced Canadian painting.

In January 1913 Harris travelled with J.E.H. MacDonald, head designer at Toronto's leading commercial art firm, Grip Engraving Ltd. (where also Tom Thomson and future Group of Seven members Arthur Lismer, F.H. Varley and Frank Carmichael worked as graphic artists), to Buffalo, New York, to see a large exhibition of modern Scandinavian painting at the Albright Museum. The show proved a turning point for the two painters. The Nordic landscapes strengthened their desire to create fresh, indigenous solutions to capturing on canvas the look and feel of Canada's similarly rugged, northern geography, free from the pervasive influence of European pastoral landscape traditions. "Except in minor points," MacDonald recalled in 1931, "the pictures might all have been Canadian . . . and we felt, 'This is what we want to do with Canada.'"

Harris and MacDonald were particularly attracted to canvases by Symbolist artists who, in order to convey their subjective responses to the vastness and silence of the Scandinavian wilderness, developed simplified, sweeping landscape compositions, often decoratively arranged and coloured, that suggested transcendental meanings. The mystical character of the vast boreal forest was a subject of keen interest among Symbolists;

3
LAWREN STEWART HARRIS
(1885–1970)
Winter Afternoon, City Street,
Toronto (Sunday Morning)
1918
Oil on canvas
101.8 × 114.2 cm

the outward forms of the wilderness were believed to correspond to higher spiritual realities hidden behind surface appearances. At the turn of the twentieth century, there was a widespread belief in Europe, supported by popular occult religious philosophies such as Theosophy and other mystical belief systems, that an aesthetic and spiritual revival would come from the north. Pristine environments of snow-covered mountains, lakes and forests, all bathed in a clear, crystalline light, strongly evoked a sense of divine immanence, the experience of which, both directly and through art, would, it was believed, excite a more elevated spirituality.

Harris was drawn in particular to the winter landscapes of the Swedish artist Gustav Fjaestad, a Theosophist. In his paintings the boughs of fir trees sag under the weight of snow, their stylized forms shaped into Art Nouveau-inspired designs. Fjaestad's contributions to the Buffalo show also included several wall-hangings, woven from his landscape designs. Often conceived as designs for tapestries, his paintings consequently tended to take on a flattened, decorative quality that appealed to the painter of *Houses, Richmond Street*. To suggest the sparkle of snow and frost crystals the Swedish artist employed small dabs and stitches of pastel pigments, a technique that also caught Harris's attention. In response to Fjaestad's winter scenes, beginning in 1914, and in tandem with his

Lawren Stewart Harris

4
LAWREN STEWART HARRIS
(1885–1970)
Winter Woods
1915
Oil on canvas
119.6 × 127.7 cm

increasingly decoratively designed urban scenes, Harris inaugurated
a four-year-long series of stylized snow pictures. *Winter Woods* (fig. 4),
executed in 1915, is one of these, once again, like *Houses, Richmond Street*,
almost square. Again like others in the series, the vantage point of
Winter Woods is low, the subject viewed frontally, and the composition
comprised of receding planes. All these snow pictures were very con-
ceptual productions, studiously addressing the abstract problems of
picture design. Yet Harris's large snow pictures were based on studies
mostly made in Toronto's High Park and Rosedale Ravine. *Winter Woods*
was painted in the artist's quarters in the Studio Building, a new three-
story, six-studio structure erected in the Rosedale Ravine near Yonge
Street, which Harris had planned and financed and intended to make the
headquarters of the new nationalist school of landscape art he so ardently
advocated. In January 1914 Thomson, MacDonald and newcomer A.Y.
Jackson from Montreal had moved into the new centre, and Harris had
followed shortly afterwards.

World War I disrupted the new landscape movement just when it was
about to blossom. Harris himself, having enlisted in April 1916, experi-
enced mounting psychological and emotional stress, exacerbated by the

5
LAWREN STEWART HARRIS
(1885–1970)
Falls, Agawa River, 1918
Oil on wood-pulp board
26.8 × 32.3 cm

tragic deaths first of Tom Thomson in Algonquin Park in the summer of 1917 and then of his brother in action in France in March 1918. He greatly admired Thomson's twin masterpieces of 1917, *The West Wind* and *Jack Pine*, and in comparison to these magnificent pictures that so fully expressed the power of the North Harris's own decorative urban and snow compositions may have seemed to him inconsequential, undermining his self-confidence as an artist. His spiritual beliefs seem also to have been undergoing profound changes. The cumulative result of these pressures was a nervous breakdown, and discharge from the army.

To restore his spirits, in May 1918 he travelled by train into Ontario's Algoma wilderness region, just east of Lake Superior, with Dr. James A. MacCallum, a Toronto ophthamologist and a generous early patron of Tom Thomson and the other painters of the nationalist landscape movement. Harris was thrilled by Algoma's scenery, describing it as "a rugged, wild land packed with an amazing variety of subjects . . . a veritable paradise for the creative adventurer in paint." As a result, in the autumn of 1918, he organized a group sketching tour with MacDonald, Carmichael and Frank Johnston – Jackson and Varley were still overseas, and Lismer was teaching in Halifax. The fall trip was to be the first of seven Algoma sketching tours that he arranged and financially assisted.

At Harris's request, the Algoma Central Railway supplied the artists with a freshly painted boxcar that contained bunks, table, chairs and a stove, and served as their travelling campsite and studio on wheels. Attached to the rear of a northbound train, the car was first dropped off at Canyon Station, the northernmost point on the trip, then, on the way south, at sidings at Hubert and Batchewanna. The artists sketched in pairs, using a red canoe and a railroad handcar to reach more distant sites. Discussions and arguments lasted far into the night, ranging, according to Jackson, "from Plato to Picasso, to Madam Blavatsky and Mary Baker Eddy." Harris, a Baptist who later became a Theosophist, and MacDonald, a Presbyterian who was interested in Christian Science, inspired many of the arguments.

Harris's early Algoma oil-sketches are far more spontaneous and direct than his carefully plotted urban and snow studies. There is a sense of immediacy in *Falls, Agawa River* (fig. 5) that recalls the fluid Algonquin sketches of Tom Thomson. In this *plein-air* study, made in the vicinity of Canyon, Harris used broken brushstrokes and white highlights to capture the transient effects of sunlight on moving water at the foot of a waterfall.

In May 1919 Harris, Macdonald and Jackson held a three-man show at the Art Gallery of Toronto devoted solely to works painted the previous year in Algoma. MacDonald entered a total of 38 works, Johnston 56; Harris contributed two large northern-landscape canvases and 45 small oil-sketches from the fall 1918 trip and five from his earlier, springtime visit. No previous Toronto art exhibition had been dedicated completely to

northern wilderness subjects. The exhibition catalogue noted: "The whole collection may be taken as an evidence that Canadian artists generally are interested in the discovery of their own country." A supportive journalist linked the artists to the acclaimed poets of the late nineteenth-century Canadian school of nature poetry: "What [Archibald] Lampman and [Charles D.G.] Roberts, [Wilfred] Campbell and Bliss Carman said in poetry is now being expressed by art. And many of the finest things can never be said in words. The remoteness of the northern wilds, the dignity of the forest, the splendor of evening raptures are more adequately portrayed by paint than by poetry." In the painters' works, he continued, "the spirit of Canada has found itself It is not ostentatious. It is highly intellectual and poetic."

In mid September 1919 Harris organized a second 'boxcar' trip to Algoma. Jackson joined the others and they revived the fraternal spirit of the pre-war years, renewing their commitment to depicting the Canadian wilderness in strong colours and bold, simplified designs. It was probably during this sojourn that the idea arose of founding the Group of Seven as an association of like-minded artists exhibiting separately from the OSA. For Harris, the rugged and diversified Algoma landscape was a magnificent laboratory in which to experiment artistically. In a number of small studies he depicted the forest close up as a dense wall of tree trunks, its surface splashed with bright fall foliage. In others he pictured rocky cliffs and waterfalls in flattened, static designs, or painted stands of trees, often seen across water, their forms starkly silhouetted against the sky or background (figs. 6, 7). He also tackled problems posed by rapids and running

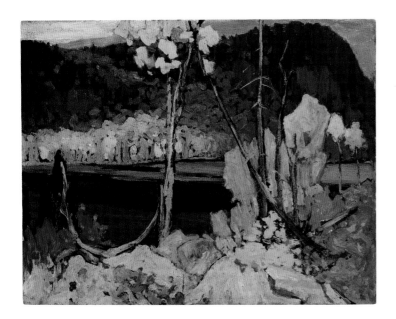

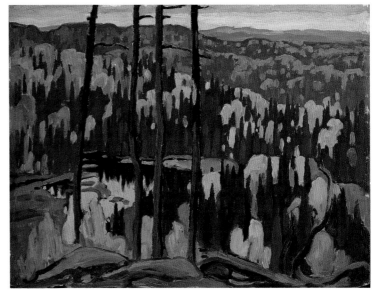

8
LAWREN STEWART HARRIS
(1885–1970)
Above Lake Superior, 1919
Oil on wood-pulp board
26.7 × 35 cm

9
LAWREN STEWART HARRIS
(1885–1970)
Island, Lake Superior, *c.* 1921
Oil on paperboard
30.3 × 38 cm

streams, but with less success than MacDonald, who excelled at such subjects. Above all he learnt radically to simplify wilderness forms, for, as F.B. Housser was to write in his landmark early history of the Group of Seven, *A Canadian Art Movement* (1926), the very prodigality of the Algoma landscape demanded a "greater summarization and simpler handling Form was organized to meet design. Broken rhythms in nature were connected and modified."

Before they returned to Toronto from their fall 1921 Algoma trip, Jackson and Harris travelled west by train along the north shore of Lake Superior to Rossport, where they remained for several days. While Harris made only two small oil-sketches at Rossport, the physical and affective qualities of the rockbound scenery along the North Shore deeply and indelibly impressed him, more so than the "half revealed" view from Canyon. As Jackson later put it: "The Algoma country was too opulent for Harris; he wanted something bare and stark." The Lake Superior landscape fully satisfied him. Forest fires had stripped the region of its mixed forests, leaving behind fire-blackened stumps and trunks, and, reduced to essential forms by successive ice ages, the ancient rockbound terrain of the Canadian Shield seemed to exist outside time. That indwelling sense of eternity captivated Harris and drew him back to sketch along the shore for the next eight years.

Harris's first North Shore masterpiece, *Above Lake Superior* in the Art Gallery of Ontario, based on a 1919 sketch in the Thomson Collection (fig. 8), was one of two Lake Superior scenes by Harris included in the May 1922 Group of Seven exhibition. It marked a new and decisive chapter in his

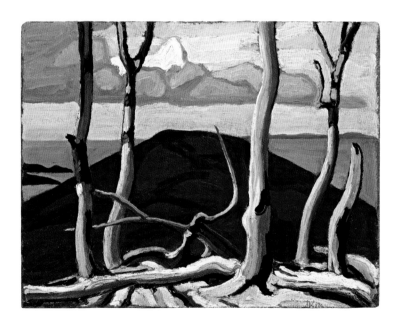

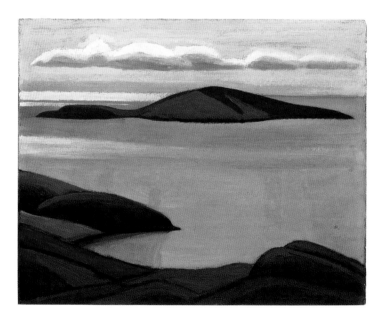

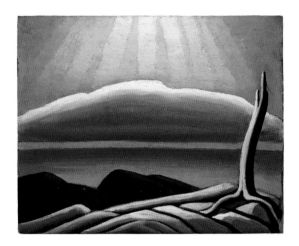

10
LAWREN STEWART HARRIS
(1885–1970)
Lake Superior Sketch XIII, c. 1926
Oil on paperboard
30.1 × 38 cm

oeuvre. In comparison to his previous pictures, the colours were greatly reduced in range and intensity, and, instead of vigorous brushstrokes, the surface was smooth and evenly painted. Indeed, all descriptive details and transient effects were suppressed, resulting in an abstracted, impersonal depiction that appealed not so much to the senses as to the mind's eye (figs. 9, 10). In his 1926 narrative Housser underscored that fact: "There is that in it which lifts it out of the moulds of art *qua* art into the realm of rare experience . . . a mystical experience which few who have seen the canvas will have shared."

Many viewers, however, were baffled, even angered, by *Above Lake Superior*. Its sculptural qualities and unearthly mood did not conform to their preconceptions of art. The Group of Seven's chief antagonist, the critic Hector Charlesworth, declared that it displayed "the morbid, sinister qualities one finds in the drawings of William Blake, with its uncanny arrangements of stripped dead trees set against a sullen background." But, as Housser was further to explain, "Harris is a modern mystic who has attempted to express through painting, moods reached though mystical experience as William Blake did The uglinesses of *Above Lake Superior* are beautiful and its lonely austerity, peace." Adverse reactions to it, he argued, were the result of "our own inner bleakness that hates, the finite part of us that dares not meet the infinite unfathomable thing – the wilderness." Housser, one of the artist's oldest friends, was a dedicated Theosophist. By 1922 so was Harris. Indeed, from this date forward, his art can best be understood and interpreted within the context of that philosophical-religious movement. "You cannot sever the philosophy of the artist from his work . . .", Harris later cautioned. "Without the philosophy, or in other words, the man, in the work of any great artist you have nothing." Although Theosophy's popularity and influence waned in the 1930s, Harris remained steadfastly committed to its teachings for the remainder of his life. During his last years he believed he was the reincarnation of one of the Society's founders, William Q. Judge.

For Theosophists, the entire planetary universe was alive and interconnected, composed of 'spirit matter' emanating from God. As an objective reality, solid matter – the corporeal forms of nature – was a "great illusion." The only true 'reality' was a formless, invisible one, a higher truth, located behind yet corresponding analogically to outward appearances. The Theosophical artist was creatively empowered to look through the surface of nature and 'see' an image of that otherwise concealed reality. Admittedly, the artist could not reproduce in paint the richness of that mystical vision, but he believed his picture could play a significant role in influencing mankind's spiritual development. Typically, early twentieth-century artists influenced by Theosophy – painters such as Vasily Kandinsky, Piet Mondrian and Kazimir Malevich – turned to non-objective or abstract means of expression to represent that higher, non-material reality. It

11
LAWREN STEWART HARRIS
(1885–1970)
Lake Superior, undated
Oil on canvas
111.8 × 126.9 cm

would not be until early 1936 that Harris, too, finally relinquished the wilderness landscape as the vehicle of his creative and spiritual expression and committed himself to purely abstract forms. Up to that point his vision had been split, one eye focused on nature, the other attuned to the hidden meanings behind its surface.

Lake Superior (fig. 11) is a landscape composition that deliberately gives form to Harris's Theosophical beliefs. Based on a 1925 sketchbook drawing and a small oil-on-board study, it depicts crepuscular bands of sunlight – so-called 'God's rays' – breaking out from a dramatic pattern of clouds over the lake, illuminating the waters and several purple-toned islands. An unnatural composition in appearance, it was doubtless based on real experience, for such crepuscular rays are commonplace phenomena. Yet the melodramatic character and grouping of the painted lines of light appear to have been reworked at a later date to emphasize its occult character. The three golden rays on the right probably symbolize Theosophy's upper level

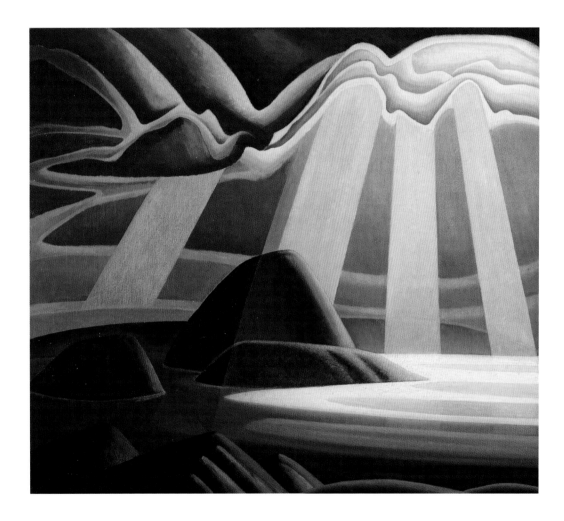

Lawren Stewart Harris

12
LAWREN STEWART HARRIS
(1885–1970)
Lake Superior III, *c.* 1923–24
Oil on canvas
102.5 × 127.6 cm

of immortal consciousness, while the single band of white luminosity probably represents the Ray from the Absolute Being – the white light of pure divinity that inaugurated the universe. The golden rays strike the landscape, but the white ray appears to shed its light on another world, seemingly behind the physical horizon.

Unlike many of Harris's other North Shore canvases, *Lake Superior III* (fig. 12) is devoid of foreground tree-trunks, thick cloud formations and dramatic effects of streaming light. From the narrow shoreline, composed of elongated, sculptural landforms that fold into one another, a smooth rocky headland extends diagonally out into the lake toward the left. The real subject and pictorial focus of the picture is the glowing, unnatural light – the manifestation of spirit life – that emanates from an unseen point outside the picture's left hand edge, illuminating the surface of the lake, highlighting the swelling landforms and whitening the edges of the grey clouds. The pervasive blue tonality of sky and water clearly, yet mystically, expresses 'religious' feeling.

Lake Superior III was first exhibited in the 1928 Group of Seven exhibition as part of a series of Lake Superior paintings simply titled I through V. Hector Charlesworth wrote about Harris's works on view: "Einstein seems to have had a hand in some of them; they suggest the fourth dimension as a reality Space and time to Harris are the mother of color and form. He could explain this religiously. I might call it transcendentalism; others

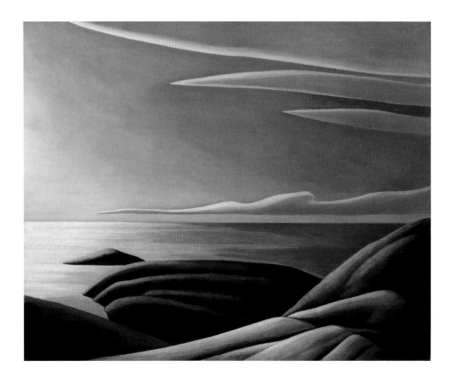

13
LAWREN STEWART HARRIS
(1885–1970)
Untitled Mountain Landscape
c. 1927–28
Oil on canvas
122.3 × 152.7 cm

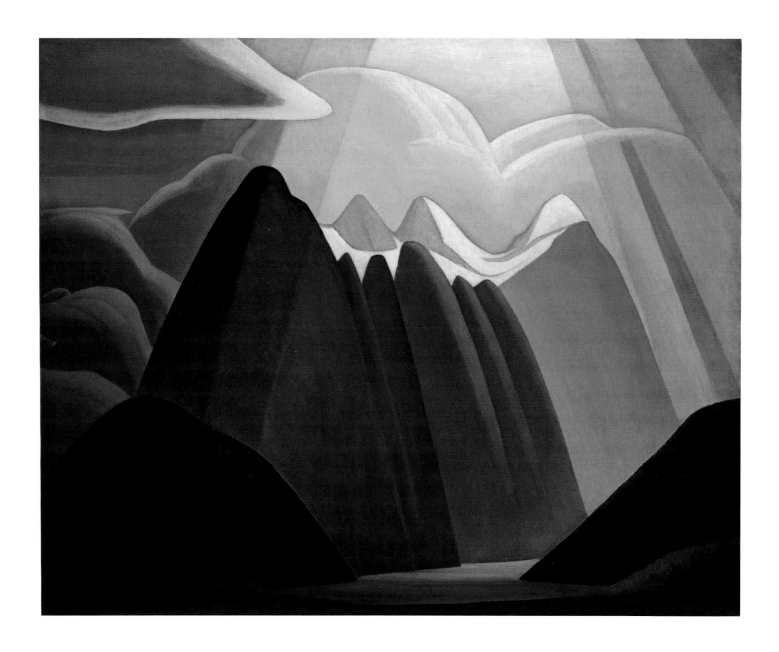

– bunk. But it is all despairingly beautiful and inhuman." He went on to declare that Harris's canvases "negated faith" in anything but "what the painter thinks his soul feels like when he paints." Another writer described Harris's mystical artistic vision on display as "the world as it was and will be . . . regarded in the light of eternity. Here the soul of man may become one with the Everlasting His works should be contemplated in silence and immobility; only thus do they become comprehensible."

In 1924 Harris and his family went on a two-month summer vacation to Jasper Park in the Canadian Rockies. Initially Harris was disappointed: the Rockies did not live up to his preconceptions of their advertised natural beauty. But as he returned annually to sketch amidst them for the next four years, he discovered an inestimable "power and majesty and wealth of experience at nature's summit." In the 1925 Group of Seven show Harris exhibited a total of five of his new mountain canvases. The highly abstracted landscape compositions – among the most cerebral and remote in expression he yet had painted – dominated the show. A reviewer described one of them as "pure form." Another, however, was struck by their overall sublimity: "I felt as if the Canadian soul were unveiling to me something secret and high and beautiful which I had never guessed – a strength and self-reliance and depth and a mysticism I had not suspected."

Untitled Mountain Landscape, also known as *Mountain Painting IX* (fig. 13), is an archetype of the Rockies, not an identifiable peak. Since its composition generally resembles *Lake and Mountains* in the Art Gallery of Ontario, it was possibly painted 1927–28. As in some of his Lake Superior canvases, Harris isolates wide rays of light streaming down on the painted scene as his primary subject. Atop the mountain, whose vertical folds reach upwards and converge, a snow-filled bowl acts as a luminous receptacle for the flooding divine spirit. The brilliant flow evokes the biblical injunction: "And God said, 'Let there be light'; and there was light" (Genesis 1: 3). However, many viewers intensely disliked the lack of realism and the emotional coldness of Harris's mountain canvases. By contrast, the Rocky Mountain paintings of MacDonald and Varley were far more emotionally accessible and aesthetically satisfying. Yet Harris's bold abstractions of form had created a wider stir. In 1927 a reporter noted: "People here from Europe crave admission to his studio."

Harris made hundreds of pencil drawings as he hiked and sketched in the Rockies. From such on-the-spot sketches he subsequently painted oil-on-board studies, some of which he selected to be developed into large canvases. Based on a specific drawing, the oil sketch *Mount Robson, from the South East* (fig. 14) dates from 1929 and is the preliminary design for one of Harris's most realistic Rocky Mountain canvases, *Mount Robson* in the McMichael Canadian Collection. A monumental composition, the latter is a skilful and satisfying arrangement of abstracted natural forms rising to a majestic triangular point – the highest in the Rockies. Harris was deeply

14
LAWREN STEWART HARRIS
(1885–1970)
Mount Robson, from the South East, 1929
Oil on paperboard
30.3 × 37.9 cm

15
LAWREN STEWART HARRIS
(1885–1970)
Mountains in Snow: Rocky Mountain Painting VII
c. 1929
Oil on canvas
131.3 × 147.4 cm

impressed by the physical grandeur of towering Mount Robson. The sketch was one in a series of six oil studies of the landmark he made from different points of the compass which, together with morning and evening views from the glacier-fed Berg Lake, he exhibited as a group in the 1930 OSA *Little Pictures* show. It was a favourite work, owned by Bess Housser Harris until her death.

Another oil-on-board study in the Thomson Collection, *Mountain Sketch LXV*, was the basis for a large and impressive canvas dating from 1929–30, *Mountains in Snow: Rocky Mountain Painting VII* (fig. 15). In the final composition Harris altered the forms and shapes of the small study; the gleaming summit is more attenuated, rising higher and more dramatically. The pure white form of the peak is silhouetted against the pale azure of the sky that theosophically symbolizes 'self-renunciation and union with the divine.' The entire compositional arrangement might be interpreted as Harris's pictorial 'thought-form' emblematic of man's arduous path of spiritual ascent. The pilgrim's demanding journey upwards is symbolized by the jagged, geological massing on the shoulder of the mountain as it rises toward the white peak that soars effortlessly skywards.

Mountains in Snow incorporates the age-old sacred triangle, a symbolic shape central to Theosophy's mystical geometry. In fact, the luminous

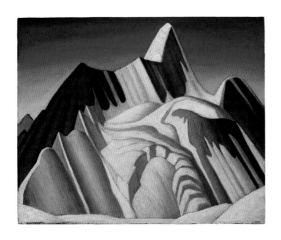

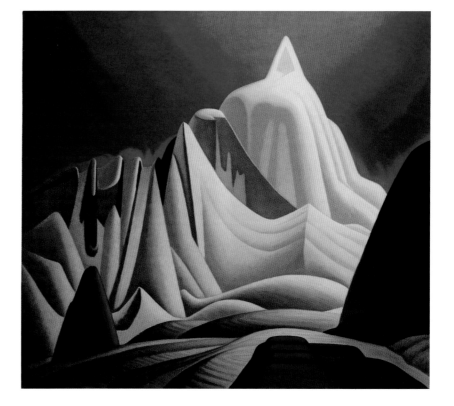

Lawren Stewart Harris

mountaintop is a dual triangle, for it incorporates a smaller, shadowed triangle within it – a prefiguring 'astral' design for the larger one. In the left foreground, a dark triangular rockform likewise analogically mirrors the bright peak, but on the lower, physical plane of existence. Given the unnatural character of Harris's representation, the composition lends itself to symbolic interpretation. Among other esoteric meanings, the three-sided figure of the mountaintop represents the triad of man's eternal higher self – the Sanskrit trinity of *atma-buddhi-manas* – or the immortal union of the spirit, soul and higher mind that alone was subject to reincarnation. A triangle of pure light also signified the very highest, unknowable plane of divine consciousness. The emblem of the Theosophical Society was composed of two intertwined, contrasting triangles, a white, upright one representing 'concealed spiritual wisdom' and a black one, facing downwards, signifying 'revealed material wisdom.' Harris was intimately familiar with esoteric meanings of geometrical figures. As he himself later wrote, "In some Eastern teachings the symbols contain the whole of the philosophy; there is the square, and the triangle with the apex pointing upwards – the four lower principles and the triad of divine principles together symbolizing the sevenfold man, the microcosm, and the sevenfold cosmos, the macrocosm Symbolism offers us a key to the meaning and purpose of life."

In the Group of Seven's fifth exhibition in 1928, among his fourteen canvases Harris included two oddly titled paintings, *Design for a Chapel* and *A Fantasy*. For decades it was assumed that these pictures, probably dating from 1927, were lost or destroyed. However, they have recently been rediscovered and can be identified as *Figure with Rays of Light* (fig. 16) and *Abstract Painting* (private collection), Harris's most 'unearthly' compositions to date. *A Fantasy* depicts rays of light bursting out from behind a looming, organic abstract form on the right and illuminating an odd sculptural arrangement of massed ovoid shapes. One prominent ray cuts across these rounded forms and is itself bifurcated by a translucent, knife-like blade into two colours – green and blue – likely signifying Theosophy's two-part 'mental' plane in which blue-toned consciousness begins its ascent from the physical to the spiritual level. What is particularly striking is the purely abstract nature of the forms – the first to appear in Harris's work.

There were two probable sources of direct influence on Harris's move away from representation in these compositions – the metaphysical abstractions of Bertram Brooker, a friend of Harris who had exhibited his avant-garde compositions at the Arts & Letters Club, Toronto, in January 1927, and the revolutionary travelling exhibition, *International Exhibition of Modern Art*, held at the Art Gallery of Toronto later in April. Works by Kandinsky, Mondrian, Duchamp and El Lizzitsky, and 101 other artists from twenty-three countries, were on view. Harris himself had pushed hard to bring the show to Toronto and to explain abstraction to gallery goers.

16
LAWREN STEWART HARRIS
(1885–1970)
Figure with Rays of Light, *c.* 1927
Oil on canvas
121.9 × 152.4 cm

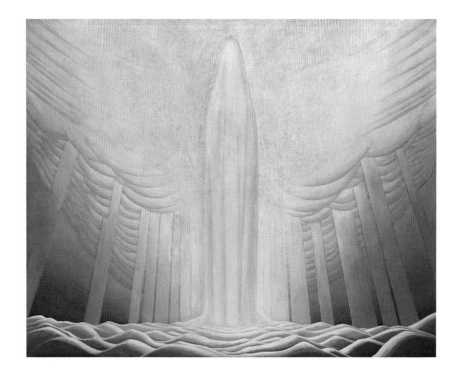

Figure with Rays of Light is less abstract in subject than *A Fantasy*, but equally supernatural in meaning. A strong vertical shape, figural in character, rises up out of a low sea of rippling forms, suggestive of a vision above a ceiling of clouds. Like the great vertical tree trunk in Harris's Lake Superior masterwork, *North Shore, Lake Superior* (1926) in the National Gallery of Canada, to which it is formally and metaphysically related, the ghostly central 'figure' reaches almost the full height of the picture. But instead of being transfigured by focused bands of light from on high as in the earlier painting, the spectral shape is itself light-filled and radiant. Moreover, it is seen against an extraordinary background composed of streaking shafts of occult 'life essence' that break out of a massive burst of cloudlike energy whose echoing, sculptural forms recede into infinite blue space. As Harris admonished, the viewer is not to ask what it means, but what experience it contains.

In all likelihood, that 'experience' is the ecstatic expansion of cosmic consciousness on the 'fourth dimensional,' Buddhic plane. Harris had a test for great art: "Does it move us toward ecstasy?" If so, then that ecstasy convinces that "we can and must become gods In us can glow the transmuting flame of eternal life." If the exhibition title of the picture was a *Design for a Chapel*, then its likely architectural context, along with *A Fantasy*, was the Theosophical lodge that Harris attended. In 1922 and 1923, and again in 1925, Harris was a member of its decorating committee.

17
LAWREN STEWART HARRIS
(1885–1970)
Baffin Island Mountains, *c.* 1931
Oil on canvas
101.6 × 127.2 cm

On August 1, 1930 Harris and Jackson boarded the Arctic supply ship *Boethic* for a two-month voyage north along the rocky eastern coasts of Baffin and Ellesmere Islands as far as the Kane Basin, off the north-west coast of Greenland. It was to be the culmination of Harris's exploration of Canada's landscape. It was also an escape from the gloom of the Depression. The artists had difficulty making pencil sketches on deck, since the most exciting subjects were encountered while steaming through rockbound channels or bumping up against the treacherous pack-ice. Moreover, they encountered much fog, even a fierce storm that Harris captured on movie film. However, at several stops, including Pangnirtung and Pim Island, they made excursions on shore to sketch at greater leisure. Back in their cabin, with only a porthole for light, the artists worked up oil-on-board studies from their drawings while seated on the edge of their bunks. In all, Harris prepared some fifty small oils, among the most abstracted of his landscapes.

In December 1930 the painters held an exhibition of their Arctic pictures at the National Gallery in Ottawa and the following May Toronto audiences were treated to a show at the Art Gallery, *Arctic Paintings by Lawren Harris and A.Y. Jackson*, in which Harris displayed six large canvases and thirty-two oil sketches – a remarkable output. In December 1931, the Group of Seven held its final exhibition. Out of fifteen large canvases Harris submitted, seven were new Arctic subjects, including *Baffin Island Mountains* (fig. 17).

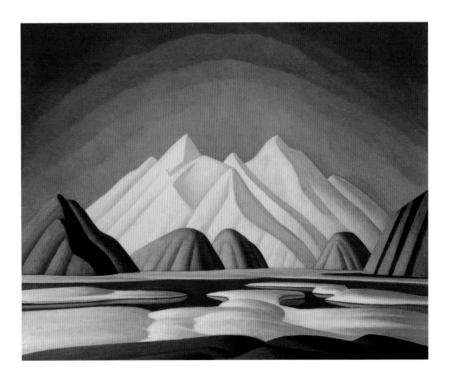

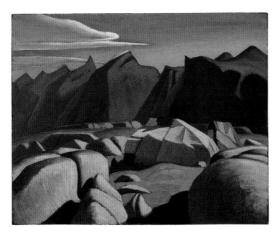

18
LAWREN STEWART HARRIS
(1885–1970)
**Eskimo Tents, Pangnirtung,
Baffin Island**
c. 1930
Oil on wood-pulp board
30.3 × 37.9 cm

In its harmonized interrelationships of form and colour, the calm, symmetrical composition of *Baffin Island Mountains* represented pictorially what Harris termed "the epitome of the cosmic order . . . [its] many parts, factors, phases, and meanings functioning together as one living whole." Just beyond a narrow, rocky foreground, undulating shapes of pack ice appear to float lazily across open blue waters toward abstracted, sunlit shoreline mountains. Occupying the centre of the composition, a series of triangular, snow-covered mountain forms in the distance converge toward twin peaks. Above the white mountains, in a cloudless sky, a series of painted blue bands expand outwards and upward, their tonality ranging from pale azure to deep blue, emblematic of transcendent religious feeling.

In the Arctic Harris came face to face with the ultimate, polar North, the locus for what he believed was "a flow of beneficent cosmic power behind the bleakness and barrenness and austerity of much of the land." Because of their proximity to the Arctic, Canadians, he asserted, had a special role to play in the spiritual evolution of humanity. In a 1926 essay, 'Revelation of Art in Canada,' published in *Canadian Theosophist,* he had written: "We are on the fringe of the great North and its living whiteness, its loneliness and replenishment, its resignations and release, its call and answer – its cleansing rhythms. It seems that the top of the continent is a source of spiritual flow that will even shed clarity into the growing race of America, and we Canadians, being closest to this source[,] seem destined to produce an art somewhat different than our Southern fellows – an art more spacious, of a greater living quiet, perhaps of a certain conviction of eternal values. We are not placed between the Southern teeming of men and the ample, replenishing North for nothing."

Harris's notion of race is tied to its theosophical meanings. He believed that, because of its newness, the emerging 'race' of America – the fifth of seven cosmically evolving races – was more spiritually advanced than that of Europe. As a separate people within that new dispensation, Canadians, with their greater "clarity," could lighten the "heavy psychic blanket" that lay over their neighbours and thus assist their evolution. *Baffin Island Mountains* can thus be considered not only one of Harris's most attractive and impressive Arctic canvases but a revelation of Canadians' geographically influenced destiny.

While he was working up canvases from his Arctic studies (fig. 18), Harris wrote to the artist Emily Carr in Vancouver, revealing he was not wholly confident in his creative powers: "I'm painting some of the Arctic things – not bad – but nothing to usher the soul into eternal bliss. I am striving but also not realizing I'm trying to get to the summit of my soul and work from there – there where the universe sings." By the summer of 1931 he had entered a paralysing period of personal crisis and virtually stopped painting. Writing to Emily Carr again in 1933, the year the Group of Seven dissolved and the larger Canadian Group of Painters was established (Harris was

elected president, Housser secretary), the anguished painter admitted: "Haven't painted for ages [;] it seems my painting days are over.... Occasionally I get a flicker of an idea then it fades or sufficient enthusiasm is lacking, and there we are. I am at a crossroads [;] really have as yet no vision to know what to do; what road to take. But my O my, I am anxious to be on my way and that is trying when one doesn't know the way."

In June 1934 the road ahead suddenly opened up. Fred Housser separated from his wife Bess and Harris, who had been in love with her for some time, left his own wife and family. The following month the two drove from Toronto to Reno, Nevada, where they divorced their respective spouses and married. Toronto society was scandalized. As a result, the couple remained in the United States until 1940, when they moved to Vancouver. While living in Santa Fe, New Mexico, in 1939 Harris had been a founding member of the non-objective Transcendental Painting Group, whose manifesto stated the artists' shared intention to "carry painting beyond the appearance of the physical world through new concepts of space, color, light and design to imaginative realms that are idealistic and spiritual."

From 1936 until his death in 1970 Harris continued to seek to express higher truth exclusively through painting abstract compositions. Unconnected to mainstream schools of modern art, but rather to occult ideas and personal aesthetics, Harris's idiosyncratic, non-representational work never found favour with the Canadian public. It remained an art of the spiritual, its true meanings only accessible to the artist and to other mystics. His urban scenes and wilderness landscapes of the period 1908–30, however, were to remain essential icons of national identity, even if the symbolic significance of those painted from 1922 to 1931 is not as fully understood today as at the time they were created.

FURTHER READING

Jeremy Adamson, *Lawren S. Harris: Urban Scenes and Wilderness Landscapes, 1906–1930* (Toronto: Art Gallery of Ontario, 1978)

Ann Davis, *The Logic of Ecstasy: Canadian Mystical Painting, 1920–1940* (Toronto: University of Toronto Press, 1992)

Bess Harris and R.G.P. Colgrove, *Lawren Harris* (Toronto: Macmillan of Canada, 1969)

F.B. Housser, *A Canadian Art Movement: The Story of the Group of Seven* (Toronto: Macmillan of Canada, 1926)

Christopher Jackson, *North by West: The Arctic and Rocky Mountain Paintings of Lawren Harris, 1924–1931* (Calgary: Glendon-Alberta Institute, 1991)

Peter Larisey, *Light for a Cold Land. Lawren Harris' Work and Life – An Interpretation* (Toronto and Oxford: Dundurn Press, 1993)

Roy Mitchell, *Theosophic Study*: http://www.theosophical.ca/TheosophicStudy/RM.html

Joan Murray and Robert Fulford, *The Beginnings of Vision: The Drawings of Lawren Stewart Harris* (Toronto: Douglas & McIntyre in association with Mira Godard Editions [c. 1982])

Roald Nasgaard, *The Mystic North: Symbolist Landscape Painting in Northern Europe and North America, 1890–1940* (Toronto: University of Toronto Press, 1984)

Dennis Reid, *Atma-Buddhi-Manas: The Later Work of Lawren Harris* (Toronto: Art Gallery of Ontario, 1985)

J.E.H. MacDonald

"… for if there is any country fitted to inspire the noblest art, it is our own …"

SHIRLEY L. THOMSON

Arriving in Canada at the age of fourteen in 1887, twenty years after Confederation and at a time of provincial wrangling and regional expansion, J.E.H. MacDonald (1873–1932) lived through stirring times in the country's development. He died in 1932, when his art and that of his colleagues in the Group of Seven had achieved a measure of recognition and acceptance, displacing traditional artists such as Horatio Walker and Homer Watson. He was a man of the Empire, a citizen of the Dominion, believing in the Canadian thrust towards independence within the imperial Commonwealth. His disapproval, frequently noted throughout his writings, of the stilted compendium of values imported from the United Kingdom and Europe was directed towards the taste of those wealthy patrons in Toronto and Montreal who purchased only gentle pastoral visions of the Barbizon or Hague School artists.

At the same time, as indicated in the numerous lectures and presentations he prepared for his students and the members of the Arts & Letters Club in Toronto, MacDonald was well grounded in the history of European art, holding in special honour the art of John Constable, William Morris and the Arts and Crafts movement. Nor was he unaware of the current trends in European painting, citing, though in a gently belittling tone, artistic movements such as Post-Impressionism, Expressionism and Surrealism. His teaching notes reveal his understanding of design and composition, an insight reinforced by his work at Grip Engraving Ltd., a printing firm that he first joined in 1894. His experience there enabled him to guide his students for over a decade at the Ontario College of Art, where he was successively Professor and Principal.

Animated by his sense of the importance of art in the daily life of 'everyman' and that the appreciation of art was the birthright of every citizen, it is little wonder he became an enthusiastic devotee of the throbbing poetry and populist ideas of Walt Whitman. Equally engrained in his mind were the thoughts heralding the experience of the individual and the possibility of a higher spiritual life derived from the transcendental constructs of Ralph Waldo Emerson and Henry David Thoreau. (His only son bore the name Thoreau.) MacDonald's literary skills, amply revealed in numerous essays, lecture notes, letters, diaries, poetry and scraps of ideas hurriedly jotted on bits of paper, suggest a rich interior life that found expression in his paintings.

He did, however, have to earn a living, and he did so partly in the field of commercial art. MacDonald produced numerous brochures and posters for a number of industries, from Canadian Steamship Lines to Canadian Pacific Railway hotels and real estate interests in the greater Toronto area. In describing the many motifs worthy of the artist's eye in his essay 'The Canadian Spirit in Art,' published in *The Statesman* in March 1919, he lauds the expansion of new choices of subject-matter such as "the gas tank district and the railroad yard … conveying the rough sense of dignity and

1

J.E.H. MacDONALD
(1873–1932)
Trucks and Traffic, 1912
Oil on paperboard
11.6 × 15.3 cm

generosity which the aspect of the country provides." Yet the sketch *Trucks and Traffic*, 1912 (fig. 1), a nocturne in the vein of James McNeill Whistler, is one of the few urban industrial subjects the artist explored in paint, and was realized with his associate, Lawren Harris, who revelled in depicting the hitherto neglected cityscape of Toronto. The rich velvety blacks often associated with Manet may well reflect MacDonald's experience on the printing floor of Grip. It is a sensuous sketch with a rich and fluid application of black paint on the hulking forms emerging from the shadowy greys of the night, the whole graced by startling touches of pink above the horizon line

In August 1914 MacDonald and Harris travelled to the Gatineau River and Cascades just north of Ottawa. *Gatineau River near Cascades* (fig. 2) propels the viewer into the drama of the crashing logs, trapped by the jagged rocks, during their reckless descent down the river. The scene was a common one in the region. Logging and the attendant industry of pulp and paper production, serviced by the hydroelectric power of these rivers, was a major source of economic activity in the Ottawa/Gatineau region until the mid twentieth century. MacDonald had already shown interest in logging scenes in the small canvas *By the River, Early Spring*, 1911, and had painted loggers at work in 1913. In the Gatineau sketch he was obviously intrigued by the movement of the timber hurtling against the crystalline limestone formation of the river bed. Added to the visual drama was the iridescent flow of water, constantly changing in plasticity and colour as it surged over the intransigent shapes.

Despite the motif of such vigour and elemental force, MacDonald's palette typically shows a delicate range – from the rich dusky purple of the rocks grounded by a deep chocolate brown to the pale pink of the jammed logs on the rocks beneath an overhang of dense and dark evergreens. The intense build-up of compositional force is enhanced by the deft application of deep red with a touch of yellow on three logs that underline the triangular force of the middle ground.

Of a very different character and devoid of human industry is *Fair Weather, Georgian Bay*, 1913 (fig. 3), which, exhibited at the Ontario Society of Artists 1913 show, was dismissed as "nothing remarkable in composition" and, laconically, as a picture of "color, mood, and the feeling of clarity and ozone" – even if the same critics admitted that MacDonald, along with Lawren Harris, were recognized amongst the younger artists as possessing outstanding talent. By this point MacDonald had left Grip at the urging of Harris to try his hand as a full-time artist.

The sky is the real subject of *Fair Weather, Georgian Bay*. As MacDonald remarked in his teaching notes, "Let there be light. Generally speaking, put your sky in first." The waters of the bay expressed in strong parallel strokes, suggesting the flickering light of the sun on the gentle ripples of the surface, lead to the briefly described horizon line of dark green trees

J.E.H. MacDonald

2
J.E.H. MacDONALD
(1873–1932)
Gatineau River near Cascades
1914
Oil on composite wood-pulp board
20.3 × 25.4 cm

fronted by an irregular strip of beach. Upon this structure lies the luminous sky of cerulean blue subtly highlighted by light swathes of pink and soft grey. The vast calmness is emphasized by the lie of clouds drifting low along the horizon and punctuated towards the zenith by fluffy cumulus in a zigzag pattern to the upper right of the canvas. The work exudes a classical stillness in the controlled panoramic regression from the foreground to the middle-ground to the sky. Only the picnickers, perched on the sun-bleached triangle of rock at the base of the painting in a Watteau-like flourish, reminiscent of the actors on the island of Cythera, interrupt the minimal stillness, yet they serve to emphasize the vastness of the beneficent, sheltering sky.

The comment "color, mood . . . ozone" was possibly dismissive, yet the quest for these very qualities is not unfamiliar for the travellers of today to the natural surroundings of Georgian Bay. Old mahogany outboards, lovingly restored, cruise through the channels around the many islands bearing the ruins of large early twentieth-century hotels and inns now converted into tennis and canoe clubs for day-trippers or cottagers. While a certain cynicism may exist about the purity of the scene, there is still the anticipation that the sight of the granite cliffs lining the voyageur's route, the blue waters, the beaver dams, and the tangled underbrush of the roadside swamps will calm the harried soul if only for the brief span of time in a rented canoe on the bay or a summer campfire on the outer rocks.

3
J.E.H. MacDONALD
(1873–1932)
Fair Weather, Georgian Bay
1913
Oil on canvas
98.6 × 143.7 cm

There could hardly be a starker contrast to this vast and classic panorama of a peaceful expanse of nature than *A Rapid in the North*, 1913 (fig. 4), which depicts rapids on the Magnetawan River that flows into Georgian Bay in the Parry Sound District in Northern Ontario. MacDonald concentrates nature in one powerful snapshot – in the swiftly flowing river constrained in an explosive burst over mottled rocks, within a V in the centre of the painting. The deep blue of the rushing waters is transformed into lacy ripples of white as it froths over the rocks. Dense foliage in the upper part of the painting frames the smoothly eroded rocks that direct the flow of water. Amazing touches of pink, in the palest hue, add a glow to the adamant surfaces. A surprising note is the repetition of pink splotches on the outgrowth of rocks on the lower left. Perhaps the colour scheme is not so surprising, however, given the precision of MacDonald's observations of

J.E.H. MacDONALD
(1873–1932)
A Rapid in the North, 1913
Oil on canvas
51.1 × 71.2 cm

the complex range of colours buried in nature – in the eroded limestone of the river bed, the composite rocks of ferrous oxide with tones of ochre red to jet black, the reddish brown of the hematite, and especially the garnet encrustations of dark pinks and reds.

A Rapid in the North was one of eight paintings that MacDonald exhibited at the MacDowell Club in New York in March 1913. In January of that year, he had travelled with Harris to Buffalo to see the exhibition of Scandinavian art being held there. The impact of the show on the two artists was immense, for it confirmed to both that they were not solitary practitioners of a vigorous landscape style. As MacDonald later wrote, "I merely wish to suggest that we have our feet on Canadian earth and live in the Canadian sun and that art begins at home. I think I still feel about the Scandinavians that this is what we want to do with Canada As artists we would do what we can to pass on that apprehensible Canadian world of ours to you. These northern brothers seem near to us, but the incomprehensible unites with the whole and perhaps, I may say without preaching, that the great benefit of these art studies we are making is to join us all equally in the contemplation of something larger than our little selves."

In January 1914 MacDonald moved into the Studio Building in Toronto, intended to house the new school of Canadian painters of Canada, and undoubtedly benefited from the fruitful interaction of its artistic community. In the fall of 1915, he, Tom Thomson and Arthur Lismer collaborated on a series of mural paintings for their patron Dr. James MacCallum at Go-Home Bay. He exhibited with the Ontario Society of Artists, in March 1916, *The Tangled Garden*, a painting that at the time gave rise to a wave of vitriolic debate between the defenders of 'modernism' and the traditional critics and connoisseurs, and today is one of the icons of the history of art in Canada. In the substantial literature on this particular literary and artistic skirmish, one retort by MacDonald to the press in 1916 is as relevant today as it was then: "If the function of the artist is to see, the first duty of the critic is to understand what the artist saw *Tangled Gardens* . . . *Elements* and a host more, are but items in a big idea, the spirit of our native land."

In spite of the oppressive pall of World War I, with the attendant reduction of monies for public and private purchase of art as well as for commercial design and the recurring bouts of ill health by which he was prevented from war service, MacDonald, nevertheless, continued his artistic practice, sometimes directed towards patriotic causes, and taught in various capacities. Partly inspired by the Canadian contribution to the war effort, MacDonald gave a talk in 1918 on 'The Spirit of Canadian Art' in which he contrasted the "raw, youthful plainness of Canada to the overblown beauty of the recognized art countries." He detected the glimmer of a "distinctive Canadian expression," an expression intensified by his observation, "We have been drawn towards perfection by the suffering of war," a comment worthy of any line by W.B.Yeats or Rupert Brooke. As deeply as he had been affected by the anguish of conflict, the mysterious death of Tom Thomson in Algonquin Park in 1917 heightened his distress, for he had developed a deep and thoughtful relationship with the younger artist.

Flower Border, Usher Farm, York Mills (fig. 5), painted at his new abode at York Mills, north of Toronto, in 1918, evokes comparison with *The Tangled Garden* and *Garden Thornhill*, 1929–30 (fig. 6), in the explosion of its centrally located pure colour. It lacks, however, dominant elements such as the sunflower and the barn boards that serve to control the composition in *The Tangled Garden*. Framing the central mass in *Flower Border* are two contrasting elements: a triangular-shaped path in sandy pink at the base is balanced at the upper edges by a sky composed of dark amorphous clouds that provide colour rather than structure. Clamped between these two elements is an undulating wave of repetitive vertical elements in the form of blue delphinium (or larkspur) to the left, two stalwart spears of pink hollyhock (or perhaps a custodial murdoch or mullen) in the centre, and a thick stand of blue delphinium on the right. Fronting the blue sentinels in this tropical labyrinth on the lower left is another wave of colour, this time

lilies, in complementary orange against a dense growth of greens. Slightly off centre, in the same register, is a clump of pink blossoms that is carried in a diagonal to the upper stand of blue. No area is left untouched. Punctuating the lower edges to the right in an audacious fillip are several stands of straggling red sylva that serve to underline the riotous and irrepressible plenitude of a domestic garden at the height of summer.

Inspired by a similar rural setting is *Fall Evening, Thornhill*, 1920 (fig. 8). In this sketch, a flat overall pattern has gained ascendancy over specific description. The maxim of Maurice Denis comes to mind: "Remember that a picture, before being a battle horse, a nude, an anecdote or whatnot is essentially a flat surface covered with colours assembled in a certain order." MacDonald may have been grappling with such an idea when he wrote in his 1918 lecture that "our artists do not paint pictures of places so much as pictures of ideas. They prefer not to localize their productions, as they wish to represent the spirit rather than the form."

One might imagine the artist wandering in the outdoors and seeing only patterns created by the failing light. MacDonald structured his compositions here as in other works in a classical perspectival progression. Foremost, at the base of the sketch, lies a swathe of burnt brown, perhaps that of a harvested hay field. In the middle ground the paint is applied in thick slabs, smudged and kneaded, and the distant horizon is constituted by the tempestuous sky, into which various types of cloud are crammed. It may be that a sketch such as this is primary evidence of MacDonald's search for "poetic feeling," a term that frequently occurs in his notes and lectures, in opposition to his criticism of the sterile character of much

95

7
J.E.H. MacDONALD
(1873–1932)
Algoma, 1918
Oil on composite
wood-pulp board
21.7 × 26.6 cm

8
J.E.H. MacDONALD
(1873–1932)
Fall Evening, Thornhill
1920
Oil on wood-pulp board
21.5 × 26.4 cm

of contemporary art – "... a cold geometry of pattern, a leaden quality of volume, and a mystery of significant form." In MacDonald, a sensitive and detailed observation of the magnificence of the land finds a reflection in the passionate lines of Walt Whitman as the poet meditates on the "large and unconscious scenery of my land with its lakes and forests ... always steadily moving with the great drift of creation."

In the fall of 1918 MacDonald was invited by Harris to accompany himself, Frank Johnston and Dr. MacCallum on a sketching trip to the region of Algoma. Although previous artists had travelled by rail to interpret the vast expanse of the evolving Dominion, surely the Algoma venture was one of the most imaginative safaris in the history of Canadian art. On five occasions the various artists travelled from Sault Ste Marie to locales along the route of the Algoma central railway. Dropped off in a domesticated boxcar on a siding in the wilderness, they selected their motifs and painted and sketched assuredly, secure in the knowledge that transport, food and shelter were close at hand. The experience in the wilds of Algoma served to reinforce MacDonald's praise for the potential of the land. He detected "a sense of rough dignity and generosity which the aspect of the country suggests" that enabled him to believe that "the complete drama of life is played in Canada as elsewhere, only to the Canadian spirit in art, the setting appeals more than that of any other country." His words cascade over the page with the same striking and vivid imagery as does the paint in his 1919 interpretation of the waterfall of *Algoma* (fig. 7).

MacDonald has chosen a low vantage-point from which to describe the grail-like vision of the shimmering waterfall surging over successive ledges between the restraining walls of pink rocks that form the infrastructure of the composition. The creamy waters disappear behind the imposing wedge of rock at the base of the sketch, described in a melange of velvety tones of blue, violet, black and brown. The viewer moves from dark to light, from this tenebrous base to the bank of huge trees in a strong black-green partially obscuring the cliff that is crowned by a cerulean sky. The gradation of flattened triangular shapes from the base to middle distance to the horizon line emphasizes the schematized flatness of the composition, against which the sonorous tonalities of the thickly applied paint – scumbled in areas with pinks and oranges – create a powerful and sensual image of hectic energy.

Another highly charged and decorative interpretation of an autumnal scene, *Mountain Ash*, 1922 (fig. 9), was painted while MacDonald was still under the spell of the boxcar trips to Algoma. The graceful screen of red rowanberries on the surface of the painting belies the multi-layered depth and baroque intensity of the work. A series of dynamic interlocking

10

J.E.H. MacDonald
(1873–1932)
October Shower Gleam
c. 1922
Oil on paperboard
21.6 × 26.5 cm

diagonals in stereoscopic precision provides a framework for the discovery of the natural elements of water, rock and vegetation. A line of force, initiated by the source of the stream glimpsed at the lower right of the painting, meanders in a zigzag pattern through the various outcropping of rocks to the upper right. Deep pools of water highlighted by turquoise blues and whites and retained by reddish-brown boulders are placed at the crux of the zigzags. The waters, in a dizzying reverse of gravity, appear to flow from the base of the painting to the upper right edge. Balancing the splashes of dusky pink and low keyed purple (like buried rubies) that activate the overall rich brown surfaces of the maze of rocks is a band of autumnal foliage in ochre yellow and orange in the upper left. The tension amongst the various components of the painting – the stillness of the pools, the flow of water edging towards the presumed torrential power of rapids sensed in the distance, and the lush overhang of ripe berries curtaining the inflexible substance of the land – are captured in

11
J.E.H. MacDONALD
(1873–1932)
Solemn Land, 1919
Oil on paperboard
21.3 × 26.6 cm

a contrapuntal interplay of line and colour. The painting is a paean of praise to the munificence and power of nature, such as would have been echoed in the words of Thoreau. The same spirit pervades *October Shower Gleam*, *c*. 1922 (fig. 10) and *Solemn Land*, 1919 (fig. 11).

The rugged rocks and rapids of Northern Ontario and the more gentle land around the outskirts of Toronto were not the only prospects of Canada that attracted MacDonald. Nova Scotia had long held a compelling interest for him, owing to his long-time friendship with Lewis Smith, a Haligonian artist whom he had met, while employed at Grip, in 1894. MacDonald's *Nova Scotia Coastal Scene*, 1922 (fig. 12), is an exemplary maritime scene of fishing shacks placed along a tidal river inlet with farm buildings on the opposite shore. The composition unfolds with classical clarity in three predictable perspectival areas of foreground, middle ground and background. The rotund rocks of the shore, rendered in a mossy green brown with daubs of pink and purple, anchor the painting in the foreground. Perched on the rocks in the middle ground are the fishing shacks, described in delicate pinks and greys, which serve as a compositional link over the tidal river – perhaps Petite Rivière – to the houses on the far shore. Here in the background is repeated the tripartite horizontal composition of the whole painting; a sandy beach at the base anchors the hills and rocks on which sit houses and sheds in the middle ground fronting the woods beyond, culminating in a cloud-tossed sky in the upper reaches of the background. Other views of Nova Scotia find MacDonald face to face with the ever-changing light on the waves of the open ocean, and the surge of power that belies human control, but in this interpretation of Nova Scotia, nature is tranquil, filled with peace and harmony, where "every prospect pleases."

True to MacDonald's fervent belief in the potential of the country to provide him with all the inspiration he needed, he travelled to the Rockies, sometimes alone, sometimes with colleagues, on seven successive occasions from the summer of 1924 to his last trip in August 1930. In these majestic surroundings, it might be surmised, he found fulfilment in his search for a motif that was equally as rich in spiritual significance as in picturesque scenery. Some idea of his passionate reaction to the raw power of the mountains, the abundance of wildlife, the variety of trees, the air, the light, the panoply of colour, may be gleaned from his diaries and letters, couched often in deft and wry phrases. His experience in the Rockies prompted recollections of the exhibition of Scandinavian art in Buffalo some fifteen years earlier. He cited one painting in particular, *Mountain Lake Moonlight*, by the Swede Gustav Fjaestad: "He has beautiful records of the night as in these moonlight birches frosty against the northern stars or in the *Moonlight on a Mountain Lake*, where water and cloud reflections beat in a calm rhythm of color and solemnity ... and seemed to us true souvenirs of the mystic North round which we all revolve." Indeed MacDonald's

12

J.E.H. MacDONALD
(1873–1932)
Nova Scotia Coastal Scene, 1922
Oil on wood-pulp board
21.4 × 26.4 cm

canvases of mountain landscapes are often austere, planar and restrained in colour, as if the sun had been filtered out and relegated to a role secondary to the power and structure of the form. "[Lake] Oesa felt like the ages before man," he noted, "and there were the cold grey days, when one heard echoes of chaos and old night in the upper slopes, and the spirit of desolation wafted coldly about the rock slides, one found even the sight of a little old dried horse dung a consolation and assurance."

In contrast to the riotous energy of the Algoma work, his mountain views appear cold and analytical, an intellectual construct perhaps, as if he were overwhelmed and isolated. That MacDonald might entertain such thoughts fits with his suggestion that Constable, on a visit to the Lake District, found that "the solitude of the mountains oppressed his spirit." He added that, to Constable, "Lake Superior or the Rocky Mountains would probably have seemed like old chaos and old night"

Is it possible to interpret *Moon over Lake O'Hara*, 1926 (fig. 16) and the related sketch, *Lake O'Hara, Rockies*, 1926 (fig. 15) and canvas, *Lake O'Hara*, 1930 (fig. 14), as a tribute to the power of the mystic North and an acknowledgement of oppressive solitude? It is a beautiful nocturne in brooding tonalities of blue and turquoise, highlighted on the horizon line by brushloads of the palest of pearly pinks on the glacial ice of the peaks.

Depth is created from the line of moonlit rocks in the foreground over a deeper and luminescent blue of the lake that recedes to the dark purple of the implacable mass of mountain, which fills the top two thirds of the composition, subsuming the habitual role of the sky. To the left of centre, safeguarding the rocky shore, stands a velvety black evergreen hanging in an amazing strip of incandescent sky. The solitary tree becomes a metaphor for the wandering soul in search of enlightenment in a vast and mysterious universe, as forsaken as a character in a painting by Caspar David Friedrich.

Back in Toronto and thoroughly involved with various responsibilities – including those of Principal at the Ontario College of Art and President of the Arts & Letters Club – MacDonald undertook what was to be his last sketching trip to Sturgeon Bay and McGregor Bay in August 1931. In *Sturgeon Bay*, 1931 (fig. 13), a lowering blue-grey sky imposes a muted blue tonality over the entire sketch. The theme of transition is stressed in the varied shape of the clouds. Once again the foreground is introduced by a humped, weather-beaten rock eroded by ice and rain. A narrow strip of thinly painted water laps against the far rock and shoreline where a stylized line of deep black suggests a forest. A gnarled shape assumes the image of a twisted pine that has become a repetitive indication that 'this is the North.' Pink-tinged thunderheads hover over lozenge-shaped clouds, heavy with rain, along the horizon line. Furtive dashes of pink denote a setting sun. The mood is elegiac, gently so, and the sky, "the chief organ of sentiment in a landscape and the source of light," has regained its place of prominence in this one last glimpse of the waters and land of the North.

In a succinct summation of his various artistic explorations over the decades, MacDonald wrote in a lecture he prepared in 1930: "Art is the successful communication of a valuable experience." It was a goal for which he strove all his life in the various interpretations of this "large country with 3,000 miles of landscape to do and a great, vital, varied nature to stand behind us while we do it." As a teacher and administrator, MacDonald influenced other artists and students to think beyond tradition. As a designer, he introduced to the commercial world new ideas based on Canadian symbols. As a poet and essayist, he became engaged in the debates shaping the growth of Canada from colonialism to nationhood. He played a crucial role in the growth of the Group of Seven from before the War, probing complacency with his perceptive observations, thereby initiating a distinctive expression of the Canadian landscape. The fore-word to the 1922 Group of Seven exhibition catalogue eloquently captures his spirit: "New materials demand new methods and new methods fling a challenge to old conventions Artistic expression is a spirit, not a method, a pursuit, not a settled goal, an instinct, not a body of rules Art must take to the road and risk all." The Canadian public still responds to the brilliance of his colour, the vigour of his compositions and the rich variety of his landscapes.

13
J.E.H. MacDONALD
(1873–1932)
Sturgeon Bay, August 1931
Oil on board
21.6 × 26.7 cm

14
J.E.H. MacDONALD
(1873–1932)
Lake O'Hara, 1930
Oil on canvas
53.6 × 66.5 cm

J.E.H. MacDonald

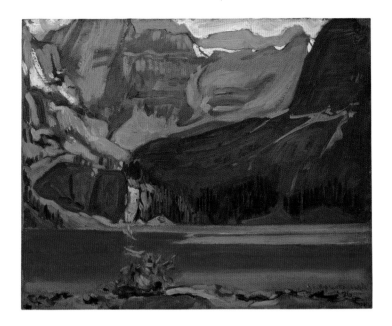 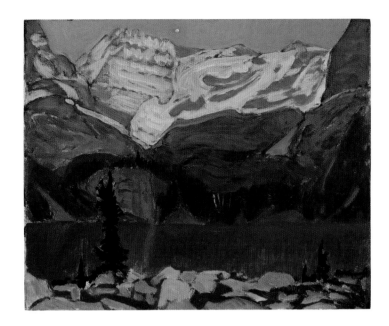

15
J.E.H. MacDONALD
(1873–1932)
Lake O'Hara, Rockies
1926
Oil on wood-pulp board
21.5 × 26.6 cm

16
J.E.H. MacDONALD
(1873–1932)
Moon over Lake O'Hara
1926
Oil on multi-ply paperboard
21.5 × 26.6 cm

FURTHER READING

Lisa Christensen, *The Lake O'Hara Art of J.E.H. MacDonald* (Calgary: Fifth House, 2003)

Paul Duval, *The Tangled Garden* (Scarborough, Ontario: Cerebus, 1978)

Charles C. Hill, *The Group of Seven, Art for a Nation* (Ottawa: National Gallery of Canada, 1995)

Charles C. Hill, *Terre Sauvage: Canadian Landscape Painting and the Group of Seven* (exhibition catalogue, Copenhagen Kunstforeningen, 1999)

E. Robert Hunter, *J.E.H. MacDonald: A Biography and Catalogue of his Work* (Toronto: The Ryerson Press, 1940)

Gemey Kelly and Scott Robson, *J.E.H. MacDonald, Lewis Smith, Edith Smith – Nova Scotia* (exhibition catalogue, The Gallery, Halifax, 1990)

J.E.H. MacDonald, 'Scandinavian Art', *Northward Journal*, 18/19 (1980)

Nancy E. Robertson, *J.E.H. MacDonald, R.C.A. 1873–1932* (exhibition catalogue, Art Gallery of Ontario, Toronto, 1965)

Robert E. Stacey, with research by Hunter Bishop, *J.E.H. MacDonald, Designer: An Anthology of Graphic Design, Illustration and Lettering* (Ottawa: Archives of Canadian Art, an imprint of Carleton University Press, 1996)

Bruce Whiteman, *J.E.H. MacDonald* (Kingston, Ontario: Quarry Press, 1995)

Consulted as well are poetry and lectures by J.E.H. MacDonald, including *Sketchbook* (1915–1922), *A Glimpse of the West* (1924), *A Few Country Poems* (1933), *My High Horse, A Mountain Memory* (1934) and Frederick Broughton Housser, *A Canadian Art Movement: The Story of the Group of Seven* (1926).

Miscellaneous unpublished correspondence, diaries, letters, notes and poems in the archives of the Arts & Letters Club, Toronto, of the National Gallery of Canada and the Library and Archives of Canada, Ottawa.

Charles C. Hill, Curator of Canadian Art at the National Gallery of Canada, has guided me with insight and generosity in the preparation of this text in addition to his contribution to the bibliography.

Tom Thomson: Trailblazer and Guide

JOAN MURRAY

Tom Thomson (1877–1917) was a country boy from first to last, although what he meant by country changed with time. At first he would have understood as 'country' the rural environment of his childhood. Born in Claremont, Ontario, and raised in Leith in the township of Sydenham, he graduated from business school in Chatham, another small Ontario town. Then he travelled to a city bursting at the seams – Seattle, Washington. From this rapidly growing urban centre he returned to a city three times its size in Canada – Toronto, which he made his home. It was here that he took his first steps as a professional artist and developed his love of Northern Ontario, particularly as it is embodied in Algonquin Park, where, in the years from 1912 to 1917, he discovered the imagery that gained him worldwide recognition. The paradox is that he realized the possibilities of the landscape of the Park while working as a commercial artist in the city. However, in Toronto Thomson found a cultural world that supported an interest in the Canadian Shield, just one of the manifestations of a powerful nostalgia for nature that accompanied the increasing industrialization and urbanization of Canada at the time.

When we talk about Thomson's beginnings as an artist, the way in which he became interested in Canadian imagery is rarely mentioned. He discovered the land which gave the shaping power to his imagination through fishing and sketching expeditions that he made from early in the 1900s, but particularly from 1910 to 1912. He made the latter trips with friends, fellow artists from Grip Engraving Ltd., the ambitious commercial art firm with which he had found a job in 1909. But we may wonder what drove him to discover this imagery and why he so insistently made it the keynote of his later work.

Though a first-class designer, Thomson had a hard time establishing himself as a commercial artist of stature at Grip. As a newcomer, he was given at first only the humbler jobs. The art director Albert H. Robson, one of the top men in the field and himself a painter, later wrote that Thomson's speciality in the company was lettering and the laying of Ben Day tints on metal plates, a mechanical technique to indicate the parts of the design which needed shading. Such tasks did not require imagination so much as patience and persistence.

Robson was a man with a strong desire for success, particularly for Grip Ltd. He wanted the company to gain a large section of the Canadian advertising market by offering work competitive with New York, where much of the business was handled. To do that, he believed it to be necessary to discover imagery which would suggest the "true spirit of the country." He therefore encouraged the artists on the staff to take an interest in painting landscape – to "bring it back alive" to the offices of Grip. The directive was given in 1905, but the spirit behind it continued to flow through the staff in the years that followed. Through contacts with members of the Toronto Art League and the Mahlstick Club, the workers

at Grip began to take weekend sketching trips with the intention of discovering picturesque environs that conformed to Robson's wishes.

Thomson may have heard of the directive even before joining Grip, while working as an independent designer. In a postcard postmarked September 21, 1905, which he sent Robson from Bear Island in Temagami, he told the art director that he had "better come along" and join him, presumably to paint the scenery – a message implied in the watercolour landscape which he painted on one side of the card. Besides asking Robson to come north, Thomson added that expenses were low and the canoe came "gratis."

Robson never seemed to remember that he had heard from Thomson at this early date. When he wrote about him later, he remembered his first meeting as occurring when Thomson applied for a job with Grip (Robson thought this might have been about 1908) and brought to the interview a portfolio of designs and examples of his commercial art. Some of the works by Thomson had an "over-tone of intellectual as well as an aesthetic approach," Robson recalled. One work from this period, which Thomson might have shown Robson, had a Canadian reference, probably because it was a drawing for a cover of the *Canadian Home Journal*. It is of a woman's head in profile. She wears a wreath of maple leaves in her hair.

If he had not already heard about the directive, Thomson certainly would have learned about it when he was hired by Robson. From around 1910 Thomson proceeded accordingly, taking sketching trips during which he was painting images that have a northern feel, though they may not have been painted in 'the North.' In 1911 and 1912 we know that he did travel to more distant locations. In 1911, with a colleague from Grip, Ben Jackson, Thomson made trips to Owen Sound and Lake Scugog, during which he painted small sketches. The following year he and Jackson went to Algonquin Park, where, as Jackson recalled, Thomson painted again, although the sketches were small, mostly colour notes. On a second trip in 1912, with the artist William Broadhead, Thomson explored the area north-west of Sudbury by canoe, travelling through Biscotasing, Spanish Lake, the Mississagi Forest Reserve, and ending at Squaw Chute. The two men sketched and used a camera – surely with the idea of following Robson's directive and using the raw material for advertising or magazine articles – but their canoe capsized on two different occasions and most of the film was lost. As Thomson later wrote to a friend, he and Broadhead "got a great many good snapshots of game – mostly moose and some sketches . . . [but] only saved 2 rolls of films out of about 14 dozen." Could the friend contact a certain Dr. Hicks and ask him to find a man he had told Thomson about, "who was through the trip last year" and had "a fine lot of photos." Thomson ended his letter with a characteristically wry comment that if Dr. Hicks could remember the man with the photos,

"he may save a life." In other words, Thomson, as a Robson man, kept his employer's directive firmly in mind. Proof of his attachment to Robson is not far to seek: in the fall of 1912, when Robson moved to Rous & Mann Press Ltd., another leading company of the day, Thomson, along with other Grip artists, followed.

The praise and acceptance Thomson received for the small panels painted on trips taken so far surely encouraged him to continue travelling to discover new imagery. As well as from his peers at Grip, this praise came from a new acquaintance he had met in 1912 – Dr. J.M. MacCallum, an ophthalmologist, who became his friend and patron. Later, MacCallum would lyrically describe these early sketches in an article in the *Canadian Magazine*. He wrote that the little panels were dark and muddy in colour, but truthful in feeling to the grim, fascinating northland. In such early work, MacCallum must have felt that he caught sight of the essential Thomson and perhaps sensed the painter he would become.

Acting as a guide or scout for his fellow artists, bringing back news of a new landscape, was far more interesting to Thomson than the routine jobs required of him as a member of staff. He was playing to a receptive audience. In particular he was revealing in Algonquin Park – which Thomson eventually sought to reveal in all its varied moods and forms – a place which for many of the men of the company existed only as a fantasy. The Park, created in 1893, was considered by urban dwellers as the romantic 'North.' Another allure of the Park for Thomson must have been the fishing – his favourite sport and one at which he was extremely adept. He prided himself on his catch, as the photographs he took and one of his later sketches suggests.

It is Thomson 'the guide' that appears in his work; he is showing us what was for him a new world, the environment, its wildlife, even the impact of logging within its boundaries. He portrayed Algonquin Park through rhythmic repeats of trees, bushes and lake at different times of day and in different seasons. He was, perhaps, a prophet of what became an image of the North for most Canadians and, in time, came to be considered an essential part of being Canadian.

Thomson's work, though it suggests at points a more abbreviated rendition of specific themes, consists above all of a tumultuous flood of images of Algonquin Park, of motifs he drew there from nature. As a result, the viewer can shift attention from panel to panel to oil painting and back again without losing focus. Together the images add up to so many fresh, resonant portraits of a new realm. Yet Thomson, hard at work to capture the look of the North, gained through his application to his task a new intensity and a more coherent technique.

Cliff by the Lake (fig. 1) is one of the most controlled of Thomson's early sketches. It reveals the powerful sense of design and handling of colour that he already possessed in 1912. In this small board, Thomson painted

trees that seem to spring out of a large rocky ledge which extends across the painting. The trees were painted in a way that he would later develop with greater sureness of touch: the undercoat is brown but, on top of this colour, Thomson laid patches of pink to indicate sunlight. The effect, though so simple, prefigures his later pictorial powerhouses with their multilayered surfaces and shards of colour, full of mystery and life.

Although Thomson and his associates used traditional formats – oil on small board and oil on canvas fitted to stretchers – his and their ambitions were much wider and more expansive. It was around the same time that Lawren S. Harris, J.E.H. MacDonald, F.H. Varley and others, including A.Y. Jackson and Arthur Lismer, exploring in their different ways greater or lesser transcendental experiences, began to make painting seem full of possibility. Jackson would repeatedly stress that Thomson's real development as a painter began only in the autumn of 1914, when he and others of this group painted together in Algonquin Park.

Indeed the autumn of 1914 marked a major turning-point in Thomson's career. With the encouragement of peers such as Jackson, Thomson became mesmerized by the rhythmic designs of nature. The basic principles of his work took root: draw from landscape, but maintain a strict design process; express a powerful inner life through means of colour and strong composition, and (in Jackson's words in a letter to the absent MacDonald) "plaster on" the paint. Stimulated by contact with his friends, Thomson discarded literal representation of nature in order to emphasize form, structure and colour. Jackson described him as transposing, eliminating, designing and finding happy colour motifs amid tangle and confusion, revelling in paint.

The idea that he could be released from literal representation and design from nature seems like a simple one. Every introductory student of art knows as much. But Thomson had not taken much in the way of basic studies and for him the idea of transposing, eliminating and most of all designing may have come as a revelation. Certainly, contact with his peers resulted in work with a new vitality and vivid rendering, and the fall of 1914 signalled a formal breakthrough in his painting style.

The Thomson Collection records this development. It contains several sketches from 1913, which belonged to friends of Thomson such as J.W. Beatty, and early, tentative canvases such as *Grey Day in the North*, of a northern lake on a stormy day, as well as Thomson's major canvas *Morning Cloud*, in which he adopted the broken brushwork of Impressionism, but with more subdued colour.

The Thomson Collection also contains a number of sketches from 1914. In the spring of that year Thomson and Arthur Lismer camped and painted together, delighting in the rich colouring of the woods and the first advances of the glorious greens of the season, which Thomson recorded in sketches such as *Spring, Algonquin* and *Logs at Water's Edge*. In these he displayed an increased sensitivity to texture, perhaps gained

2
TOM THOMSON
(1877–1917)
Pink Birches, summer 1915
Oil on composite wood-pulp board
26.7 × 21.6 cm

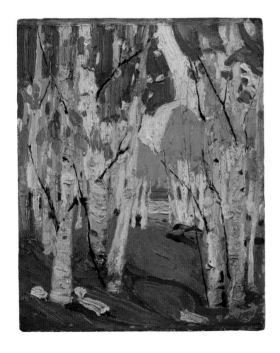

from Lismer's example. By the end of May Thomson had arrived in Georgian Bay, where he stayed with Dr. MacCallum. There he painted many sketches which record the area's turbulent waters, narrow islands and vistas of sky – as in *Giant's Tomb, Georgian Bay* – or the feathery tree patterns of the shore line, as in *Georgian Bay, Byng Inlet*. But nothing spells out as clearly the importance of Thomson's autumn engagement with his friends as the excellent examples in the Thomson Collection of sketches that the artist painted that fall – *Woodland Interior – Fall*; *Autumn, Smoke Lake*; *Algonquin Park* and *Birches* – all of which have highly keyed colour, dotted on in touches, and greatly strengthened design. They seem quite apart from Thomson's earlier work and indicate the inspiration the group had engendered.

During the winter of 1914–15 Thomson shared a studio with former Grip employee Franklin Carmichael, and in that small space he worked assiduously, creating a number of works such as *Northern River* (National Gallery of Canada) which reveal more painterly, denser compositions, and experimentation with still bolder colour and a more textured surface. The result is an effect full of life and feeling.

The Thomson Collection illustrates quite comprehensively the development of Thomson during this period, including many sketches from the spring of 1915, when, in mid March, Thomson arrived in Huntsville and painted *Snow in the Village*, before moving on to Algonquin Park, where he painted *Silver Birches, Snow*. He enjoyed travelling over a great deal of country and recording new areas, such as that depicted in *Ragged Rapids*, which had a form "like rimless eyeglasses," as a note (probably written by MacCallum) records on its back. That year, around Kearney, he stayed at McCann's Half-way House near a burnt-over area where he made many sketches, such as *Burnt Area with Ragged Rocks* and *Burnt Land at Sunset*. His ability to convey colour was strengthening, as we can see from sketches such as *Pink Birches* (fig. 2), painted that summer, in which the basic elements of the image are distilled into thin slabs of purple (background), grey-green (foreground and foliage), pink, coral and lavender (thin slabs of birches) and black (branches). A review of his works in this year illustrates the growth in his ability. The works he painted during the latter part of the year, such as *Fire-Swept Hills*; *Moonlight, Algonquin Park*; *Evening Cloud*; *Sand Hill* – all, in their way, treasures of his art – have richer colour, more delicate yet bolder handling and more complex subject-matter.

Soon, in sketches such as the one made for *Autumn's Garland*, Thomson was combining both strong design and brilliant colour in configurations partly inspired by a new sense of adventure, so, that for some observers, the effects suggest an approach to abstraction. If so, it is a branch of abstraction that looked to nature for inspiration.

In time Thomson graduated from the sketch medium to making marks on canvas which could carry the full quality of his message. In the

3

TOM THOMSON
(1877–1917)
Evening, Canoe Lake
winter 1915–16
Oil on canvas
41.3 × 51.5 cm

4

TOM THOMSON
(1877–1917)
Spring Woods, 1916
Oil on composite
wood-pulp board
21.7 × 26.8 cm

Thomson Collection are canvases he painted during the winter of 1915–16, such as *Evening, Canoe Lake* (fig. 3) and *After the Sleet Storm* (fig. 5), in which Thomson balanced light and dark colours in harmonies of purple, pink and tan or crystalline colours against dark blue and black. In *After the Sleet Storm* he laid the paint on heavily, extending large vertical strokes of lavender and pink horizontally across the canvas and setting them against a darker foreground and the receding design elements of distant lake and hills. To create the effect of ice frozen on the trees and bushes, Thomson must have tied his brush to a long stick or used long-handled brushes or the palette knife. Under the weight of so much experiment, his palette shrank back toward a quieter coloration.

Essentially, Thomson was making visible, through form, the gestures by which he had previously layered his paint on to surfaces. Touching the canvas vertically and horizontally, he accounted for the entire surface as if building a scaffold. As his work progressed, the terse network unbent and relaxed into curving lines, as in the beautiful sketches he painted the following spring – *Winter Hillside, Algonquin Park,* in which he retained a lavish handling of paint but structured the work more dramatically through the use of diagonals; *Spring, Canoe Lake,* in which he recorded the zigzag effect of clouds marshalled over distant hills; and *Spring Woods* (fig. 4), where white and red trees and bushes establish a pattern varied by a perky green tree, depicted one snow-bound afternoon in the Park. Along the way that

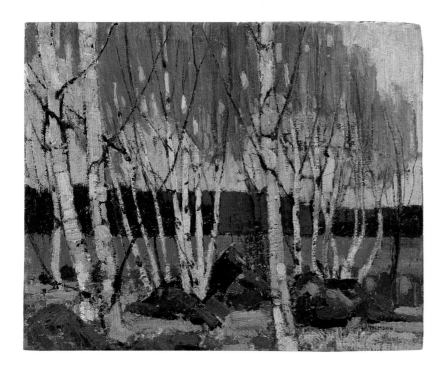

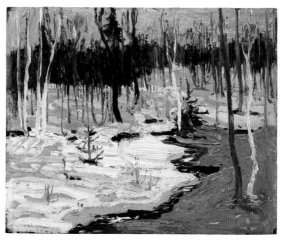

5
TOM THOMSON
(1877–1917)
After the Sleet Storm
(**Sleet in the Cedars**)
winter 1915–16
Oil on canvas
40.9 × 56.3 cm

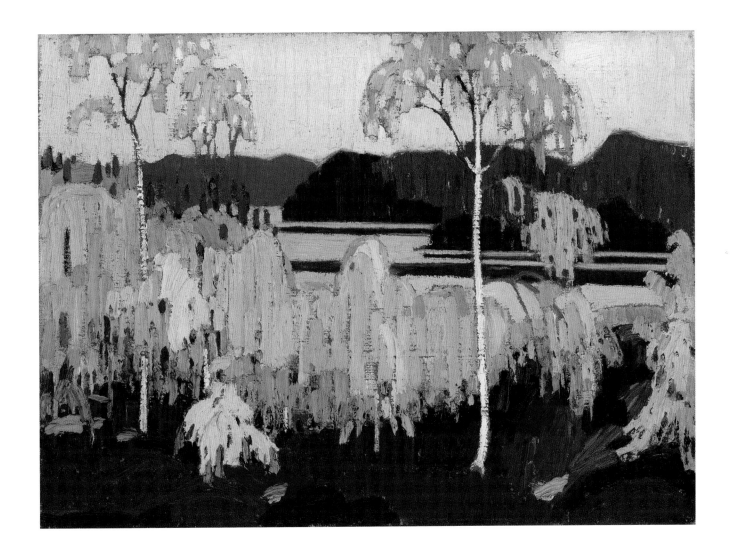

spring, he painted the woodland flowers, picking out the colours firmly and delicately, as in *Moccasin Flower*.

In May 1916 Thomson took a job as a fire ranger and reported to Achray, a park station at Grand Lake on the south branch of the Petawawa (now Barron) River. He painted many works which reveal his interest in the lumber trade, from *Sandbank with Logs* – with its complex pile-up of lumber in the foreground – to *Log Jam*: sketch for *The Drive*.

In August 1916 Thomson and a friend canoed down the south branch of the Petawawa, finding it a "great place for sketching," since it ran between high walls of rock. Panels such as *Petawawa, Algonquin Park* (fig. 6) reflect Thomson's fascination with the sensational topography, light, colour and space of the area. He recorded the way the light fell on the cliff tops, leaving the rest in shadow. The sky, which he painted in turquoise and pale green, seemed bluer in contrast. He remained in the Petawawa area until October – as one of the sketches in the Thomson Collection, *Autumn, Petawawa*, suggests – before returning to Toronto early in November.

By this time Thomson's way of painting had become a considered procedure, a way both of contemplating nature and of recording it in rich colour and rhythmic pattern. *Spruce and Tamarack* (fig. 7) illustrates the way he might create a lively interplay of board and pigment by revealing the wood of the panel through the paint. In another work, *Blueberry Bushes, October* (fig. 8), he created a totally dark background and let the crimson red of the hillside open up the view. In *Fall Woods* he essayed such simple and

8
TOM THOMSON
(1877–1917)
Blueberry Bushes, October
1916
Oil on wood
22 × 27 cm

9
TOM THOMSON
(1877–1917)
**Autumn, Three
Trout (Catch)**
fall 1916
Oil on composite
wood-pulp board
21.6 × 26.7 cm

10
TOM THOMSON
(1877–1917)
**Winter Thaw
in Woods**
c. spring 1917
Oil on composite
wood-pulp board
21.6 × 26.8 cm

boldly blocked effects – patching in orange and yellow woods and purple tree-trunks and playing the colours off a turquoise sky – that matter seems illusory and appearance a matter of energy. In *Autumn, Three Trout* (fig. 9), he lovingly recorded his catch, stressing the size and beautiful colour of the fish. As in earlier years, he recorded the first snow. *Near Grand Lake, Algonquin Park* and *Winter Thaw in Woods* (fig. 10), with their abbreviated but accurate handling, forceful rhythm, and telling revelation of weather in late fall, are magnificent examples. Of these two, *Winter Thaw in Woods*, with its lavish paint handling and the exciting interplay of the shapes of its three main trees bounded by the diagonal of a fallen log, is perhaps the more impressive. In the sketch areas of soil in patches of Indian red, covered by vermilion, dark green and black, show through the creamy white snow. Thomson characteristically left an area of sky at the top of the sketch to "open up the view."

Thomson painted the large canvas *Maple Saplings, October* (fig. 11) during the winter of 1916–17 along with works we know to be his masterpieces such as *The West Wind* and *The Jack Pine*. If we step forward then backward in front of this canvas, the illusion of colour almost dancing in the woods is created. The forms coalesce at a distance, then register as pure brushwork when seen up close. Thomson captured the pattern of the woods – how trees and foliage point, tilt, seem to signal – and he conveyed these forms

11
TOM THOMSON
(1877–1917)
Maple Saplings, October
c. 1916–17
Oil on canvas
94.1 × 102 cm

12
TOM THOMSON
(1877–1917)
The Rapids, spring 1917
Oil on wood
21.6 × 26.7 cm

without affectation. Like the other paintings of this season, *Maple Saplings, October* is boldly orchestrated in colours ranging from red and vermilion for the maple leaves to orange and turquoise for the background.

That spring, as he returned to the Park, Thomson sought out earlier subjects, but gave them impressive new turns. Works such as *The Rapids* (fig. 12); *Path behind Mowat Lodge* (fig. 13); *Open Water, Joe Creek*; *Early Spring* and *Winter Thaw* reveal his sense of wiry, graceful composition and spell out his genuine maturity as an artist. Freedom in colouring and powerful composition had become integrated with his vision of nature. Using abbreviations of form, Thomson deftly captured the essential elements of views he enjoyed in Algonquin Park at that time of year – snow, ice, water, trees, distant hills, sky – in a descriptive manner. Though his handling is bold, it also has a fluid delicacy, as we can see in the trees and bushes which poke

13
TOM THOMSON
(1877–1917)
Path behind Mowat Lodge
spring 1917
Oil on wood
26.8 × 21.4 cm

up through the composition like exclamation marks. His colour sense, too, had matured, so that in *Open Water, Joe Creek*, we find a pattern of birches in a dance of cream, coral, olive green, brown and black, or, in *Path behind Mowat Lodge*, shadows of cerulean blue and green and a sky of light blue with dots of a different green. By now, Thomson could convey movement into depth with great conviction, using the sloping curve of the path to create a sense of recession.

Such works will have to suffice us. Having stopped painting that year to carry out odd jobs, in July 1917 Thomson met his death at Canoe Lake, no one knows how. Thomson's friends, particularly Jackson, were profoundly moved. Thomson was "the guide, the interpreter, and we the guests partaking of his hospitality," wrote Jackson to MacDonald. He added that his debt to Thomson was "almost that of a new world, the north country, and a truer artist's vision." In another letter to MacDonald he wrote that Thomson "blazed a trail where others may follow, and we will never go back to the old days again."

But though Thomson had died, his work lived on, providing an important example to the artists who founded the Group of Seven in 1920, and to many others. Some focused on his imagery and the way he painted in nature, others on the formal and material possibilities they found in his painting itself, from its richly layered patterning and mark-making to his improvisations and glowing combinations of colour.

FURTHER READING

Joan Murray, *Tom Thomson: Trees* (Toronto: McArthur & Co., 1999)
Dennis Reid (ed.), *Tom Thomson* (Toronto, Ottawa, Vancouver: Art Gallery of Ontario, National Gallery of Canada and Douglas & McIntyre, 2002)

References in this essay have been taken from Albert H. Robson, *Tom Thomson* (Toronto: Ryerson Press, 1937), p. 5; Albert H. Robson, *Canadian Landscape Painters* (Toronto: Ryerson Press, 1932), p. 134; Joan Murray, *Northern Lights* (Toronto: Key Porter, 1994), p. 17; Robson, *Canadian Landscape Painters* (1932), p. 138; J.M. MacCallum, 'Tom Thomson: Painter of the North', *Canadian Magazine* 50, no. 5 (March 1918), p. 376; A.Y. Jackson, 'Foreword', *Catalogue of an Exhibition of Paintings by the Late Tom Thomson* (Montreal: The Arts Club, 1919), and from archival sources: letter, H.B. Jackson to Blodwen Davies, May 5, 1931, Library and Archives Canada, Ottawa, MG30 D38; letter, Thomson to Dr. M.J. McRuer, Huntsville, postmarked October 17, 1912, transcribed and reproduced in Joan Murray, 'Tom Thomson's Letters', *Tom Thomson* (Toronto, Ottawa and Vancouver: Art Gallery of Ontario, National Gallery of Canada and Douglas & McIntyre, 2002), pp. 297–98; letter, A.Y. Jackson to J.E.H. MacDonald, October 5, 1914, Library and Archives Canada, MG30 D111, vol. 1, correspondence 1914–24; letter, Thomson to Dr. J.M. MacCallum, October 4, 1916, transcribed and reproduced in Joan Murray, 'Tom Thomson's Letters' (as above), p. 302; letter, A.Y. Jackson to J.E.H. MacDonald, August 4, 1917, McMichael Canadian Art Collection, Kleinburg; letter, A.Y. Jackson to J.E.H. MacDonald, August 26, 1917, Library and Archives Canada, MG30 D111, vol. 1, correspondence 1914–24.

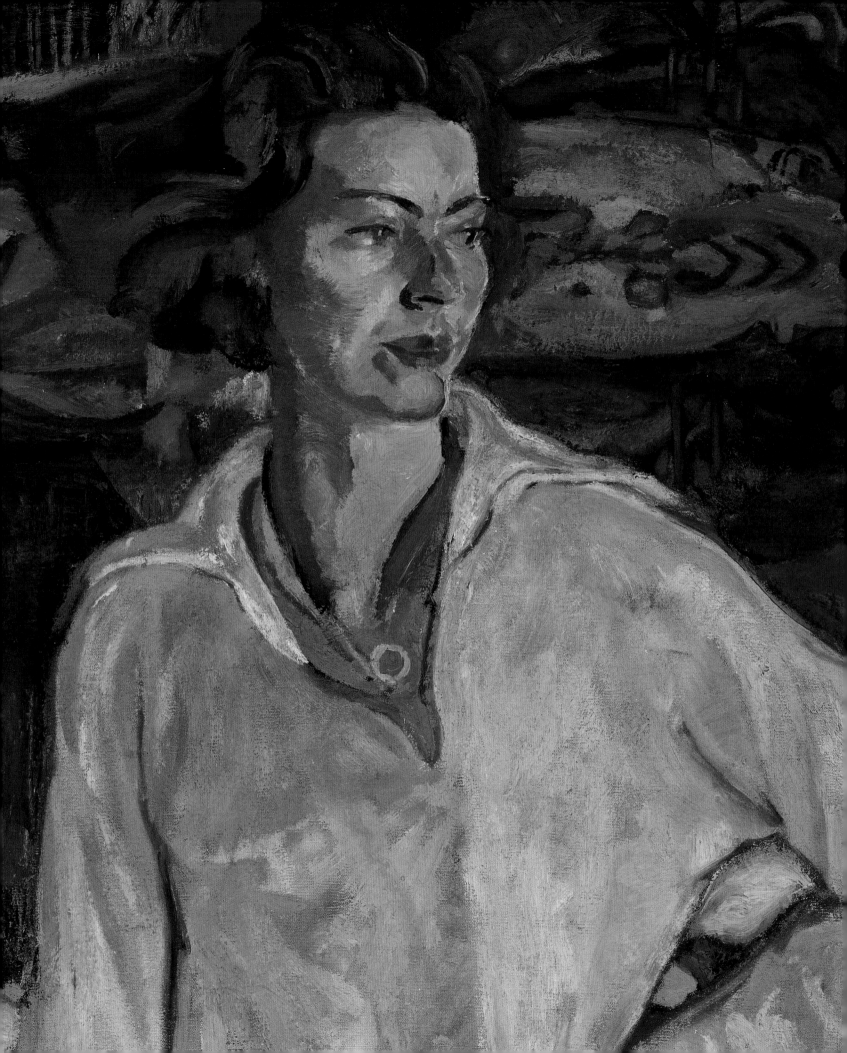

F. H. Varley

"I am a restless lad, too damned impressionable
to be healthy in this commercial life"
F.H. Varley

KATERINA ATANASSOVA

Frederick Horsman Varley (1881–1969) has been described as one of Canada's most misunderstood artists. Although he was indisputably one of the country's finest portraitists, his place in the history of Canadian art has been largely determined by his being seen first and foremost as a member of the Group of Seven. This is to ignore the various transformations the artist underwent over the course of his career. For Varley's free spirit, the real and purported facts of his bohemian lifestyle – he became known as the "gypsy of the Group"– and his deeply personal and evocative images are all aspects of a more complex story.

Born in 1881 in the steel-producing city of Sheffield, Varley was raised and educated in the traditions of Victorian England. His father, a skilful draftsman and a professional lithographer, supported young Fred's artistic interests. During his earliest training in Sheffield and then at the Académie Royale des Beaux-Arts in Antwerp, Varley showed talent, sensitivity and a thirst for the unknown. In later years he recalled feeling confined by the unhappy atmosphere in his conservative household and the bleak reality of his home town. However, he loved the nearby rough, unspoiled hills and moors, which served as inspiration for many of his early sketches, drawings and watercolours.

In 1912, at the urging of his friend and fellow artist Arthur Lismer, Varley emigrated to Canada. In a letter to his sister Ethel he shared with her his first impression of Canadian art: "A strong lusty child unfettered with rank, musty ideas – possessing a voice that rings sweet and clear." In Toronto, employment as a commercial artist temporarily freed him from financial worry and allowed him to pursue his artistic dreams. Weekend forays with his new friends and colleagues at Grip Engraving Ltd. and later at Rous & Mann – Tom Thomson, J.E.H. MacDonald, Frank Johnston and Franklin Carmichael – rekindled his interest in painting, particularly in oil. To capture the rhythm of the landscape Varley sought new compositional means.

Despite his many objections to making a living by commercial art, it was primarily through illustrations published in the *Canadian Courier* at the outbreak of World War I that Toronto audiences were introduced to Varley's work. No one was surprised when, in 1918, his appointment as one of Canada's official War Artists was announced. The art Varley produced for the Canadian War Memorials Fund would become the foundation of his future career.

Returning from England at the end of the summer in 1919, Varley endeavoured to develop a practice as a portraitist, but discovered that, despite the post-war economic boom and the presence of a social and professional elite in Toronto, to do so required more than artistic talent alone. For Varley, however, "selling one's wares" was not an option. Meanwhile among his friends, still mourning the sudden death of Tom Thomson two years earlier, landscape was the dominant theme. As it

elaborated a programme of creating a national identity through art, the Group of Seven, which held its first exhibition in 1920, was focused particularly on the barren wilderness of Northern Ontario. Varley summarized the Group's credo: "We are endeavoring to knock out of us all the preconceived ideas, emptying ourselves of everything except that nature is here in all its greatness, and we are here to gather it and understand it if only we will be clean enough, healthy enough, and humble enough to go to it willing to be taught and to receive it not as we think it should be, but as it is, and then to put down vigorously and truthfully that which we have culled." While he acknowledged that a critical look at landscape was vital to his new life in Canada, Varley, being a portraitist at heart, would seek to achieve this goal by situating the human figure within nature.

In the late summer of 1920 Varley and Lismer were invited to the cottage in Georgian Bay of Dr. James MacCullum, one of the Group's first patrons. The rugged landscape of the area demanded a less restricted treatment of form and provoked an almost immediate change in Varley's handling of paint. *Rain Squall, Georgian Bay*, *c.* 1920 (fig. 1), is a clear example of that transformation. This scene of jagged trees standing against a clear body of water, with clouds and distant hills in the background, could stand as a signature image of the new art collective. Painted on a small panel, the preferred surface for the Group's regular field trips, this work possesses the immediacy and power of a visual diary. Plans were made to explore

1

FREDERICK H. VARLEY
(1881–1969)
Rain Squall, Georgian Bay, *c.* 1920
Oil on wood
21.5 × 26.6 cm

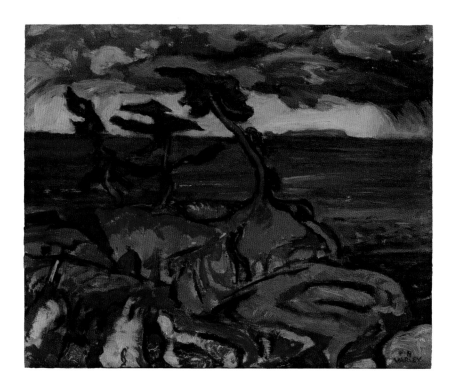

F.H. Varley

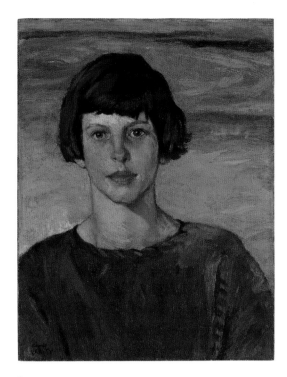

2

FREDERICK H. VARLEY
(1881–1969)
Study of Joan (Fairley), 1925–26
Oil on canvas
43.8 × 33 cm

Georgian Bay and Algonquin Park again the following year, but Varley would leave Ontario in 1926 without ever having returned to the area.

Recently published studies have sought to establish to what extent the founding members of the Group of Seven actually challenged the prevailing conventions of landscape painting in Canada. The long-held view has been that the Group's approach, inspired by the desire to forge a national identity, infused a new meaning into the landscape genre, giving it an almost mythological power. No one at the time or for a long time afterwards questioned to what degree the Group's programme was original and modern, or to what degree the work of each of the seven artists coincided with that defining vision and framework. For Varley, certainly, it was an uncomfortable fit from the very beginning of his association with the Group.

From the works he presented in Group exhibitions between 1920 and 1931, it is evident that Varley's inspiration more often came from his kinship with humanity than from the majesty of the Canadian wilderness. And the portraits and the drawings of heads and figures he included earned the praise of critics and artists alike. The audience at large admired his elegant line, lyrical technique and poetic vision. The majority of his portraits from that period were commissioned, although he also painted family members and friends on numerous occasions. To make a living and maintain his family he also accepted the economic help of some of his closest friends, albeit reluctantly. Among his most ardent supporters was Barker Fairley, a fellow Yorkshireman, whom Varley had met at the Toronto Arts & Letters Club in 1912.

Study of Joan (Fairley), 1925–26 (fig. 2) is one of the artist's most successful paintings of children. It is worth noting that, back in England, the British aristocracy had commonly commissioned children's portraits, although critics rarely took them seriously. At the end of the nineteenth century, growing affluence in both Europe and North America introduced a significant shift, and children became the centre of attention of family life. No doubt Varley was familiar with portraits of children by famous contemporaries such as John Singer Sargent, William Orpen and Augustus John. It was a genre in which his keen sense of observation and intuitive ability to assess a child's nature would serve him well.

The portrait of his best friend's teenage daughter combines a finely modelled sculptural head and a rather flattened upper body. The division of space offers a feeling of calm and stability. The luminous, monochromatic background is characteristic of Varley's portraits from the 1920s. The palette of muted mauves, blues and browns and the treatment of light contribute to the emphatic tonal contrast preferred by the artist. The background is open to interpretation: we might be looking at an open stretch of land or water with hills or a barren island at the far end, or we could be seeing clear blue skies with darker clouds. Oddly, *Study of Joan (Fairley)* was

offered for sale at $300 in the Canadian National Exhibition in 1926, yet it remained a cherished Fairley family possession for years to come.

The facility with which Varley executed portrait after portrait in the early 1920s is astonishing. Each sitter was painted with unprecedented verve, energy and insight. Not only did he succeed in capturing the physical likeness, but also something of the essence of the person. As a portraitist Varley viewed the relationship between artist and model to be vital to the quality and depth of his work. "My father was a very good reader of character," Peter Varley discloses, "and certain types caught his interest, no matter what their situation in life. He recognized their inner hidden natures, their affection for living."

In the fall of 1926, to the disappointment of his circle of friends in Toronto, Varley moved to Vancouver to head the Department of Drawing and Painting at the Vancouver School of Decorative and Applied Arts (VSDAA). The province of British Columbia in the mid 1920s held out the promise of a beautiful and undiscovered landscape. At the outset, Varley found the changeable climate uninspiring and complained to Arthur Lismer, "The weather is wearing; incessant rain, mountains blotted out for weeks." With time, however, his vision adapted to the new patterns.

Direct contact with nature resulted in a body of work marked by experimental colour schemes and innovative compositions. Each canvas had the visual impact of a poetic encounter with a "newly found heaven," a feeling he compared to his first awakening to the song of the earth as a child. As Varley later explained in an essay for the VSDAA magazine *The Paint Box*, art for him was never "merely recording surface life – incidents, emotions." The open landscape became his element. There he could sense the world breathing and explore the interaction between sky and earth. He developed a way of painting that would enable him to capture the forces – the very soul – of nature.

A particular favourite of the artist's was *West Coast Sunset, Vancouver*, *c*. 1926 (fig. 3), which he sent as a gift to his sister Ethel in England. This evocation of the setting sun – seen from Jericho Beach, where the family was living at the time – over sand bars and sea to Bowen Island carried a message about his success in the West. There is a remarkable transition of colour across the water, and the distant mountain range is silhouetted against an evening sky that shades from darkest cerulean to fiery orange. Varley elaborated his own theory of colour, seeking the exact value and hue instead of resorting to formulas. His overall aim was harmony. The tonality of his work is always carefully controlled, the surface is alive with movement, and wherever the eye moves it is carried by the gesture of his brushstroke, whether gentle or rough.

The feeling of expansiveness and the bold modernist colours of *West Coast Sunset, Vancouver* are typical of Varley's production during his decade in British Columbia. The landscapes are testimony to his use of nature

as sounding board for his moods and feelings. Such works have been compared to the Symbolist canvases of the nineteenth-century Swiss painter Ferdinand Hodler. Exploring open-casement scenes, Varley showed an inclination to the frame-within-a-frame device. It has been suggested that the use of this metaphor signalled a sense of unity with nature, a growing understanding of the notion of eternity.

Sketching trips were not limited to the city of Vancouver and its immediate surroundings. Varley organized excursions into the British Columbia interior, accompanied by his son John, his colleague J.W.G. ('Jock') MacDonald, or students. Some of his best views are of mountain stumps on the horizon, stands of softwood and fir in the middle distance, and a deep river gorge straddled by a narrow plank bridge – his symbolic passage to paradise. Beloved sketching spots included Rice Lake, Lynn Peak, Mount Seymour and Grouse Mountain. *Lake Garibaldi, B.C.,* 1928 (fig. 4) was painted in another destination of choice, Garibaldi Park, about a fifteen-mile trek from the railway line.

During the early 1930s, while hiking on Vancouver's North Shore, Varley and Vera Olivia Weatherbie, an attractive student who was to become his closest companion, discovered Lynn Valley, a forty-minute ferry and tram ride from downtown. In this lush semi-wilderness, the

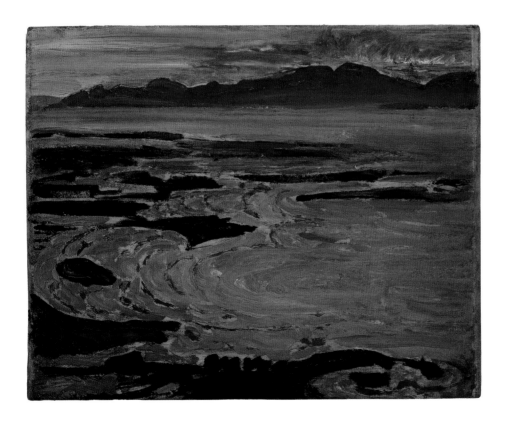

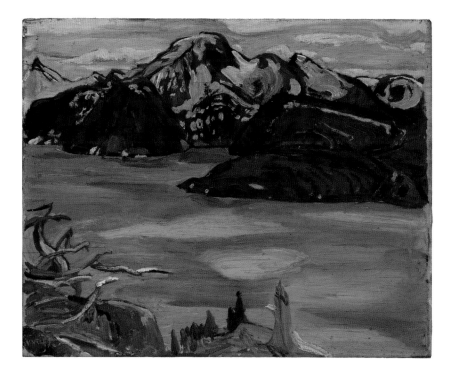

4
FREDERICK H. VARLEY
(1881–1969)
Lake Garibaldi, B.C., 1928
Oil on wood
30.2 × 38 cm

two recognized the perfect meeting of nature and civilization. *The Trail to Rice Lake*, *c*. 1935 (fig. 5), a view of Lynn Valley, is a fine example of the artist's control over watercolour, a technically trying medium. He has seized the fleeting moment through a delicate rendering of the smallest details: the brush-drawn vegetation is sparingly handled, even while the structure of swirling stems and blossoms is translated into a dense and colourful carpet. Along the trail two figures, perhaps Vera and Fred, have been skilfully integrated into the landscape. Signs of habitation – hikers, hydro poles, a bridge – appear frequently in his works from the 1930s.

To the trained eye Varley's paintings often appear to be a very individual mixture of solid classical training and modernist experiment, expressions of his own inner world. His interests were eclectic, including Eastern philosophy and Asian art, for example, which led him to experiment in new directions; some of his British Columbia landscapes were products of fantasy, devoid of any claim to national identity. Varley's spontaneity clashed with any attempt to follow a given methodology or impose a certain structure. Both his art and the way he lived his life were driven by his wild and ebullient nature. He demanded an intense relationship with each of his works; otherwise they were not worth the trouble.

It was through Vernon Blake's *The Art and Craft of Drawing* (1927) that Varley became familiar with the origins of Asian art, and he made the text a prerequisite for his classes at the VSDAA. Chinese painting expanded the artist's understanding of the symbolic dimension of landscape and,

though unable to see any original works by the great Chinese masters in Vancouver at the time, he intuitively caught and presented to his students their concept of painting as a model of the cosmos.

Through his study of Buddhism and other Eastern thought Varley had been familiar with Rabindranath Tagore's work since 1918, but during the Indian philosopher-poet's visit to Vancouver and Victoria in 1929 he was able to take part in his open discussions on art informed by interaction with nature. Varley wholeheartedly agreed with Tagore's urge to evolve into harmonious wholeness and to free one's mind "from [man's] desire to extend his dominion by erecting boundary walls around his acquisitions."

Above all, the works Varley created in British Columbia between 1926 and 1936 are imbued with the emotional reawakening brought about by his passionate love affair with his former student Vera Weatherbie. The emphasis on portraiture continued: he accepted commissions and often depicted friends and students, but Vera became his muse as well as model. In *Portrait of Vera*, *c*. 1935 (fig. 6), the young woman's gaze is at once inward and outward. Her serene face, with eyes turned away from the viewer, creates a compositional balance to the wind-blown mass of hair. Her stance is strong and assured. Varley had always seen Vera as a spiritual person and a passionate interpreter of the landscape, capable of emptying her mind so that "she received the whole of her surroundings." According to his colour theory, the blue-green pigment on her face and in the surrounding sky and mountains represents Vera's spirit. To connect her with the landscape he

5
FREDERICK H. VARLEY
(1881–1969)
The Trail to Rice Lake, *c*. 1935
Watercolour on paper
19.1 × 26.1 cm

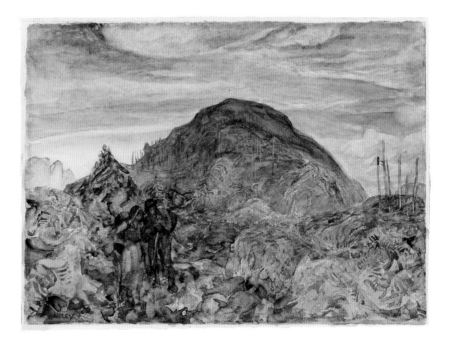

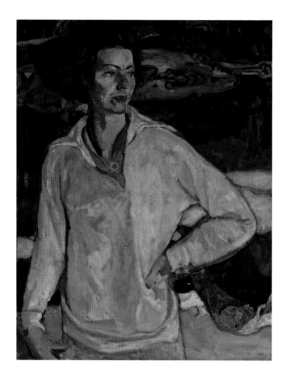

6

FREDERICK H. VARLEY
(1881–1969)
Portrait of Vera, *c.* 1935
Oil on canvas
90.8 × 70.5 cm

used a series of vertical lines that elongate her body and make her presence even more powerful. The emotive landscape behind her draws on the Chinese tradition. He employed a watery mixture of blue with green and earthy orange-brown separated by white spaces for the contours of hills.

Varley's relocation to the West gave him an opportunity to assert his independence from the rest of the Group of Seven, who remained in Ontario, though he continued to send works to Group of Seven shows and his images of the Rocky Mountains kept him not only in connection but also in competition with his friends. However, he moved back to Eastern Canada in 1936; increasingly melancholic and unsettled, he was looking for a fresh start. His chance came in 1938, in the form of an invitation to join the RMS *Nascopie* on its three-month-long voyage to the Eastern Arctic.

The vast and pristine Arctic has long beckoned southerners with its promise of a magnetic visual experience and daring adventure. For artists, the trail to the North was blazed by A.Y. Jackson, travelling with Sir Frederick Banting in 1927 and with Lawren S. Harris in 1930. Southern viewers were struck by Harris's powerful imagery, recognizing that he painted the Arctic like no other artist before him: his approach emphasized the endless, uninhabited reaches of sea and ice, reminding us that in the beginning was the land. For many artists, human life in the Arctic was almost incidental.

The trip in the *Nascopie* left a lasting imprint on Varley and satisfied his quest for the sublime. He wrote feverishly to friends, needing to share with them how close the northern light was to his spirit and how happy he felt at twilight or dawn. He delighted in the constant changes in light and atmosphere, but was troubled by the subtle signs of change that threatened the old way of life in the North. Once again, A.Y. Jackson led the way for southern artists to take a stand for the preservation of the Inuit culture and traditions. After returning from their 1927 trip, Jackson and Banting had criticized the Hudson's Bay Company for its interference with the Inuit way of life, especially their diet and clothing. Varley's letters from the Arctic reveal a similar awareness. Writing from Thule, Greenland, he admires the pride and well-being of the local people and praises the Danish government's treatment of them, then adds: "I doubt whether we shall see their equal in the trading posts of the Hudson's Bay."

Varley's fascination with the Inuits' unique features resulted in many portraits of local inhabitants whom he met on board or during the regular stops of the Arctic supply ship at Thule Island, Greenland, Baffin Island and such settlements as Pangnirtung and Pond Inlet. The natural grace and charm of the Inuit impressed the artist. He described them as "refined, artists in their dress . . . and the girls are beautiful – lovely golden skins – sloping eyes – high cheek bones – enormous round jaws – tiny little nostrils – large well formed mouths – little hands and feet."

F.H. Varley

Summer in the Arctic, c. 1939 (fig. 7), transferred from a field sketch into a larger-format canvas in oil, is generally considered the artist's most accomplished work from the trip. It is masterfully controlled in tone and the ochre shades on the ground contrast successfully with the foreground radiating with softened light. Three colourfully clad Inuit women are painted with their backs to the viewer as they walk with their children towards an encampment in the distance; one looks with shy curiosity over her shoulder at the artist. True to his nature, Varley never missed an opportunity to shake hands, drink tea and share a laugh with the people he encountered. Long after his return from the North, he was able to work in contemplation, dipping into his memories to create noteworthy images. In a letter to his friend Harold Mortimer-Lamb, Varley referred to his Arctic journey as an uplifting spiritual experience equal to the discovery of a new world.

Back in Montreal and then Ottawa at the beginning of the fall of 1938, Varley was still in awe of the vastness and the grandeur of the Arctic. Melancholic and sad after his departure from British Columbia, he was in constant search for renewal for the rest of his life. It was almost as if he needed both distance and seclusion from the world around him, in order

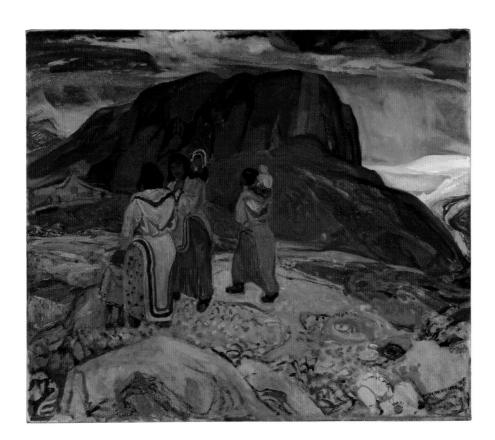

8
FREDERICK H. VARLEY
(1881–1969)
Autumn Prelude, 1938
Oil on canvas
55.4 × 70.9 cm

to connect to the subconscious. The variations of radiant light, at all times of day and night, fascinated him the most. The excitement he felt while painting *en plein air* is clearly visible in the luminous surface of *Autumn Prelude*, 1938 (fig. 8).

The use of intense pink and red hues, applied with bold vertical and horizontal brush strokes was an expression of the artist's deep rooted sense of connection to earth and sky. Perhaps as a result of his many wakes on his trip North, this lyrical interlude captures a fleeting moment at the end of the summer day, leaving a feeling of doubt as to the time of the day. Is it sunrise or sunset? In an interview on CBC Radio recorded shortly after his return from the journey, Varley compared the light in the Arctic with "a light passing through a prism." Born of that experience, *Autumn Prelude* gives the feeling of a pathway of light opening through the rural landscape as though the sky is reaching down to the earth in a spirit of harmonious union.

The 1940s and early 1950s were turbulent and restless years for Varley. Unable to find work, he moved between Ottawa, Montreal and Toronto, teaching and painting. His output was inconsistent and began to show signs of weariness and disappointment. Nonetheless his never-ending interest in the human face is evident in his sensitive drawings from the 1940s. He strongly believed that his head drawings from this period

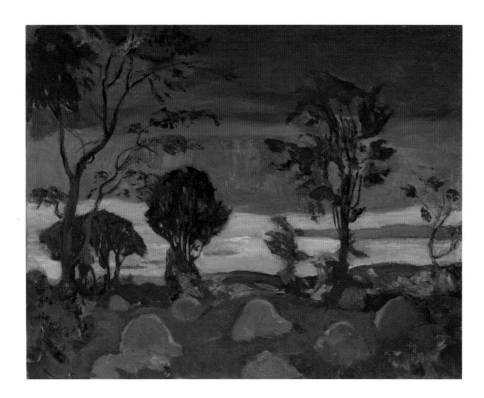

were superior to his earlier work. That judgement was echoed in a 1944 exhibition review by Pearl McCarthy, who observed: "Varley is bigger now than he was [when he left the Group of Seven], he is of today, and not yesterday, and no local opportunity to see his work has ever given the public such an adequate notion of the man's size It would be silly to waste space on Varley as part of the past history of the Canadian art movement. He is making more important art history now."

As a person and as a painter, Fred Varley was in a class of his own, enigmatic and contradictory, restless and searching, committed to his art to the end of his days. Peter Varley, the artist's son, characterized him in these words: "His impassioned gypsy side, his psychic and mystic nature, his romanticism and an absolute need for freedom of action struck out at anything that tried to restrict him." A man of grand vision and deep spiritual convictions, Varley cared little for the trappings of convention or success as the world might define it. Yet recognition arrived in many forms, including solo and group shows, works in important collections, and a Canada Council Medal for the Arts. The most enduring testament to the extent of his talent, however, is the exceptional body of work he produced over six decades.

FURTHER READING

Katerina Atanassova, *F.H. Varley: Portraits Into the Light* (Toronto: Dundurn Press, 2007)

Ann Davis, *The Logic of Ecstasy: Canadian Mystical Painting, 1920–1940* (Toronto: University of Toronto Press, 1992)

Charles C. Hill, *The Group of Seven: Art for a Nation* (Ottawa: National Gallery of Canada, 1995)

John O'Brian and Peter White (eds.), *Beyond Wilderness: The Group of Seven, Canadian Identity, and Contemporary Art* (Montreal and Kingston: McGill and Queen's University Press, 2007)

Dennis Reid, *The Group of Seven* (Ottawa: National Gallery of Canada, 1970)

David P. Silcox, *The Group of Seven and Tom Thomson* (Toronto: Firefly Books, 2003)

Maria Tippett, *Stormy Weather: F.H. Varley, A Biography* (Toronto: McClelland & Stewart, 1998)

Christopher Varley, *F.H. Varley: A Centennial Exhibition* (exhibition catalogue, Edmonton Art Gallery, 1981)

Peter Varley, preface by Jean Sutherland Boggs, appreciation by Joyce Zemans, *Frederick H. Varley* (Toronto: Key Porter Books, 1983)

References in this essay have been taken from Sheffield City Archives, Varley Papers, F.H. Varley to Ethel Varley, January 7, 1913, and undated [May 1914]; O'Brian and White 2007, p. 11; Atanassova 2007, pp. 38, 61–62, 68 and 103–04; Peter Varley 1983, pp. 25 and 110; Chris Varley, to whom the author is grateful for sharing his memories; F.H. Varley, 'Room 27 Speaking', *The Paint Box* (June 1927); Robert Stacey, 'Heaven and Hell: Frederick Varley in Vancouver', in *The Group of Seven in Western Canada* (Calgary: Glenbow Museum, 2002), p. 76; Rabindranath Tagore, 'The Relationship of the Individual to the Universe', in *Sàdhàna: The Realization of Life* (London: Macmillan, 1914), p. 4; Tippett 1998, pp. 204–05; Art Gallery of Ontario, Varley Papers, F.H. Varley to Elizabeth Gowling, September 1938; F.H. Varley to Harold Mortimer-Lamb, July 13, 1938; Art Gallery of Alberta Archives, no. 1980-19-v, F.H. Varley to Vera Weatherbie, undated [1940]; Pearl McCarthy, *Globe and Mail* (Toronto), November 4, 1944; Peter Varley 1983, p. 15.

Paul-Émile Borduas

"Therein lies the source of all mystery in a work of art: that inert matter can be brought to life"
Paul-Émile Borduas, 1942

ROALD NASGAARD

When Paul-Émile Borduas (1905–1960) opened his exhibition *Les Œuvres surréalistes* in the lobby of the Théâtre de l'Ermitage in Montreal on April 25, 1942, advanced modernist painting had arrived in Canada. Borduas soon became the leader of a group of like-minded younger colleagues who, when they first exhibited together in Paris in 1947, would call their movement Automatisme. It may be that some thirty years earlier, in Toronto, the Group of Seven had made their own avant-garde breakthrough when they re-invented the depiction of the Canadian wilderness. Their impact, however, remained national and their pictorial language out of step with Fauvist and Cubist innovations in Europe and the United States. The automatist revolution, in contrast, was internationally current, contemporary with Abstract Expressionism in New York and in the lead of Abstraction Lyrique in Paris.

The six paintings by Borduas in the Thomson Collection date to the 1950s and were executed in New York and Paris. Borduas had departed Canada on April 1, 1953, never, except for a few short visits to Montreal, to return. He spent the first two years of his self-imposed exile in New York, sailing for Paris on September 21, 1955. There he died in his studio on February 22, 1960 at the premature age of fifty-five. When he left Montreal, the cohesion of the Automatiste group had largely dissolved. Some members, notably Jean-Paul Riopelle, had relocated to Paris and many were abandoning their founding automatist principles. Borduas's artistic quest was by now entirely personal and individual. He also knew that the time had come to test himself on the international stage, and to seek there the recognition that he never doubted his work deserved.

The Thomson paintings succinctly mark the key stages of Borduas's post-Montreal development. They show how he rethought his Surrealist principles from the 1940s and step-by-step redefined his conceptions of pictorial light and space. In New York he looked carefully at the Abstract Expressionists, at Franz Kline a little, but especially at Jackson Pollock, whose technical and formal innovations in his classic large 'drip' paintings would continue to occupy him even in Paris. Abstract Expressionism may have steered Borduas in new directions, but he never comes to look like a New York painter. When he reformulated his painting it was on the basis of determinants already there in his own work and presaged in his writings since the early 1940s. Central to it was his conception of the expressive role of *matière* – matter, the material out of which a work of art is made. The Thomson paintings tell a story of how, over the course of the 1950s, Borduas translated his long-standing aesthetic theories into new studio practices, and in doing so broached fundamental issues concerning our experience of abstract painting.

The forty-five gouaches that Borduas had unveiled in his 1942 exhibition start off from where the European abstract Surrealists had arrived stylistically in the 1930s, echoing especially Joan Mirò's flattened colours,

intertwined surface patterns and biomorphic forms. But Borduas was already his own man, his imagery quite personal and his compositions tightly aligned, in new ways, with their backgrounds, and he was more insouciant about offering recognizable subject-matter. He had in effect, in Montreal, reached a stage of artistic maturity comparable to Arshile Gorky's in New York, who at just the same time in his three *Garden in Sochi* paintings, executed between 1941 and 1943, finally declared his independence from his European Cubist and Surrealist predecessors.

Borduas and Gorky were almost exact contemporaries, but Gorky developed a little differently. Since the 1920s he had successively been teaching himself the newest styles, from Cézanne through Cubism and Surrealism, as information about them arrived from across the Atlantic. Borduas's gouaches of 1942, in contrast, appear suddenly because he had begun to experiment with non-figuration only in 1941. He had originally aspired to be a church decorator and, when he was in Paris from 1928 to 1930, to study in the Ateliers d'Art Sacré, he seems to have paid little attention to Surrealism or to abstract art. Montreal in the 1930s offered little in the way of advanced modernist painting. The situation changed only with the return from France in 1940, after the German invasion of Paris, of Alfred Pellan, the other modernist Montrealer, and with the arrival of other European refugees who, as Borduas noted at the time, "raised the cultural level of the city considerably."

Borduas himself had discovered Surrealism when he came upon some articles by André Breton in the June 1936 issue of the magazine *Minotaure* in the library of the École du meuble, where he began to teach in 1939. When executing the 1942 gouaches he applied two Surrealist-derived automatist procedures that would continue to govern his work up to his New York period – "unpremeditated plastic writing," as he called it, and the "paranoiac screen." The first was, in effect, automatic writing as Breton had defined it in his 1924 *Surrealist Manifesto*, a stream of consciousness technique which, when faithfully observed, would not only tap into the subconscious but also liberate the artist from obligations to content or representation and absolve him of rational or moral inhibitions, thus opening up a creative state of complete independence and freedom. The second procedure could intervene somewhere in the latter stages of the automatic writing process, when, as Borduas explained, there could occur "a coming to consciousness," or "a state of awakening" that allowed the artist to step back judgmentally. Borduas had been especially impressed by Breton's account in *Minotaure* of the way Leonardo da Vinci had admonished his students to "go to an old stone wall, look closely at it for a long time, and little by little you will see beings and objects appearing in it. You will discover in this way a very personal subject for painting." As Borduas realized, he could use his automatically produced sheets of drawn and coloured shapes like this, as surfaces or as paranoiac screens, which,

he wrote, "when stared at lengthily" could serve "to produce phantasms." They could be used as launching pads suggesting further imaginative interpretations, allowing him sometimes to coax forth from his abstract markings imaginary visions of birds or tigers or aquatic landscapes – "those strange forms [that] float up from the subconscious mind," as he told the *Ottawa Citizen* in 1948. Hence, while the gouaches were originally untitled and only numbered, some subsequently received titles such as *Chantecler* (or *No. 6*), *Leopards eating a Lotus* (or *No. 9*), and *The Bottled Condon* (or *No. 12*).

After the gouaches Borduas faced the problem of transposing his automatist methods into the medium of oil. Oil, unlike gouache, did not permit automatic drawing because it was too slow to dry. Borduas, as a consequence, learned to work in two stages. First he painted the ground in an automatic way. Once dry, the vagaries in the ground could serve him in turn as the "paranoiac screen" for a fresh set of marks and shapes that he would add on top of them, using the brush and soon, more characteristically, the palette knife, dragging out the paint into streaky slabs of variegated colours. In the 1940s clusters of these painterly markings described semi-figurative signs hovering in a kind of dream space over a deeper ground. Eventually, like Cézanne's "*petite sensations*," they became the basic building blocks of Borduas's paintings, and those of several of his fellow Automatistes. Like the gouaches, some of the 1940s paintings remain nameless while others acquired evocative titles.

In the meantime Borduas had attracted around himself some of the brightest of the younger generation of artists in Montreal – the painters Pierre Gauvreau, Fernand Leduc, Marcel Barbeau, Jean-Paul Riopelle, Jean-Paul Mousseau and Marcelle Ferron, as well as dancers, choreographers, poets and critics, because the automatist movement was from the beginning truly interdisciplinary. The young painters all produced significant bodies of work as they experimented with any number of inventive automatist methods, making frenetic non-figurative, informal paintings – in effect, creating their own versions of action painting, independent and little aware of what was happening in New York. The Automatiste movement culminated in their publication in 1948 of the manifesto *Refus global* (Total refusal). The manifesto, a collective effort but mainly written and edited by Borduas, was a passionate repudiation of the Catholic Church and the repressive right-wing nationalism of the Maurice Duplessis government in Quebec. A public furore ensued, which caused Borduas to be fired from his job at the École du meuble. He never again returned to a teaching position.

The *Refus global* was an uncompromising call to action but not, ultimately, for a political revolution. The Automatistes had followed closely the internal debates among the Surrealists in Europe, divided between those who aligned themselves with the Communists, insisting that no revolution of

consciousness could occur before there was a social revolution, and those who gave priority to the revolution of conscience, who sided with Breton. Breton's position became a model of sorts for *Refus global*. For Borduas artistic freedom was won only when the individual broke definitively with all social conventions and institutions, rejected their rewards, and refused, as he wrote, "to live knowingly at less than [his/her] spiritual and physical potential." Spiritual revival required the automatist artistic act in which thought arose spontaneously to be fulfilled with reasoned reflection.

After leaving Canada Borduas spent the summer of 1953 in Provincetown working constantly, producing some forty new paintings. In September he occupied a rented studio in New York City on East 17th Street. In January 1954 he had his first exhibition at the Passedoit Gallery on 57th Street. In the works from Provincetown, and those he executed in New York during the following fall, Borduas appears to have harboured doubts about the figure-ground structure of his earlier automatist compositions. There are paintings in which he lets the foreground dominate more of the picture surface, largely occluding the bits of deeper space visible behind. And then there are those in which he constructs both foreground signs and background with the same streaked palette knife gestures, closing up the differences between them. *Beating of Wings at Bonaventure*, 1954 (fig. 1), crosses another threshold, in which figure and ground dissolve into one another. Its composition may gyrate around a denser whitish and pinkish centre but the gestures that define it nevertheless continue outwards towards the edges of the canvas, merely going greyer and quieter.

The title of the work refers to Bonaventure Island in the Gaspé, a famous seabird sanctuary that Borduas had visited in 1938. André Breton had also given the island a Surrealist cachet when he wrote an enthusiastic description of it after his visit in 1944. The historian François-Marc Gagnon, who tends to read referential subject-matter into Borduas's paintings, has suggested that the title the artist gave *Bonaventure* evoked his "memory of the majestic rock, swirling with thousands of gannets in flight." He elaborates: "In fact, the image of the rock looming indistinctly behind a million beating wings, of the cliff teetering in the empty air, drawn outwards by the spirited dives, the dazzling climbs, the powerful swoops, is a perfect metaphor of what Borduas's painting had become in 1954: a 'churning' – to use Breton's word – of forms, fragments and emotions invading the entire surface of the canvas, carrying along everything in its path …."

The titles of related paintings – *Cool Gardens* and *Cascade d'Automne*, both from 1954 – similarly encourage us to intuit visions of real times and places. But the question nags: had the paintings found other titles, could they not have evoked different impressions?

Two Montreal reviewers, who were trying to keep track of Borduas's New York development, said little about *Bonaventure*'s real or metaphoric representationalism. Instead they focused on its abstract formal qualities.

Paul-Émile Borduas

1
PAUL-ÉMILE BORDUAS
(1905–1960)
Beating of Wings at Bonaventure
1954
Oil on canvas
96.5 × 118.9 cm

In an article in *La Presse*, which also illustrated the painting, Rudolphe de Repentigny described the way "the form has become manifold and merged with the material." Claude Gauvreau in another periodical observed that under the "influence of the shock caused by American painting" Borduas's usual forms "have been pulverized" and "composition, another traditional element in painting, seems to be vanishing." When discrete forms disappear and traditional composition – balancing one thing off against another – disintegrates, what remains to look at, to respond to and to savour is paint itself, its coloured and viscous body, and the way the artist has used it.

What is most new about Borduas's paintings of the early 1950s is that he learned to put into practice his artistic belief in the expressive power of *matière* when experienced on its own terms. If he had not so far found a conclusive way to realize this in painting, *matière* had nevertheless pre-occupied his writing at least as long and as much as his talk of automatism. When Borduas described his automatic methods to Maurice Gagnon in 1942, shortly after having completed the gouaches, he took pains to insist that as a painter he proceeded with "painterly thoughts" and "not literary ideas." The painter, he tells us, works in "a constant state of becoming so that instinct, from which the song flows, may express itself continuously as the work is being executed." In the process, he argues, "the painter's song" becomes "a vibration imprinted on matter by human sensibility. Through it matter is made to live." In Borduas's resounding conclusion, "Therein lies the source of all mystery in a work of art: that inert matter can be brought to life."

Borduas insisted as much in a lecture he delivered in 1943 entitled 'Ways to appreciate a work of art': "I insist that every art object is made of two things, each equally real: tangible material (metal, stone, wood, paint, paper, charcoal, etc.) and the sensibility of the artist." The concept of the painter's "vibration" was reformulated as "sensibility [which] is invested in matter." Borduas also clarified that sensibility was not a matter of personal expressiveness but something of larger consequence: "the more universal the sensibility, the more lively, more identifiable and more pure it will be."

This identity of matter and sensibility, he concludes, "alone is the essence of a work of art. The rest is mere illusion." Does "the rest" include images? Intimations of imagery do not really begin to disappear until the mid 1950s and referential titles persist until the end. As late as 1956 Borduas reiterated another of his often voiced convictions, that "lines, forms and colors with no profound justification in the external world would be powerless to express the psyche." Nevertheless, in 1952, even before he left Montreal, he made a statement which, in its intent, quite outdistanced his own studio practice at the time, but could well describe a Pollock 'drip' painting or, even more radically, one of Frank Stella's black

paintings from 1958: "My ideal would be to paint a canvas that would viably be a single object and where the object would become one with the ground." However, it seems that Borduas's thinking in paint, in order to attain its proper truthfulness, had to follow its own internal painterly logic, which words could perhaps anticipate but not hurry.

In the two paintings in the Thomson Collection that chronologically follow, *Taches brunes*, 1955 (fig. 2), and especially *Abstract Composition*, 1955 (fig. 3), the individual paint gestures take on the character of discrete units. They appear laid down helter skelter, but order emerges never-theless, though it is different in kind from the focal centredness of *Bonaventure*. Instead the applications have been distributed fairly evenly across the whole surface as if to emulate a Pollock all-over composition. Spatially, because of the scurrying in-and-out of the paint units and the illusionistic effects of streaking, *Abstract Composition* carries memories of the shallow chiaroscuro of Analytic Cubism. What is essentially different is that the space of the painting is anchored in the paint itself, sitting in front of the canvas and asserting its place in real space. Especially pronounced is the thick impasto, the paint pushed into high ridges, some lifting as much as a centimetre off the canvas surface so that they actively catch light and cast shadows. These are real effects that are intrinsic to our experience of the painting.

Abstract Composition comes with a generic title, so we are not obliged to discover anything figurative in it. But a companion painting from the same year is called *Nautical Celebration*, and the name fits. How then to resist shifting one's point of view on *Abstract Composition*, taking pleasure in its fresh and clear whites and its many lively colours and, invigorated by the painting's fast, light and exuberant mood, stepping forth in the mind's eye into a glowing impressionist summer day, with celebratory red, green and white flags fluttering in a refreshing breeze? Think Monet's Paris in *La rue Montorgueil, Fête du 30 juin 1878* (1878; Musée d'Orsay, Paris). Is *Abstract Composition* then abstract or representational? Is it particle or wave, to evoke Niels Bohr's principle of complementarity? Borduas's painting, like a complex system in physics, will reflect the point of view that we take on it, and no individual viewer can derive all possible observations about it from a single stance. If we look at *Abstract Composition* as an object made of paint, then it is the *matière*, "imprinted by human sensibility," that will first stir us. If we seek images, then our sensitivity to material will be dimmed.

How does the artist imprint his sensibility into matter? Borduas's palette-knife gestures are freehand and painterly, as opposed to measured and geometric. But they are too blunt to count as personal handwriting, and too controlled to resemble the 'action painting' of Abstract Expressionists like Franz Kline or De Kooning (Borduas thought De Kooning "literary"). Borduas had already, in a 1952 interview, disparaged Riopelle's Parisian

2
PAUL-ÉMILE BORDUAS
(1905–1960)
Taches brunes, 1955
Oil on canvas
38 × 45.7 cm

palette-knife touch – though close in appearance to his own – as merely a product of "the physical accident," whereas his own accident, he maintained, "is evidently not preconceived, but it is mindful of itself, it is attentive, an accident of the soul and not merely an accident." This seems a subtle distinction, especially when made by an artist who had forsworn religiosity and embraced materialism. It is not inappropriate that Borduas has been called a "mystic materialist."

Borduas's materialism had direct sources in Marxism, as he explained in *Le Retour*, a text written on the eve of *Refus global*: Marxism had given us a rational explanation for the movements of history. If at an earlier historical stage existence was incomprehensible without resort to supernatural powers, Marxism released us from the supernatural into the natural, from the spiritual into the material. The Marxists made an error, however, Borduas continued: when they suppressed the soul they also forgot the importance of the passions. "The limit of life may be to be purely material," he argued, but as "man without a body is inconceivable" so "life without passion is inconceivable." Matter, Borduas maintained, held "physical secrets" which it would divulge, and "the passions are [its] behaviour." Matter is all-embracing because there is "no rupture between the stone and the most refined spirit."

3
PAUL-ÉMILE BORDUAS
(1905–1960)
Abstract Composition, 1955
Oil on canvas
58.4 × 76.2 cm

4
PAUL-ÉMILE BORDUAS
(1905–1960)
Le Chant des libellules
(The song of the dragonflies)
1956
Oil on canvas
115.9 × 88.9 cm

When in the 1950s Borduas spoke of his own accident as "not pre-conceived" and yet "mindful of itself" and "attentive," there is perhaps reason to believe that Pollock was his inspiration. In a 1955 text in which he briefly described the key modernist steps towards the non-figurative he attributed to Pollock the capacity to make the "accident … capable of expressing both physical reality and psychic quality." The secret to Pollock's dripping and pouring style had to do with his methods, his gestures, which, because they were arm's-length rather than wrist-close, could only partly control the fall of his paint, leaving room for paint to take its own initiative to leave unplanned marks or "accidents." These accidents called for a "mindful" or "attentive" – to cite Borduas's words – response, that in turn would yield new provocative accidents, which demanded yet another taking into account and another thrust into the unknown, and so on. Borduas's broad spatula tool, unlike a small handheld brush, promised a comparable dialogue between artist and matter.

On the eve of the publication of *Refus global*, in a letter to Leduc, Borduas completed the full compass of the artistic experience by taking into account the role of the viewer. The work of art, as he proposed, was finally executed when the viewer encountered it using "the intelligence of the senses." Then he/she opened him/herself to explore the sensate presence of the artist's vibrations in the material of paint. Borduas's phrase "the intelligence of the senses" was the earliest articulation in Canada of the notion that we could, with our sensual and emotional faculties, respond directly to the material components of art, transforming them into things of meaning, beauty and desire.

Borduas came to Paris after his two fruitful years in New York anticipating that the French capital would still be, as it had been before the Second World War, an international centre of advanced artistic production. Paris disappointed, not only in this – its artistic offerings paled in comparison to what Abstract Expressionism had achieved in New York – but the city also failed to give his work serious critical attention. The Paris years were nevertheless remarkably productive. They were a period of consolidation, Borduas bringing to new resolution the lessons learned in New York. They were equally dedicated to an ongoing quest that sometimes glanced backwards, sometimes circled around and around pictorial problems, and then at other moments struck a new direction forward with paintings that surprise by their sheer material immediacy and literalness as if they were the first propositions of a new, unfulfilled adventure.

Le Chant des libellules (The song of the dragonflies; 1956, fig. 4), is a new kind of picture that uses a diversity of techniques, some familiar, some new. We should notice especially that Borduas, having just achieved a Pollock-like all-overness, composed *Le Chant* by balancing parts off one another, setting the black shapes against the larger white fields with

an almost overt grid-like regularity that evokes Mondrian's Neoplastic geometry. Such a reference is not coincidental given also the painting's increased whiteness. The white areas are built up with Borduas's signature palette knife moves, but the blacks are mostly flatter and thinner, negatives perhaps to the whites' positives, creating impressions of depth as if revealing a black heart of nothingness below. But that is metaphor, because the black's matt planarity less opens itself up to illusion than is anchored in the realm of literal flatness. And yet ambiguity prevails. The painting, after all, has a title, albeit an enigmatic one. F.-M. Gagnon, with regard to a similar picture, *Thaw*, 1956, has observed that "it clearly shows that Borduas initially saw the black as an area with a certain depth on which the white masses floated, like blocks of ice and snow on the black waters of a river after the spring thaw."

The Thomson Collection is rounded off with two great black and white Parisian pictures, *Bercement silencieux* (Silent rocking; 1956, fig. 5) and *Untitled* (1957, fig. 6). If both retain some vestigial illusionism, when grey streaks through the white impasto, it is an impoverished kind of chiaroscuro with minor force in comparison to the real lights and shadows cast across the paintings' relief surfaces, so much more evident because of the starkly reduced palette. The latter has been attributed to Borduas's interest in Kline, and observers have found a Kline-like black-white figure-ground reversibility in some of the black and white paintings. But these two works fail to support any significant relationship between the two artists. Borduas's paint in each case is too tactilely assertive to allow optical games.

Untitled is the more majestic and the more classically serene of the two. The more daring *Bercement silencieux* corresponds better to the theme of this essay. It is both like an arrival after a long journey and like an affirmation that sets the stage for a leap into a yet unknown. It is a fairly large painting by Borduas's standards. It is exceptionally physical, the paint spread into folds and creases often rising into high relief. The predominant colours are black and white, but a dark brown is a significant player. All three bodies of coloured matter sit palpably dense on the surface of the canvas, the brown sometimes like old worn leather, sometimes congealed in crimpy ripples. Neither browns nor blacks are optical holes, but compact inserts into the larger expanse of white, the whites as if shoved aside to give them space. Here and there, in slits between the massed build-ups of paint, bits of the canvas peep through, asserting its role as a literal ground. The paint surface is hand-made but has not been put to any expressionistic use. Borduas's spreading and covering are workmanlike and reinforce the paint's overt self-sufficiency. More than ever the space of the painting occurs in that of the viewer. Light tickles the raised edges and casts shadows behind them, sparkling off the creamy white, and slowing down and being absorbed into the matts of the blacks and dark browns.

5
PAUL-ÉMILE BORDUAS
(1905–1960)
Bercement silencieux
(Silent rocking), 1956
Oil on canvas
113.7 × 145.6 cm

6
PAUL-ÉMILE BORDUAS
(1905–1960)
Untitled, 1957
Oil on canvas
130.4 × 161.7 cm

Paul-Émile Borduas

When Borduas the mystic materialist spoke of the "ideal depth" of the whites in pictures such as this one, it was with reference to Mondrian's flat unarticulated planes – concept rather than illusion. Something should also be said about composition. *Untitled*, like *Bonaventure*, is ordered around a central point, whereas *Bercement silencieux* is asymmetrically constructed. The eye flits from shape to shape; it groups and regroups shapes in quickened rhythms, allowing the painting unceasingly to change under our shifting gaze. Such conscious deference to the prolonged duration of experience, precipitated by a denial of formal closure, would become a preoccupation of Montreal's Plasticiens in the 1960s.

If this materialist reading of Borduas's New York and Parisian paintings seems too one-sided, it can be justified by reference to two small mono-chromes from the artist's last years (both Musée d'art contemporain, Montreal) in which the paint seems literally trowelled onto the canvas, with little finesse, as if the artist has entirely deferred to the paint's viscosity to determine how gesture, texture and light must emerge. We do not, of course, know what Borduas thought of them: dating to 1958, they were not his last paintings. But a next generation of Canadian artists, imbued with minimalist and conceptual aesthetics, would come to understand Borduas's late paintings as material-based and therefore anticipating their own aesthetic investigations. In these his late paintings *matière* is made to sing unmediated, and, if we give Borduas the last mystical word, "to integrate itself into the Cosmos in order to communicate with the global processes of transformation."

FURTHER READING

Ray Ellenwood, *Egregore: A History of the Montreal Automatist Movement* (Toronto: Exile Editions, 1992)

François-Marc Gagnon, *Paul-Émile Borduas: 1905–1960* (Ottawa: National Gallery of Canada, 1976)

Paul-Émile Borduas: Écrits/Writings 1942–1958, ed. and trans. François-Marc Gagnon and Dennis Young (Halifax: Nova Scotia College of Art, 1978)

François-Marc Gagnon, *Paul-Émile Borduas* (Montreal: Montreal Museum of Fine Arts, 1988)

Roald Nasgaard, *Abstract Painting in Canada* (Vancouver and Toronto: Douglas & McIntyre, 2007)

William Kurelek

CHARLES C. HILL

 A large yellow glass bowl full of tomatoes sits on a brown-tiled kitchen counter backed by blue patterned wallpaper. In the midst of the red tomatoes is one green one and on the counter a rotten, overripe tomato. Purchased in 1990, this work of 1969 (fig. 1) was the first painting by William Kurelek (1927–1977) acquired by Ken Thomson, the basis of a collection of Kurelek's work that would eventually include over forty paintings and drawings covering the artist's principal subjects and most aspects of his relatively short career. Kurelek is frequently referred to as the Krieghoff of Western Canada: his depictions of childhood games and adults labouring in rural landscapes share with that nineteenth-century artist a meticulous draftsmanship and a multitude of narratives that draw the eye in to explore all corners of the composition. Yet Kurelek's paintings bear a very different message from those of Cornelius Krieghoff. While this painting is ostensibly an ordinary still life of a banal subject, the real intent is clarified in a folded piece of paper, lying on the counter, on which one can read a partial inscription: *One Bad Fruit Can Spoil a Whole Bushel of Good Ones—an old proverb*. For Kurelek, art was the means to express his fundamentalist Christian faith and his apocalyptic vision of human destiny.

William Kurelek was born in March 1927 on a farm in a mostly Ukrainian settlement near Whitford, Alberta, north-east of Edmonton. When he was seven years old his family moved to a dairy farm near Stonewall, Manitoba, north of Winnipeg, where the Kurelek children, knowing only Ukrainian, had a painful integration with their new English-speaking schoolmates. The farm at Stonewall would provide Kurelek with his most vivid childhood memories and a rich source of imagery for his future paintings. After attending high school in Winnipeg, Kurelek completed a BA at the University of Manitoba, graduating in the spring of 1949. Summers were spent working as a lumberjack or in construction to raise money for tuition. That same year his family moved to Vinemount, near Hamilton, Ontario. Against his parents' wishes, that fall Kurelek entered the Ontario College of Art (OCA) in Toronto, where he would remain for only six months.

Kurelek later denied that he had received any benefit from his studies at OCA or at the Instituto Allende in San Miguel, Mexico, where he subsequently spent five months in 1951. Yet his teachers at both institutions had lived through the political and economic crises of the 1930s and had determined to engage their art with the lives of the people, to bear witness to the inequities of their times in clearly understandable images or to bring about social and political change. Subject-matter took precedence over style, and the art of the past, as exemplified in the work of Pieter Bruegel the Elder, Hieronymus Bosch, Francisco de Goya and Honoré Daumier, was studied to provide models for a response to the social conditions of the present. These, too, would be Kurelek's goals, though his intent would not be political but religious.

Kurelek's parents had been preoccupied by the constant demands of maintaining the farm and family during the Depression. His father was completely unsympathetic to his son's sensibilities and interest in drawing, belittling his lack of physical prowess and mechanical skills. As Ramsay Cook has observed, Kurelek "was extremely thin-skinned and found personal relations almost impossible." His resultant feelings of social inadequacy and inferiority led to a profound crisis, for which he sought help in England, where he would live from 1952 to 1959. He was hospitalized for extended periods, first at the Maudsley Hospital in London and then at the Netherne Psychiatric Hospital in Surrey, both institutions where the staff were interested in art as therapy and supportive of his need to paint. Through his often horrific paintings Kurelek cried out for help and exorcized the demons that haunted him. In desperation he twice slashed his arms with a razor and underwent electro-convulsive therapy. But it was his discovery of a purpose for his life in religion and his conversion to Roman Catholicism in February 1957 that eventually freed him and enabled him to train and find employment as a framer.

Between hospitalizations Kurelek travelled to Vienna, Belgium and the Netherlands to see paintings by Bosch and Bruegel. In England he admired the work of Stanley Spencer, whose biblical narratives had been staged in the world around him. He painted a number of *trompe-l'oeil* still lifes in the 1950s that he exhibited at the Royal Academy and sold for little. These would be the precursors of *Bowl full of Tomatoes: One Bad Tomato spoils the Whole Basket* of 1969.

In other paintings Kurelek depicted the various places he lived and worked during these years in England. The watercolour and gouache *Netherne Hospital Workshop* (fig. 2) is a superb example of his skills as a draftsman and as a creator of subtle colour harmonies. The green cupboard-door and pink measuring-unit on the right are echoed in the triangular forms on the far wall and the red boxes lower left. Fidelity to visual fact or 'truth' would be a consistent concern of the artist, who gave great value to the specialized knowledge of the users of the tools and equipment he depicted. The complex arrangement of machines and lumber is built up from a multitude of details that are delineated with precision, framing the brooding figure in the foreground.

Like many of his English works this painting of the Netherne Hospital workshop is not signed, but in another painting (fig. 3) a plaque on the refrigerator, lower left, identifies the title and authorship: THE BATCHELOR MADE BY WILLIAM KURELEK. The subject is the kitchen in the fourth-floor flat at no. 46, Baron's Court Road, Hammersmith, London, belonging to Mr. Meyer, from whom Kurelek sublet a room in 1955. The picture is replete with anecdotal details. Mr. Meyer, one galosh on and one galosh drying on a *Catholic Herald* bearing the headline POLAND NO BENEFITS TO CHURCH – CASSOCK LIKE A RED RAG TO BULL, sips his tea as he reads

1
WILLIAM KURELEK
(1927–1977)
**Bowl full of Tomatoes:
One Bad Tomato spoils the
Whole Basket**, 1969
Mixed media on hardboard
52.1 cm × 54.6 cm

William Kurelek

2
WILLIAM KURELEK
(1927–1977)
Netherne Hospital Workshop, 1954
Pencil, watercolour and gouache
on paper laid down on board
50.8 × 61 cm

The Daily Mail. His wet sock awaits darning on the refrigerator, a jar labelled *Golden Garbage* sits beside what appears to be a home-made still, smoke rises from the oven, garbage overflows from the can below the sink, and through the window the sun tries to penetrate the London fog. It is an intimate portrait executed with affectionate humour.

Kurelek's early tribulations and religious conversion are effectively summarized in his oft-exhibited self-portrait of 1957 (fig. 4). As he explained in his notes for his retrospective exhibition at the Winnipeg Art Gallery in 1966, he painted it to supersede an earlier self-portrait and to affirm his identity in his newly acquired faith. The background images are arranged as overlapping cards and photographs while detached foreground images represent the steadying aspects of his Catholic faith, including a soul in hell, an icon of Our Lady of Perpetual Help, a symbolic diagram of the Blessed Trinity with a quotation from Saint Augustine, a soul in heaven, the Basilica at Lourdes and an X-ray of the Shroud of Turin; the Basilica at Lourdes overlaps photographs of Margaret Smith, occupational therapist at Maudsley Hospital, and Father Thomas Lynch, both of whom played key roles in his conversion. The background or "helter skelter" pictures, as Kurelek defined them, represent "various influences from childhood to the time of my conversion – scenes chosen from my own paintings, from photographs, and some made up scenes." Clockwise from lower left these include a tortured man cowering in bed sheets and

3
WILLIAM KURELEK
(1927–1977)
The Batchelor, 1955
Gouache over black chalk
on paperboard
71.2 × 49.8 cm

William Kurelek

4
WILLIAM KURELEK
(1927–1977)
Self-portrait, 1957
Watercolour, gouache and
ink on paper
47.5 × 38 cm

surrounded by devils; a detail of Kurelek's 1953 painting *Farm Children's Games in Western Canada*, inspired by Pieter Bruegel's *Children's Games*; a Mexican group; his 1950 painting *Burning Barn*, with his sleeping father partially buried in the ground; his 1955 painting *Behold Man without God* (now Art Gallery of Ontario); his 1953 drawing *Penge East*; the Kurelek family at table; the turret of Netherne Hospital seen from his window; the artist leaning against his bed with his arms slashed; Kurelek as a lumberjack during his student years; and his 1955 painting *When I have come back*. The artist bravely looks out at the viewer, bearing his troubled past with a new confidence supported by his faith. The watercolour was later framed with a matt board covered with a Ukrainian textile.

Kurelek returned to Canada in June 1959 following a brief trip to Israel and Jordan to research his planned illustrations for the Gospel of Saint Matthew. In Toronto he was hired as a framer at the Isaacs Gallery, where he had his first exhibition in March 1960. The exhibition, consisting of paintings from the previous decade, including his 1957 self-portrait, was a great success, and was followed by a second in 1962, entitled *Memories of Farm and Bush Life*. From this date Kurelek's paintings had largely two themes, recollection of aspects of his own and his parents' lives and a didactic, apocalyptic vision of a materialistic society doomed to destruction to attain salvation.

In many of Kurelek's best paintings the two themes would be combined, anchoring his religious vision in daily life. As his former fellow OCA student Elizabeth Kilbourn noted in a review of Kurelek's May 1963 exhibition at the Isaacs Gallery, Kurelek "fails when he paints things he knows only from dogma & not from experience When he sets out to paint heaven his imagination is inadequate. In *Dinner Time on the Prairies* [Christ crucified for the farmer's sins on a fence post in a prairie landscape, now in the collection of McMaster University, Hamilton] he creates a vision of hell. So honest are the realistic facts, so unforced the symbolism, so integrated the structure of the painting it produces a guilty shock. Kurelek shares with Stanley Spencer the ability to put a real and living representation of Jesus in a familiar contemporary setting." The May 1963 exhibition, entitled *Experiments in Didactic Art*, included several of these parables in Canadian landscapes as well as paintings illustrating the Seven Cardinal Virtues and Seven Deadly Sins. The most heraldic of the series, *The Rock* (fig. 5), while not derived from memories of farm life, succeeds through the simplicity of its message and as an emblem of the artist's steadfast faith. THOU ART PETER (THE ROCK) AND IT IS UPON THIS ROCK THAT I WILL BUILD MY CHURCH. AND THE FORCES OF HELL SHALL NOT PREVAIL AGAINST IT is inscribed on the rock below the papal crown and crossed keys of Saint Peter. In the sky above is the dove of the Holy Spirit and the saints the Church has produced. In the blood-red sea swim the internal enemies of the Church, depicted as Boschian monsters carrying

THOU ART PETER (THE ROCK)
AND IT IS UPON THIS ROCK THAT
I WILL BUILD MY CHURCH . AND
THE FORCES OF HELL SHALL NOT
PREVAIL AGAINST IT

William Kurelek

5
WILLIAM KURELEK
(1927–1977)
The Rock, 1962
Mixed media on hardboard
124.7 × 122.4 cm

banners identifying their sins: Laxity, Political Intrigue, Wealth, Simony, Power, Arrogance, Leakage, Dearth of Vocation, Factions, Class, Inquisition, Property, Personalities, Racial Intolerance, Form, Nationalism, Schism, Superstition, Ennui, Graft, Apostasy, Absenteeism, Heresy, Puritanism, *In loco parentis*, Ghetto Mentality, Sodomy, Sloth, Bad Example, Obscurantism, Errors in Political Alignment, War Making and Modernism.

Two very different works in the Thomson Collection come from a series painted for Kurelek's 1968 exhibition entitled *The Burning Barn*, a parable of humanity's indifference to its ultimate fate derived from the image of the burning barn in his 1957 self-portrait. As in his 1966 exhibition, *Glory to Man in the Highest*, paintings were paired as points and counterpoints of pleasant and unpleasant themes. *Old Age is No Joy*, an image of Sorrow, was paired with a painting of Joy, the Kurelek family on vacation. *Reminiscences of Youth*, an image of Good, was paired with a painting of Evil, a burning barn titled *Our World Today*. In a world where he saw the boundaries between good and evil being blurred, Kurelek saw himself "as an artist preaching in the wilderness."

The frame of *Old Age is No Joy* (fig. 6) is appropriately damaged and old. In a hospital ward (possibly the veterans' Sunnybrook Hospital in Toronto, where Kurelek visited his father-in-law) the male patients, several in wheelchairs, one with his legs amputated, two slouched over and strapped into their chairs, are fed or examined by doctors and nurses while an orderly closes the curtains in the TV room. There are only two visitors, a woman seated by a bed talking to an unseen patient and a young man standing by a bed sadly looking at the sleeping or incapacitated man he has come to see. There is little communication. The elderly have been abandoned to loneliness and sorrow.

As the artist noted in his texts for this exhibition, "One thing I have heard many times is 'How come a Christian paints so much gloom?' So this time I have endeavored to offset this impression by painting most of the happy scenes larger than the unhappy ones – hoping sheer area will help. I also tried tapping to its fullest the sparse happiness of my youth by introducing music or song into the illustrations." In the lower right corner of *Reminiscences of Youth* (fig. 7) the artist has included a phonograph player and records, and on a sheet of paper are inscribed in Ukrainian and English the lyrics to the Ukrainian folk song 'There Stands a High Mountain': *How beautiful how joyful, Is life in this white world! Why then does my heart grow faint, Why this heartache within? Springtime will return anew, This it is that brings sadness and pain, For youth will never come back, It will not ever return again.*

Reminiscences of Youth is, ingeniously, a painting set within a painting, the central or remembered image physically framed by the outer image of William as a young student in his rented room in Winnipeg, remembering school games played at Stonewall. There are holes in the window blind and a bottle of milk and an empty tin with a spoon in it are placed on the table

6

WILLIAM KURELEK
(1927–1977)
Old Age is No Joy, 1968
Mixed media on hardboard
61.7 × 83.1 cm

by the record player. Light comes in under the door, beside which sits his one suitcase. The painting of children playing on a snow-covered haystack recalls his 1953 painting *Farm Children's Games in Western Canada*, a detail of which appeared in his 1957 self-portrait. The dreaming figure and the playful children create a detailed and beautifully poetic, joyful image that characteristically contrasts with the memories of humiliation, violence and pain recounted in his memoirs, *Someone With Me*. Kurelek did, however, remember some happy childhood games: "I myself became aware of the thrill to be had from physical closeness to girls only in the last one or two years at Victoria School, and it took even longer to realize why. We went out in winter at recess, the whole lot of us, to a neighbour's straw pile and played King of the Castle. I noticed it was so much more pleasurable to wrestle a girl down the straw pile than one of my boy playmates." Another game had the young boys, pretending to be animals, pulling an older boy on a piece of corrugated rusty old tin at the base of the stack: "The wagon tongue and traces were a stick tied with haywire. The drivers were the older boys, and the horses – you guessed it, us 'younger boys' This was a role somehow in which the older boys were so absorbed with their

creative work that even when they pretended to whip us to make us pull faster, it was not done with meanness. In fact we invited this 'whipping' for we'd pretend to buck the traces at our horsemate."

From the mid 1960s Kurelek had always constructed his exhibitions as series, the better to communicate his messages. To be absolutely certain his ideas were understood they were accompanied by textual explanations of the instigation and intent of the series as a whole as well as of the individual paintings. His October 1972 exhibition held at the Isaacs Gallery focused on the city of Toronto. These were not just pleasant views of the artist's adopted city but also included paintings denouncing

8
WILLIAM KURELEK
(1927–1977)
Don Valley on a Grey Day, 1972
Mixed media on hardboard
122.1 × 243.7 cm

sexual licence, abortion and humanity's indifference to Christian salvation. *Harvest of Our Mere Humanism Years* is a Boschian narrative staged around Toronto's new city hall, warning the viewer of the imminence of nuclear destruction as the price of our abandonment of religion for secular philosophies. That painting was intended to complement *Don Valley on a Grey Day* (fig. 8), a lyrical painting of the same dimensions. William Kurelek and his two youngest children lean over the railing of the Bloor Street viaduct, looking down on the steady stream of cars on the Don Valley Parkway. Inspired by the London, Ontario, artist Jack Chambers's view of Highway 401 (now Art Gallery of Ontario), the large painting – almost two and a half metres wide – encompasses a panorama of the lush valley and the Don River framed by apartment and office buildings and schools. In his published notes for the series Kurelek teasingly invites us to find the crucifix he had carefully hidden in the painting, a symbol of Christ's sacrifice and presence in the world, contrasting to the blind loss of faith depicted in *Harvest of Our Mere Humanism Years*. In the sky above, shafts of light break through the grey haze, possibly additional symbols of a divine presence.

9
WILLIAM KURELEK
(1927–1977)
The Recycling of the Eaton's Catalogue, 1976
Mixed media on hardboard
118.3 × 67.6 cm

Two projects were constructed around the immigrant histories of Kurelek's Ukrainian parents and in the 1970s additional series focused on other cultural groups in Canada, including Jews, Inuit, Québécois, Irish and Poles, mostly staged in rural settings. The characteristically bawdy farm-humour subject of a man seated in an outhouse in *The Recycling of the Eaton's Catalogue* (fig. 9) somehow seems more appropriate to his earlier lumberjack series than to the series of Irish paintings. Only the green and orange liners to the barnwood frame and the sitter's green jacket suggest an Irish theme – until one remembers that it was an Irishman, Timothy Eaton, who founded the national chain of stores. The seated figure studies the items offered in the mail order catalogue, which range from wood-working tools to the more seasonal long underwear (the pages between having been used already). The cover of the second catalogue, hanging on the post, bears a detailed view of the Eaton warehouses and factory. (One wonders if Ken Thomson took a certain delight in this recycling of the Eaton catalogue pages, knowing that Eaton's was the principal competitor of the Thomson-owned Hudson's Bay Company.) Like all Kurelek's best images, this, too, derived from the vivid memories of his youth, and one is struck by the view through the door to the snowy expanse at the left.

Kurelek's didactic paintings were respectfully received but he took to heart any criticism of his religious messages. As he wrote in October 1975, "At Isaacs I have made every second exhibit a Christian moral, didactic show. The ones in between were pastoral, to keep my foot in the public's door. I tried to get across the message mostly on point–counterpoint, e.g. Hate vs Love, Construction vs Destruction, Faith vs Superstition. Well I learned my work had a depressing effect. Three years ago, therefore, I tried an off-balance proportion of twenty happy, pleasant pictures vs six message, foreboding works and still the message paintings outweighed the 'happy' ones in the public mind. This was the series represented in my book 'O Toronto.' By now I was getting quite peeved. 'By Golly,' I said to myself, 'suppose I were to paint up a 100% pleasant pastoral series? Would the public still see lurking terror and pessimism in those too? So, I did the series called the 'Happy Canadian' But no this time it worked! All visitors and critics got the message of joy. In fact, to my wry amusement the consensus was that a new, radiantly happy Kurelek had finally flowered."

Kurelek painted three works for each of the ten provinces in the *Happy Canadian* series. They are of similar dimensions and are framed with a decoration of maple leafs arranged as vines, only the colours of the frames' liners differing from one painting to the next. *The Painter* (fig. 10) is one of the most joyful of these paintings and is a view near the bog by his parents' farm at Stonewall, Manitoba. The bog "speaks to me because it is flat and it is lonely, as I often was and sometimes still am," he wrote in his autobiography. "It's moist and has these mysterious springs [On] Sunday afternoon when we boys were freed from farm duties, we

William Kurelek

10
WILLIAM KURELEK
(1927–1977)
The Painter, 1974
Mixed media on hardboard
121.9 × 91.4 cm

often headed out there, either alone, or with playmates. Maybe that, too, is a key word – 'Freedom' There were no fences in those days on the bog, or hardly any worth mentioning, and no people and no buildings On clear dark nights we'd see a glow of lights on the horizon off center to the right and were told that was Selkirk, Manitoba." On his first trip back to Stonewall on a painting trip in 1963 he lived, ate, slept and worked in his Volkswagen, photographing the site all afternoon and painting by the light in the car ceiling at night. He became as much concerned with the sky as with the bog and the springs; his evident delight in the sky effects is expressed in the painterly manner in which he has treated the clouds. The diminutive figure in the car is dwarfed by the vast expanse forcefully evocative of the one place of joy he found in his troubled youth.

The paintings and drawings by William Kurelek in the Thomson Collection effectively represent the great talent and imagination of this unique Canadian artist. Through the power of autobiography Kurelek was able to find partial liberation from the pain of his early life, but that pain became the catalyst for the urgency with which he insisted on the necessity of religion to attain salvation. He was a people's artist, not only in his intense devotion to conveying his hope for humanity, but in his anchoring of that message in autobiographical storytelling and in the daily lives of the people and environment around him. With an almost naïve literalness he expounded his arguments with a moral commitment to a truth of observable and documented fact – observed and documented with great sensitivity – that became the setting for his visionary works. He was a man of courage who left us with images of hope and despair, of joy and sorrow, of health and illness, of love and hate, of good and evil, all to save us in his guise.

FURTHER READING

William Kurelek, *Someone With Me* (Ithaca, NY: Center for Improvement of Undergraduate Education, Cornell University, 1973)
Patricia Morley, *Kurelek: A Biography* (Toronto: Macmillan of Canada, 1986)
Joan Murray, *Kurelek's Vision of Canada* (Oshawa: Robert McLaughlin Gallery, 1982)

References in this essay have been taken from Ramsay Cook, 'William Kurelek: A Prairie Boy's Visions, William Kurelek Memorial Lectures 1978', *Journal of Ukrainian Studies*, V:1 (spring 1980), pp. 33–48; Elizabeth Kilbourn, 'Dogma and Experience', *Toronto Star*, May 18, 1963; William Kurelek, *Someone With Me* (see above); William Kurelek, *O Toronto* (Toronto: New Press, 1973); William Kurelek, *Kurelek's Canada* (Toronto: Pagurian Press, 1975); William Kurelek, notes for exhibitions at the Isaacs Gallery, Toronto, in the Avrom Isaacs Fonds, Clara Thomas Archives, York University, Toronto; William Kurelek, 'Notes written the day after the opening as it is a downright disaster', in *William Kurelek: The Temptation of Modern Man Series*, Grand Rapids, Michigan, Calvin College Center Art Gallery, October 3–31, 1975; Avrom Isaacs Fonds (as above).

CONTRIBUTORS

JEREMY ADAMSON, formerly senior curator at the Smithonian Institution's Renwick Gallery, is Chief of Prints and Photographs at the Library of Congress, Washington.

KATERINA ATANASSOVA is curator at the Varley Art Gallery of Markham, Ontario.

STEVEN N. BROWN is an established authority and participant in Northwest Coast native cultures and was formerly curator of Northwest Coast Art at the Seattle Art Museum.

LUCIE DORAIS, formerly art archivist at the National Archives of Canada, is working on a catalogue raisonné of James Wilson Morrice's work.

CHARLES C. HILL is Curator of Canadian Art at the National Gallery of Canada, Ottawa.

JOAN MURRAY, author of over twenty books on Canadian art, has recently completed a catalogue raisonné of Tom Thomson's work.

ROALD NASGAARD is Professor of Art History and former Chair of the Studio Art Department at Florida State University.

DENNIS REID is Director, Collections and Research, and Senior Curator of Canadian Art at the Art Gallery of Ontario.

DAVID P. SILCOX is President of Sotheby's Canada and a Senior Fellow of Massey College, University of Toronto.

SHIRLEY L. THOMSON was formerly Director of the Canada Council for the Arts and Director of the National Gallery of Canada.

ACKNOWLEDGEMENTS

Special thanks for their assistance in the preparation of this volume are due to: Anastasia Apostolou, Greg Humeniuk, Margaret Haupt, Ralph Ingleton, Maria Sullivan, Marie-Eve Thibeault, Priyanka Vaid, Paul Wilson, Jennifer Winthrop.

FRONT COVER

Lawren S. Harris, *Baffin Island Mountains*

BACK COVER

Cornelius Krieghoff, *Breaking up of a Country Ball in Canada, Early Morning*

PHOTOGRAPHY

The photographs of paintings were taken by Michael Cullen, Peterborough, Ontario, and of First Nations objects by Frank Tancredi and Michael Cullen.

First published November 2008 by Skylet Publishing in association with the Art Gallery of Ontario

© 2008 Skylet Publishing / Art Gallery of Ontario Text and images of works of art © 2008 The Thomson Collection, Art Gallery of Ontario Works by the following artists are reproduced by kind permission of their copyright holders: Harris; Varley; Borduas; Kurelek.

ISBN 9781903470 83 1
9781903470 86 2 (5 volume boxed set)

Distributed in Canada by University of British Columbia Press www.ubcpress.ca and in the United States by the University of Washington Press www.washington.edu/uwpress/ and in Europe and elsewhere by Paul Holberton publishing www.paul-holberton.net

Produced by Paul Holberton publishing, London www.paul-holberton.net

Designed by Philip Lewis

Origination and printing by e-graphic, Verona, Italy